CYCLE STYLE

HORST A. FRIEDRICHS

PRESTEL
MUNICH LONDON NEW YORK

THIS IS CYCLE STYLE TODAY BY NICK CLEMENTS

As World War II ended a new battle began on the roads of Britain. This struggle was contained within the world of cycling with the main protagonists being the ultra-conservative National Cyclists' Union (and its affiliate the Road Time Trials Council) and the newly formed British League of Racing Cyclists. One represented the old order and all that came with it and the other a continental approach to velo-sport that embraced continental values in mass road-racing and perhaps, what was perceived at the time, as left-liberal views on other things. The BLRC represented a future full of colourful knitted merino jerseys while the NCU insisted their members only competed in time trails head to toe in black. Knowing Britain's tendency towards Dandyish behaviour, especially among the working-classes, it's not surprising that it was these points of sartorial conjecture that really irritated the Racing Cyclists and sent the Cyclists' Union into convulsions during which we can imagine the phrase "thin end of the wedge" being repeated.

Sixty years on we are in a new place. London is quite literally awash with bicycle riders of every sort and it's impossible to ignore the stylish way they approach this simple means of transport. The keys to the wardrobe of British proletarian Dandy were sold-on as a consumer item many years ago but there are still pockets of resistance that shun such commodification. Many individuals within London cycling culture display an originality in style and dress that places the Capital at the head of cycling style, worldwide.

Identifying the source of any particular British street style is like digging into a bowl of spaghetti to find its start. The intertwining of technology, politics, economics and style combine to create a series of ripples that form and re-form and rise and fall with the intensity of a winter and the strength of a new vodka. This is a city effect and no amount of dissemination through the web will make this happen on the village greens and along the country lanes. Like a virus, subcultural dress – and make no mistake London cycling is made-up of a plethora of sub-cultures – is contamination by first-hand sight, silently coordinated by the 'stylists' for whom the metropolitan centres are a natural habitat. These individuals are born and not made and perhaps carry some sort of Dandy gene as they have a natural propensity to innovate in style, a point so clearly illustrated here.

For the outside observer mid-twentieth century revival style, adopted by many of the subjects in this book, will seem novel but this situation has been developing within cycling for over 25 years. Yes, the London cycle scene has been a hothouse of style in attitude and dress for quite some time.

A brief recap takes us from the initial mountain bike boom of the early 1980s – which reintroduced the bicycle as a viable and stylish form of transport – through the following decade when American brands like Cannondale used high-tech materials and graphics reflecting those also embraced by fashion brands such as (Ralph Lauren's) Polo and DKNY. Like any action that encompasses sleek, expensive and glossy elements there will be a reaction. In London this came through cycle-courier culture that appropriated old, lightweight British frames from the 1960s and 70s and a 'make-do' low maintenance look that meant a single rear sprocket. The fixed gear revival was visible on London's streets from the mid-1980s when the best dressed courier wore contemporary, but very well worn, professional team lycra and cotton cap with Shimano SPD shoes and, most important, the right courier bag – some of the first being supplied by Joe's Basement and Metro Photographic. At this time it was important to appear slightly dirty, thin and with clothing at the end of its life so as to separate oneself from the yuppie riders in their latest team colours riding clean and new bikes to match. The styles of clothing amongst London cyclists have varied over the past 30 years but the cycles have maintained a gradual trajectory toward a retro silhouette which today has been commodified and exploited in a spectacular explosion of re-worked frames, paint-jobs and accessories. London's most celebrated frames maker, still in Greys Inn Road after 60 years, Condor Cycles offers the public both ultra-light carbon bicycles and a series of steel frames that pay direct homage to their original bicycles of the post-war period. This is cycling today and this is fashion today. They are hard to separate and we shouldn't try to prize them apart as they feed off one another.

This book encapsulates the essence of cycling style in 2012 and I hope that Horst A. Friedrichs will revisit this subject in ten years as the comparison will be an interesting one. London street style never stands still and although revival style is here today it will develop and change and go… Who knows where?

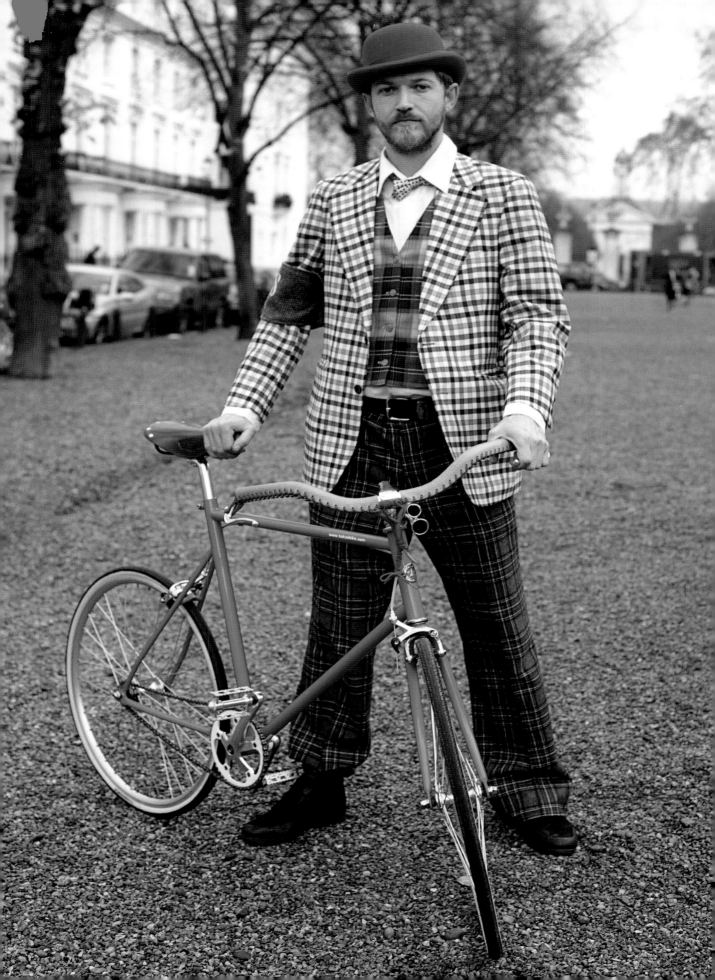

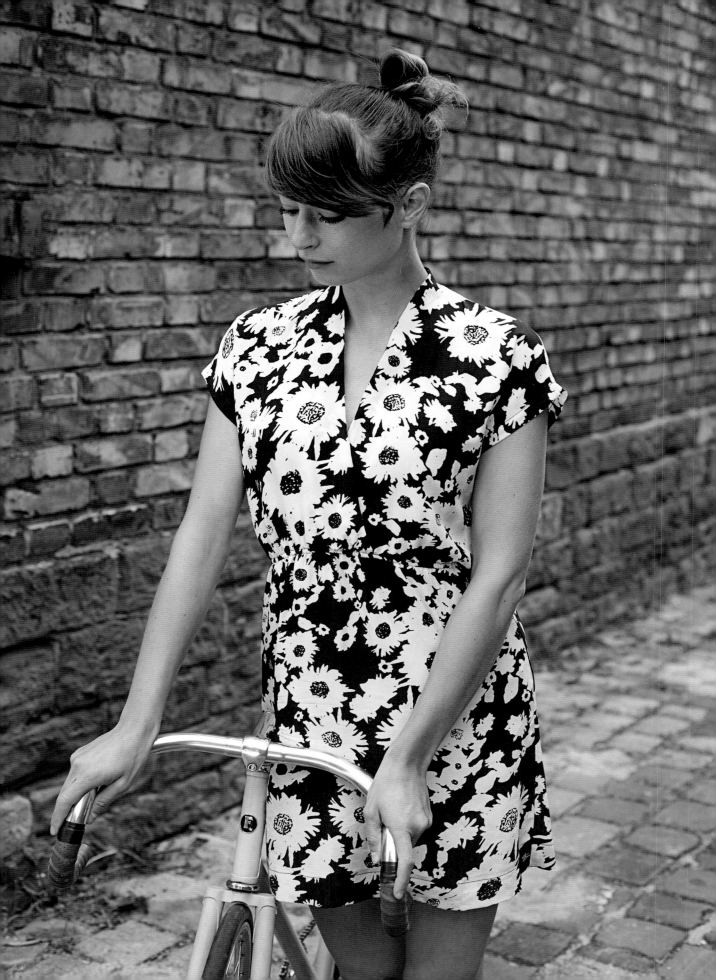

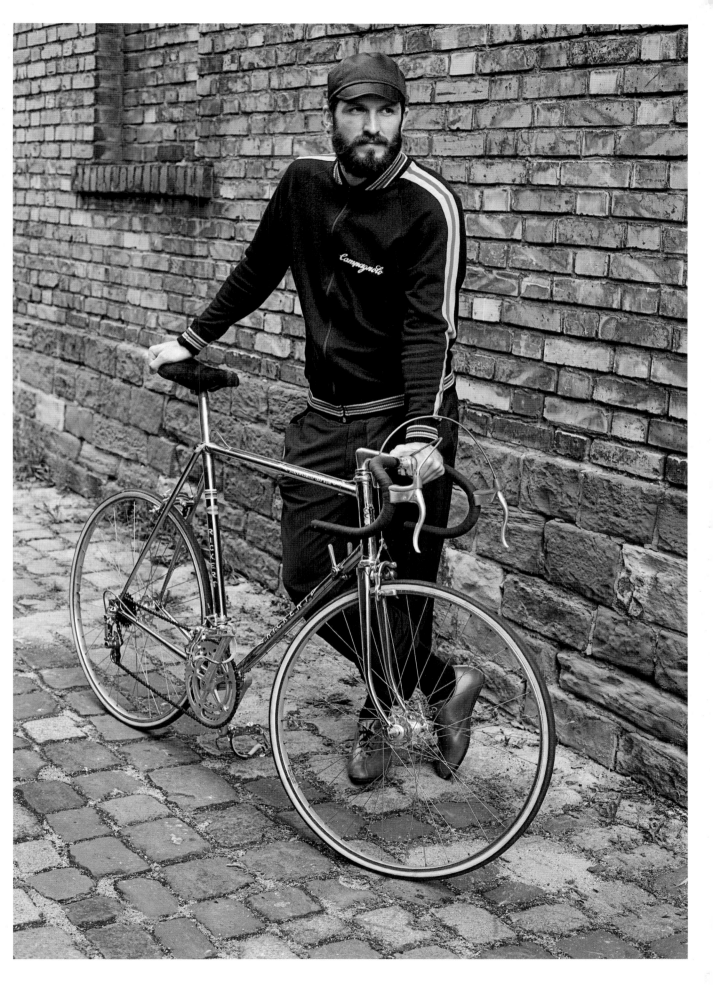

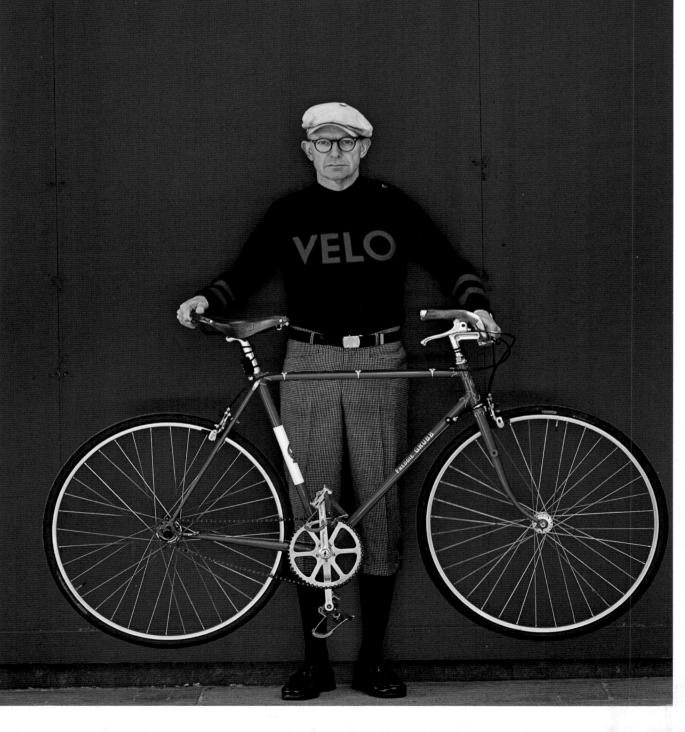

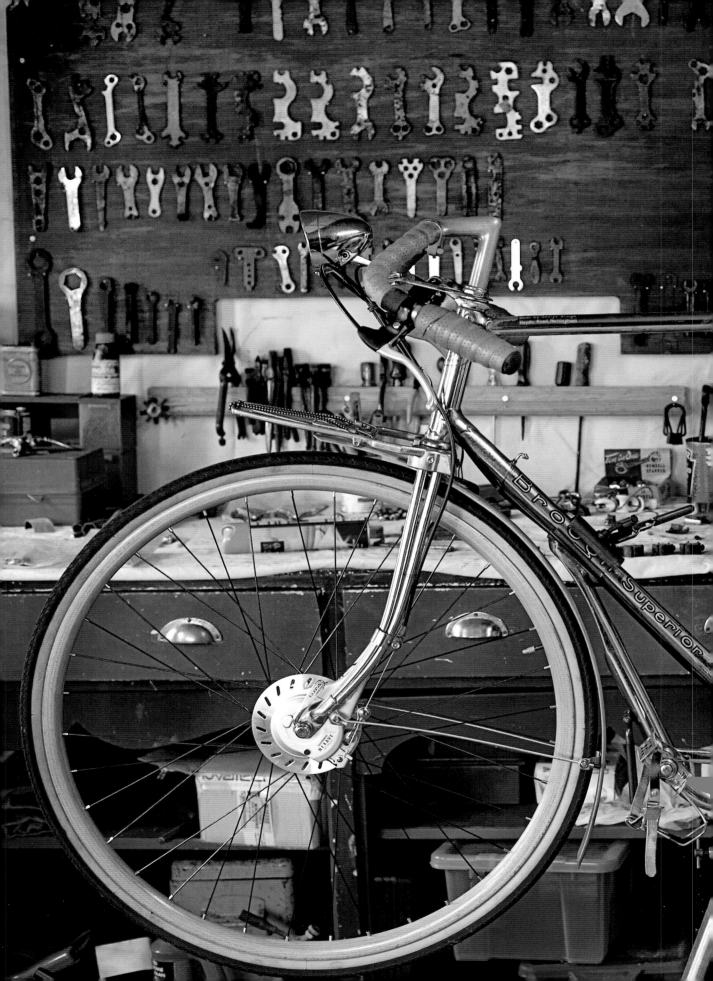

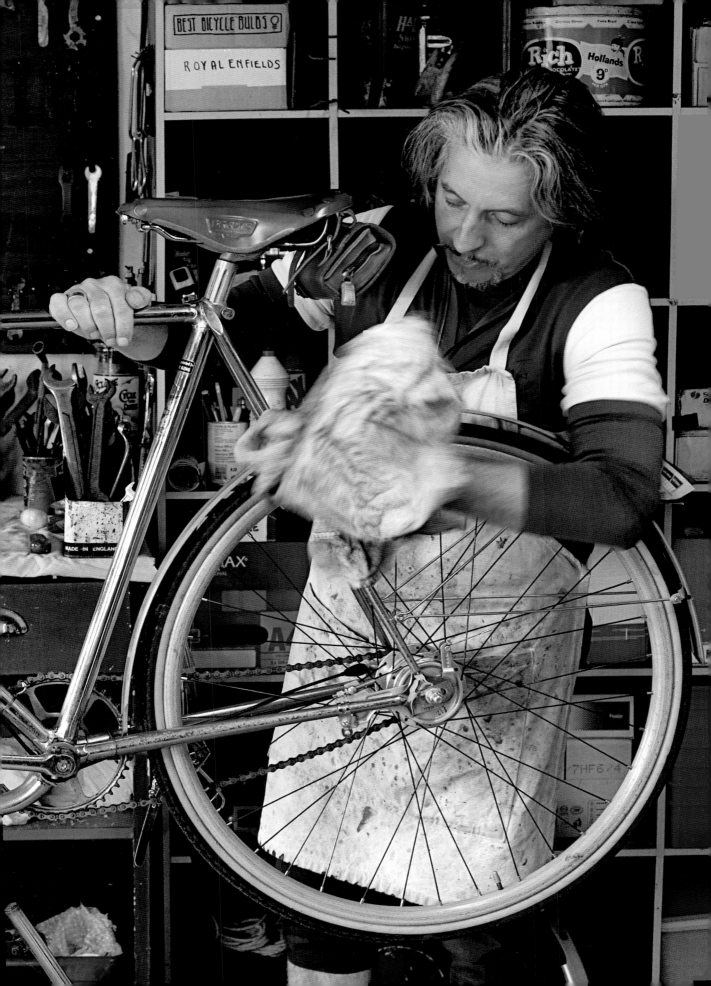

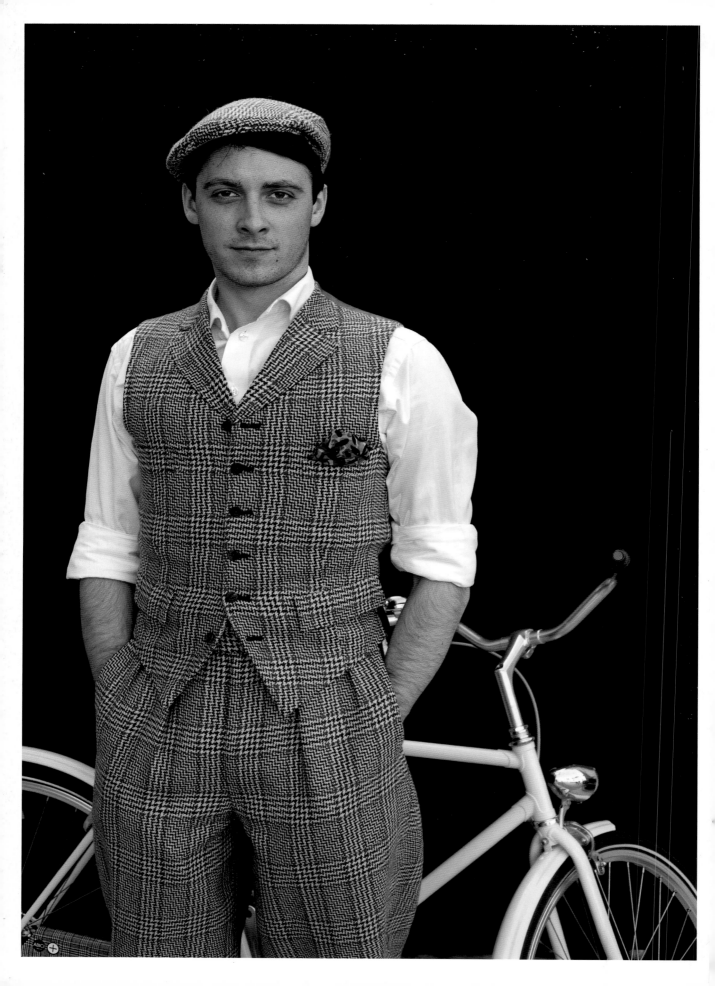

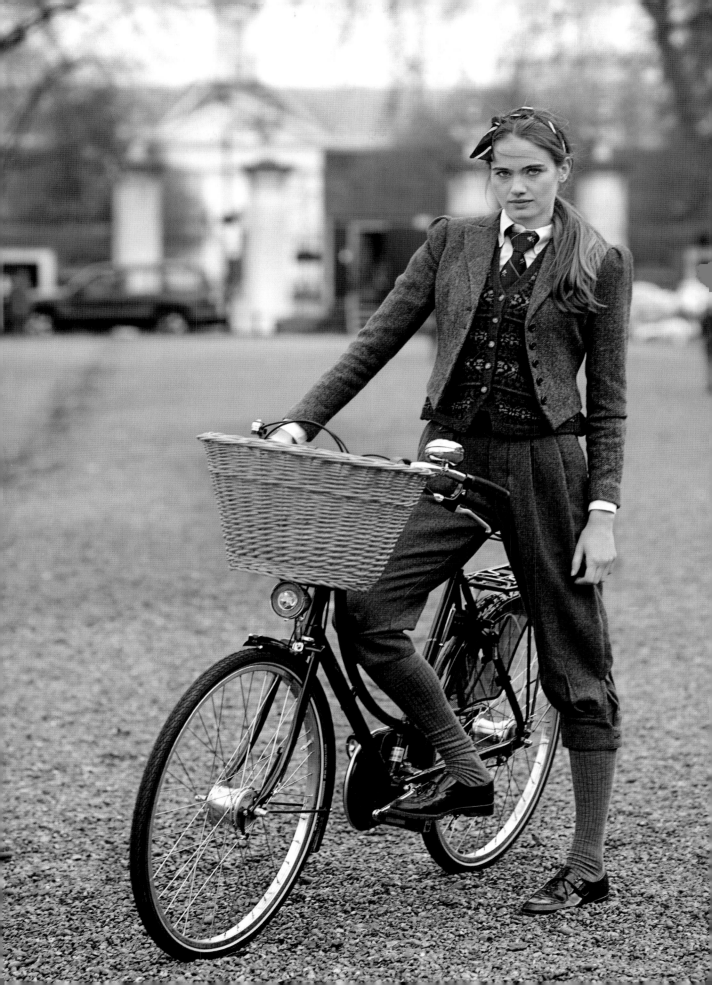

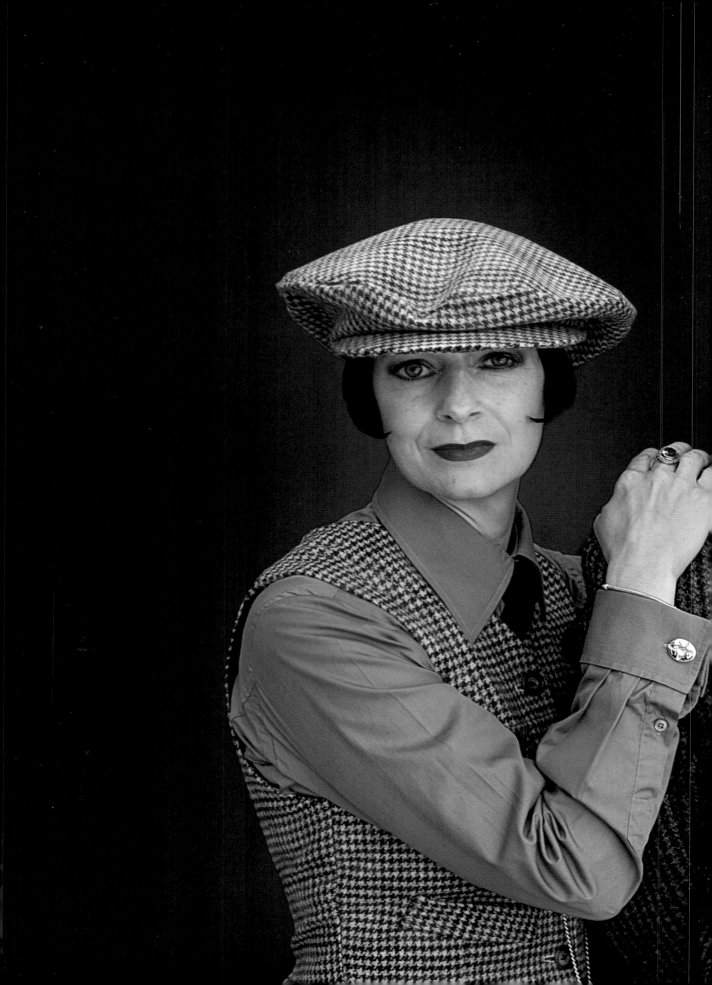

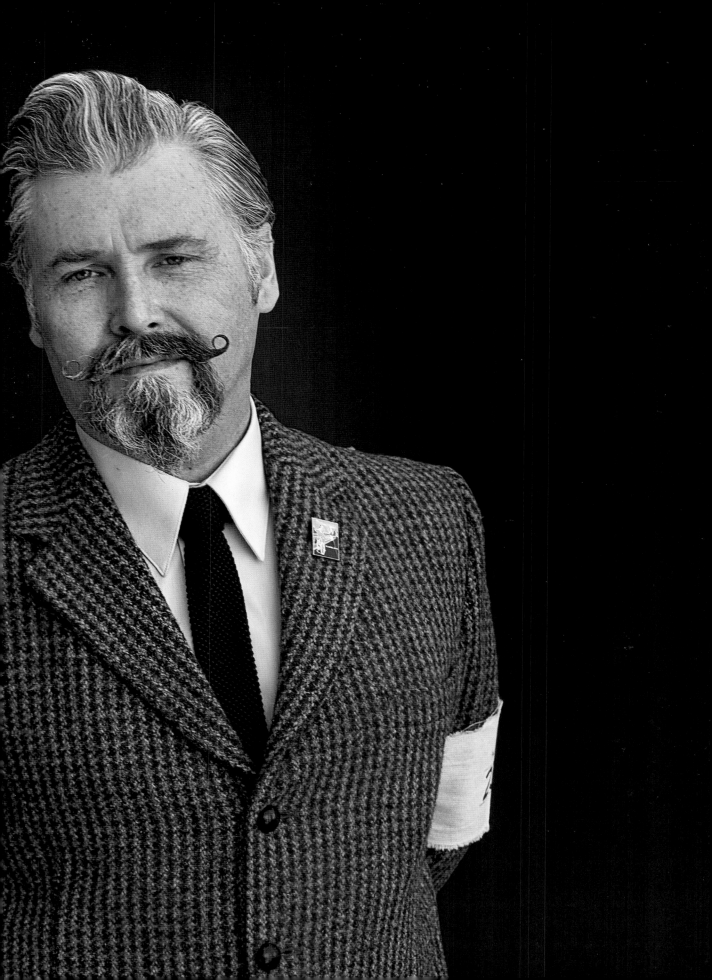

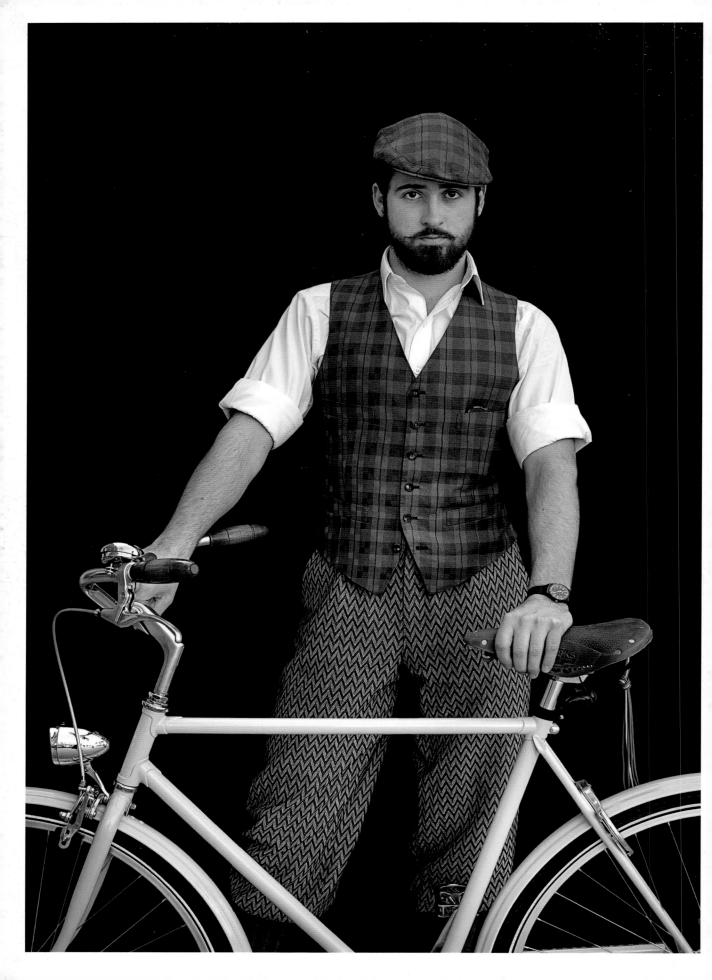

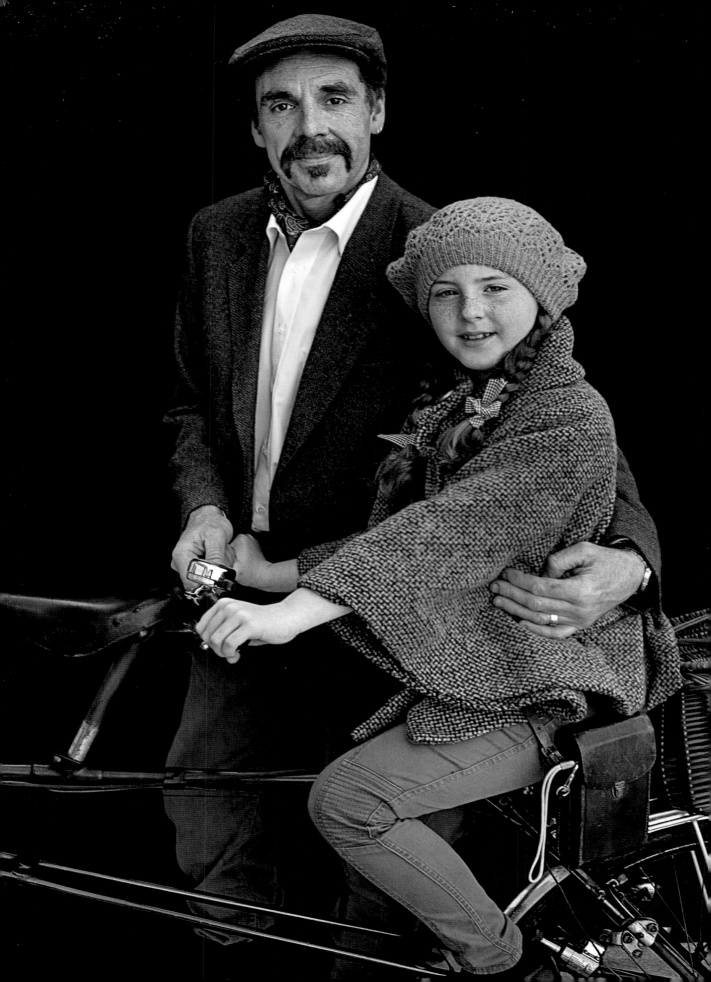

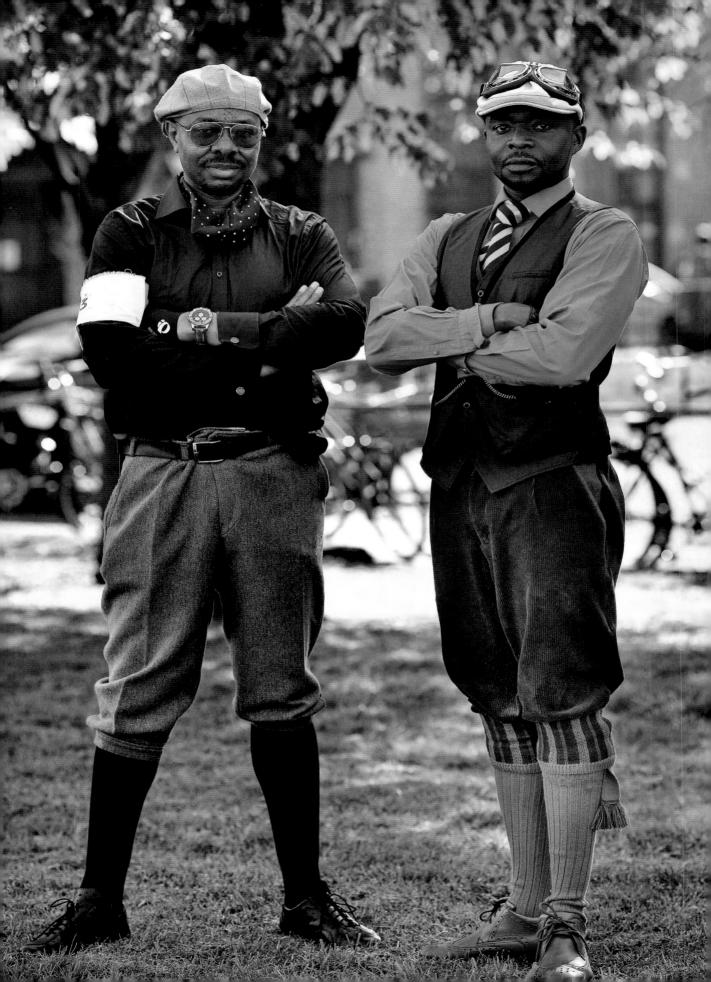

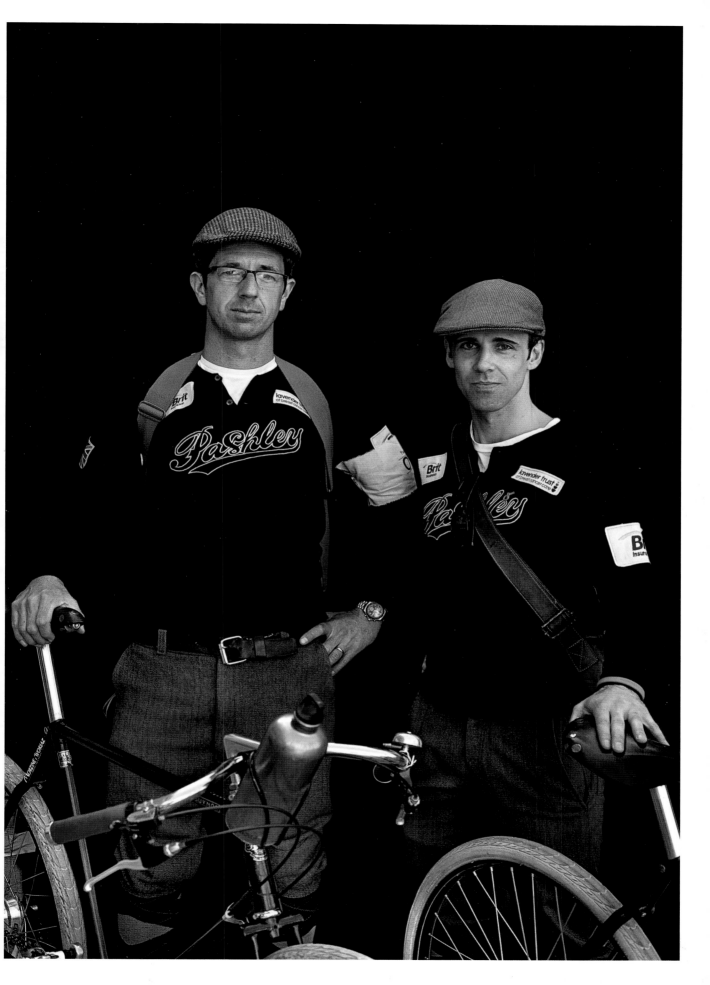

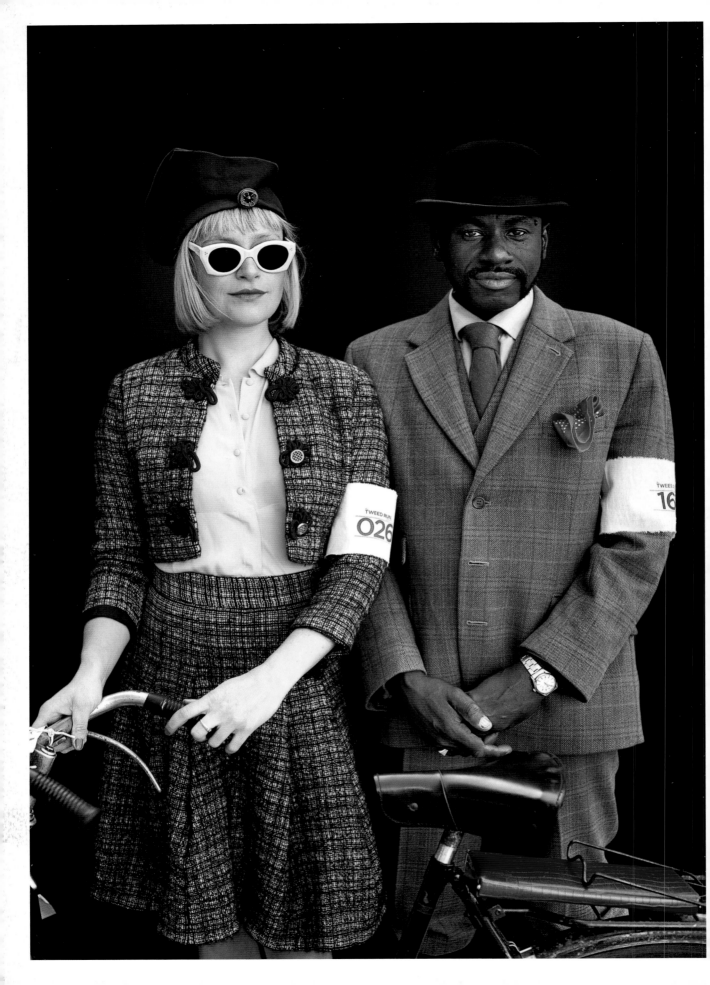

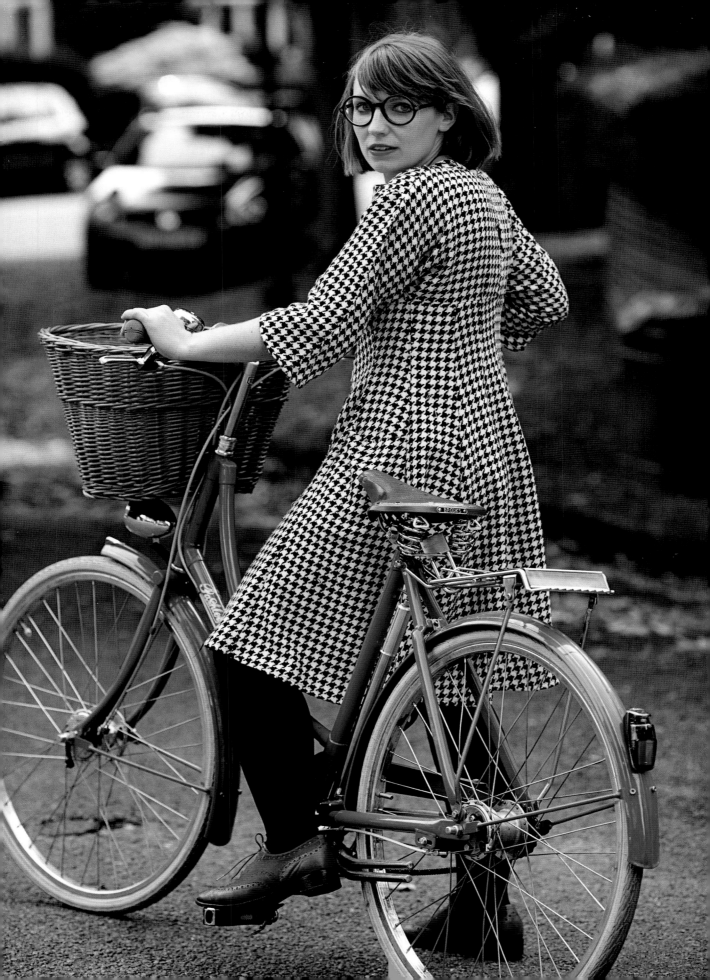

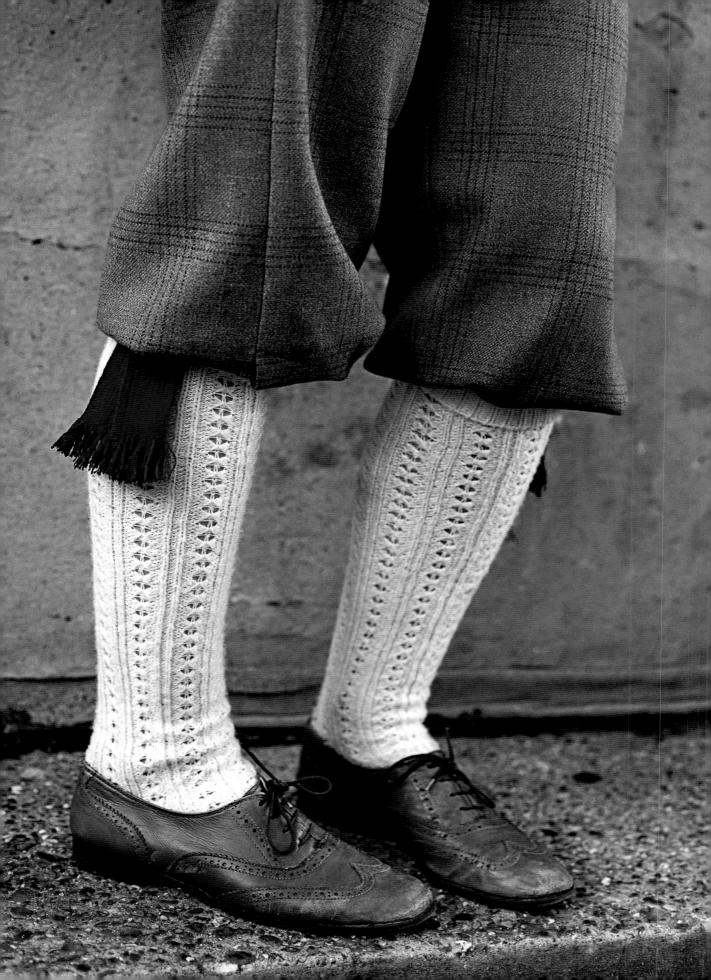

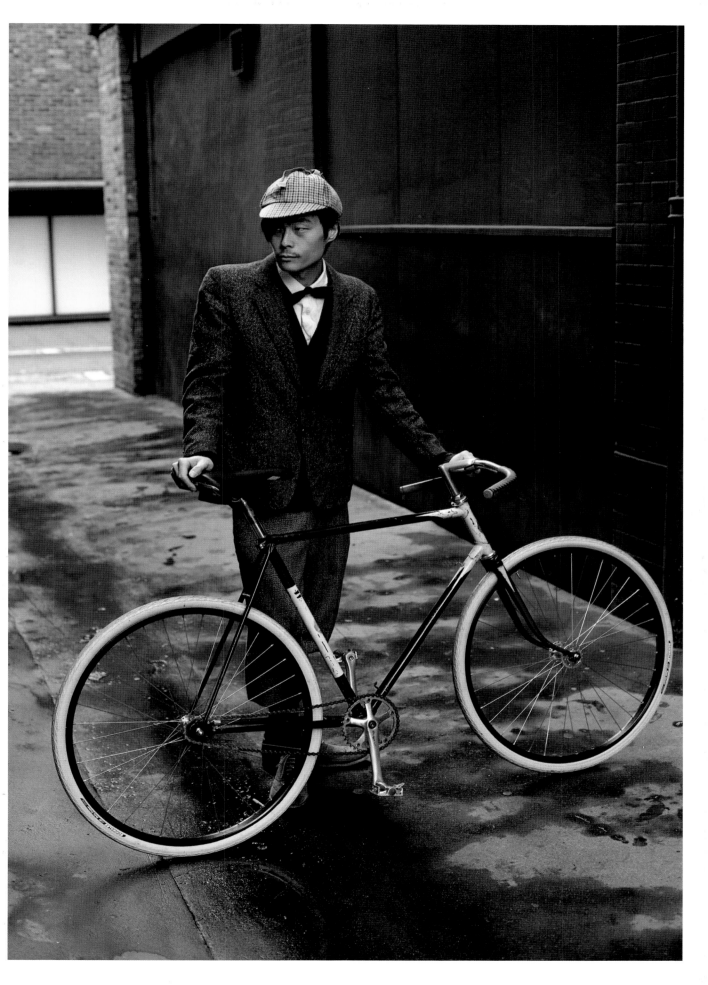

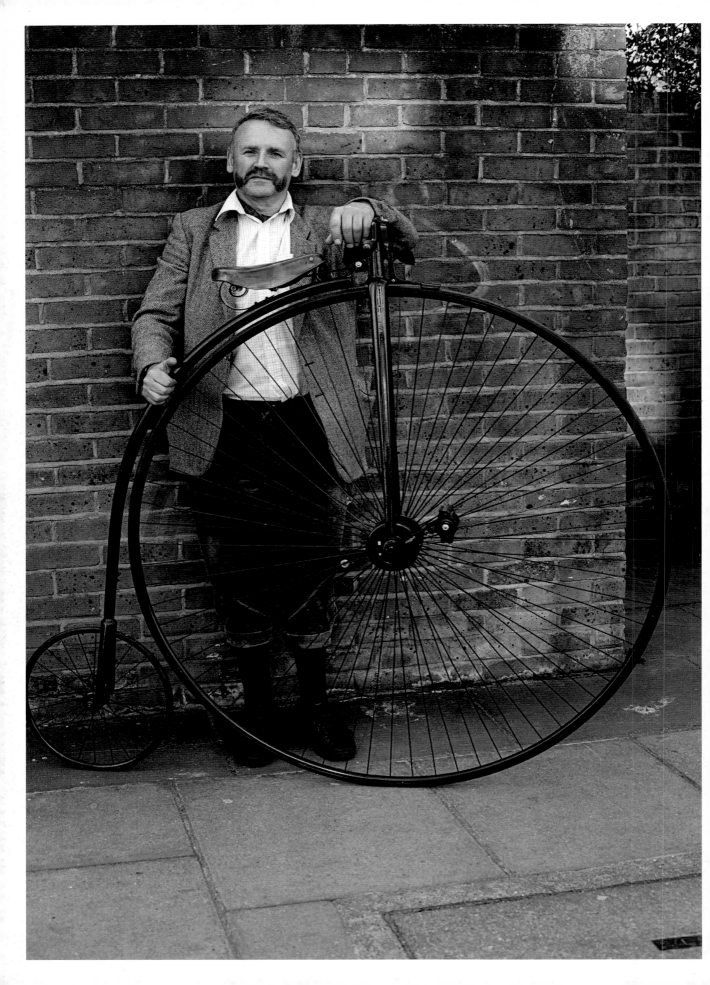

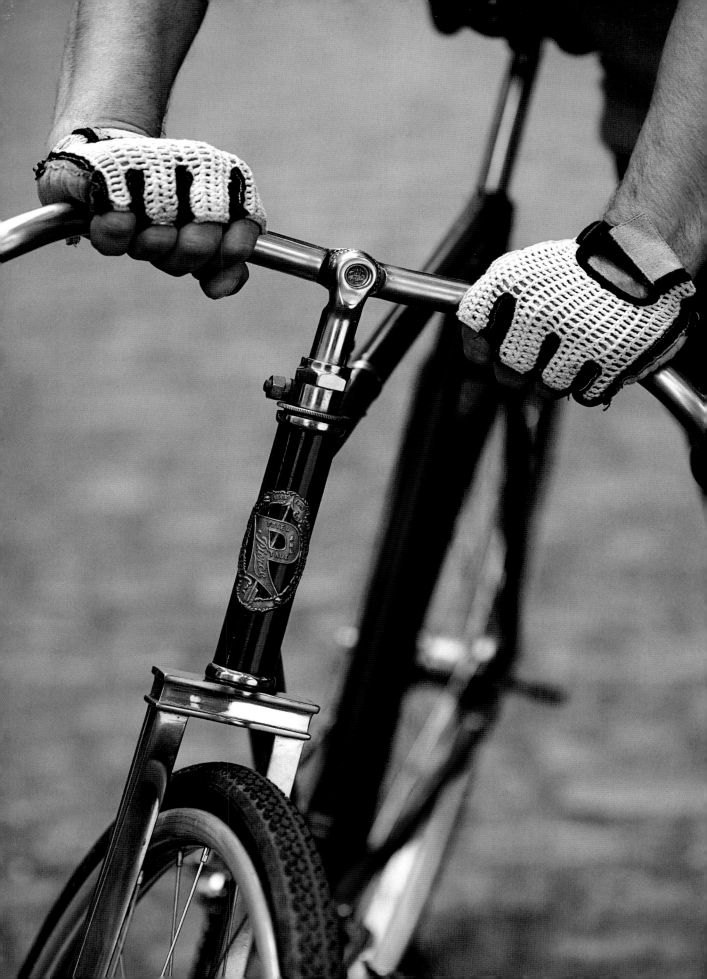

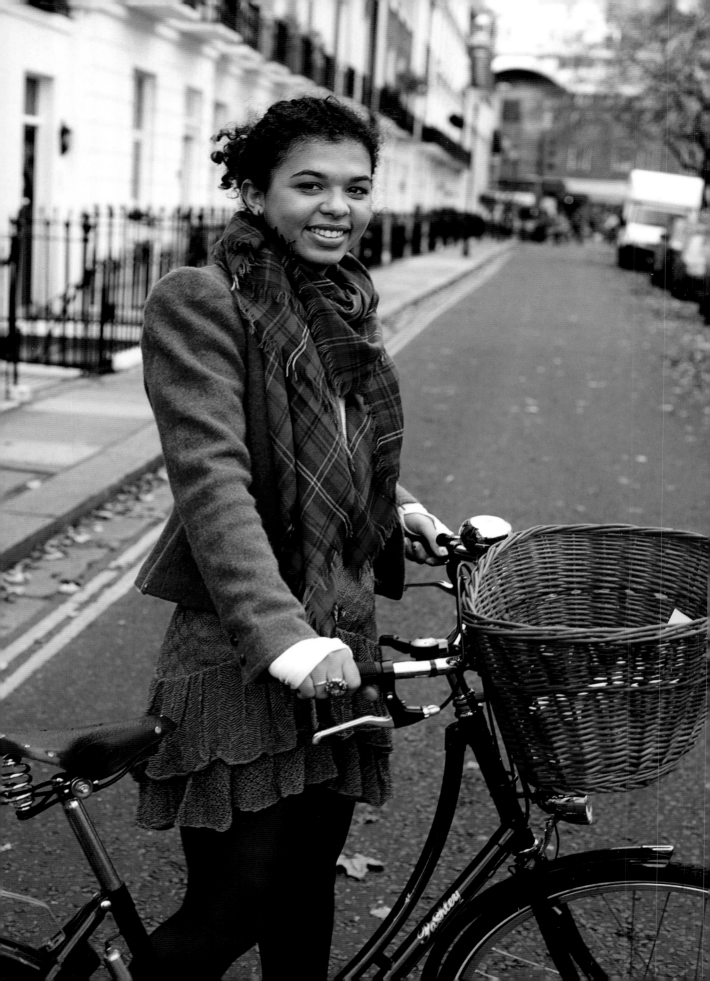

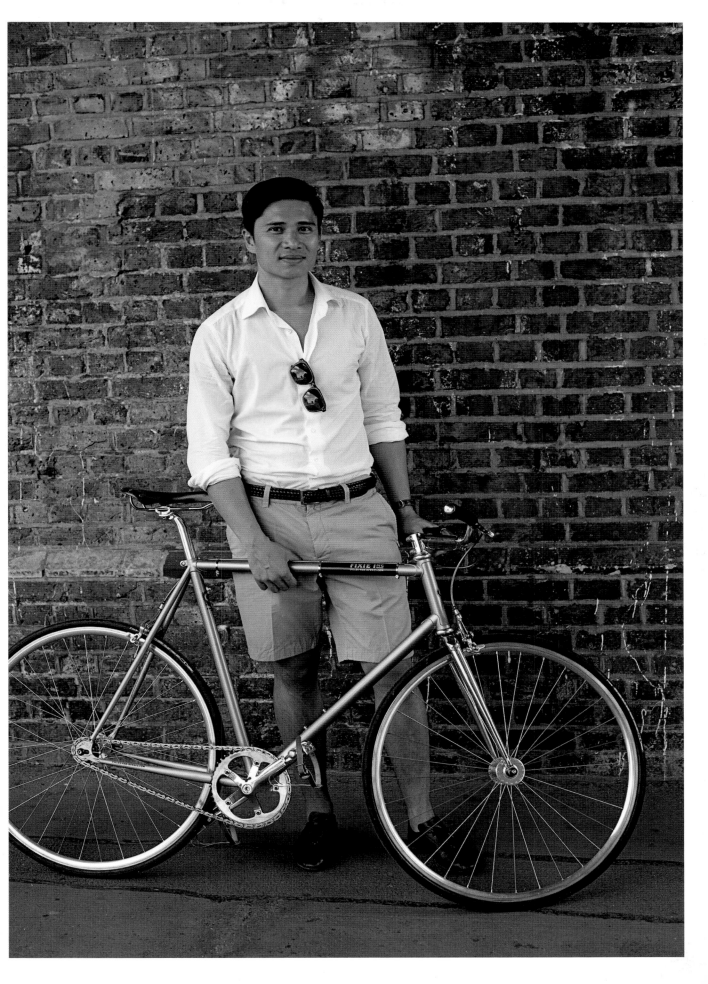

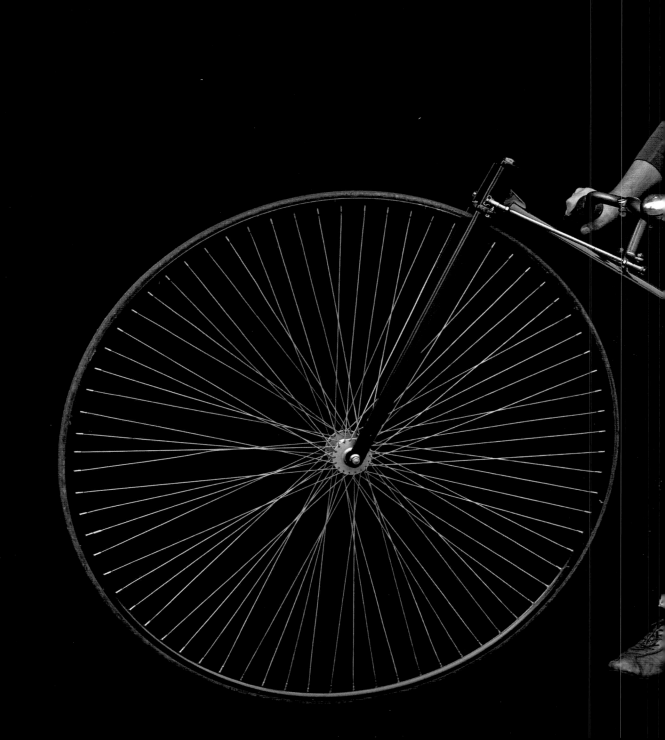

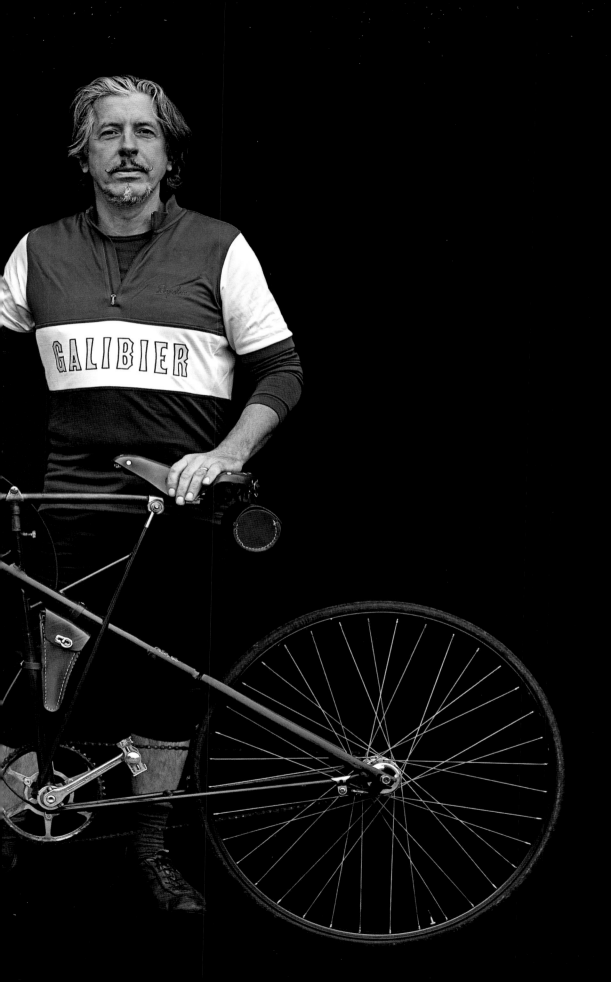

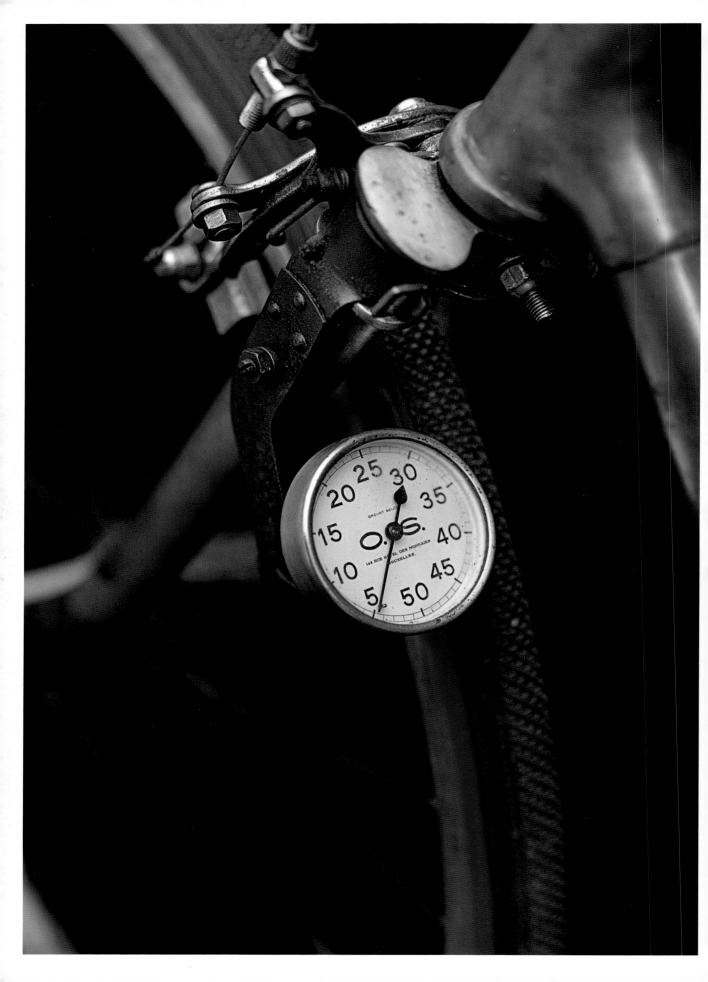

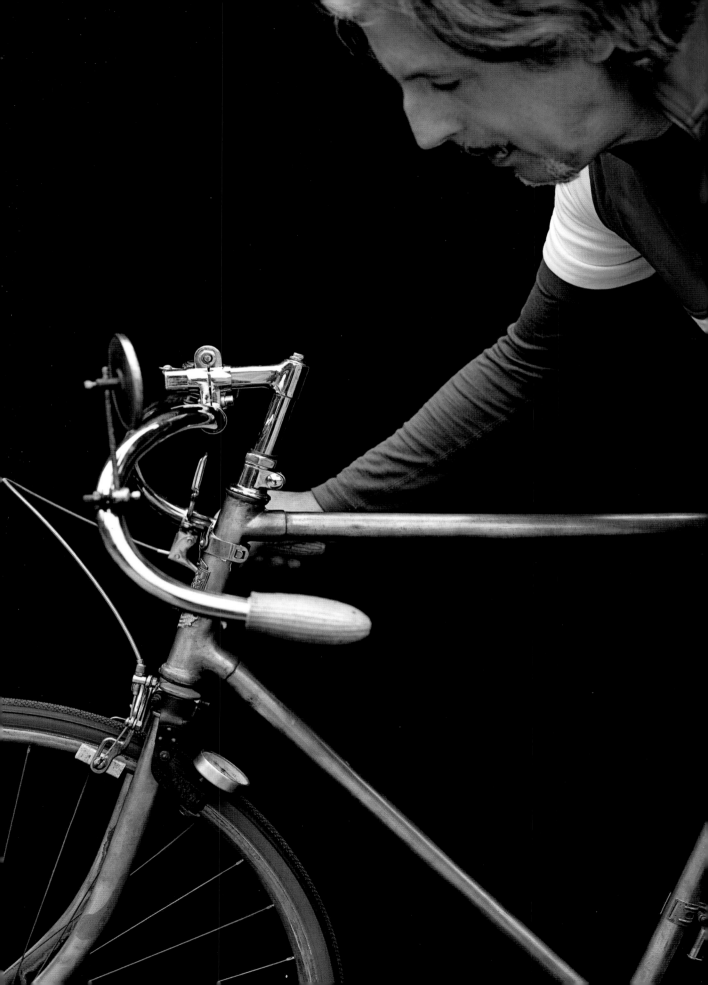

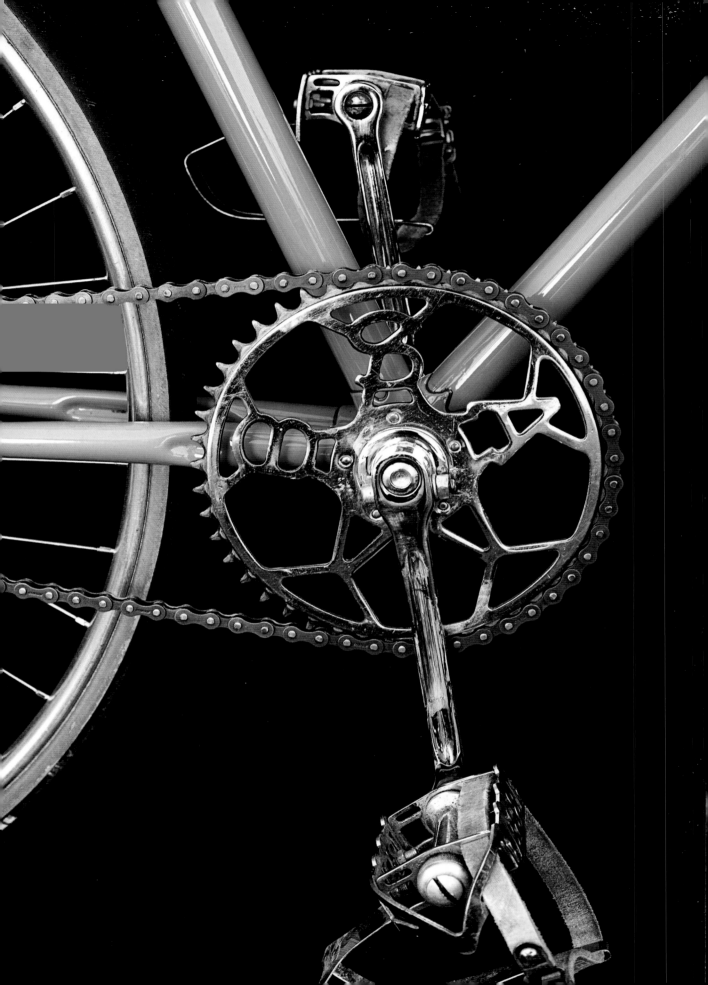

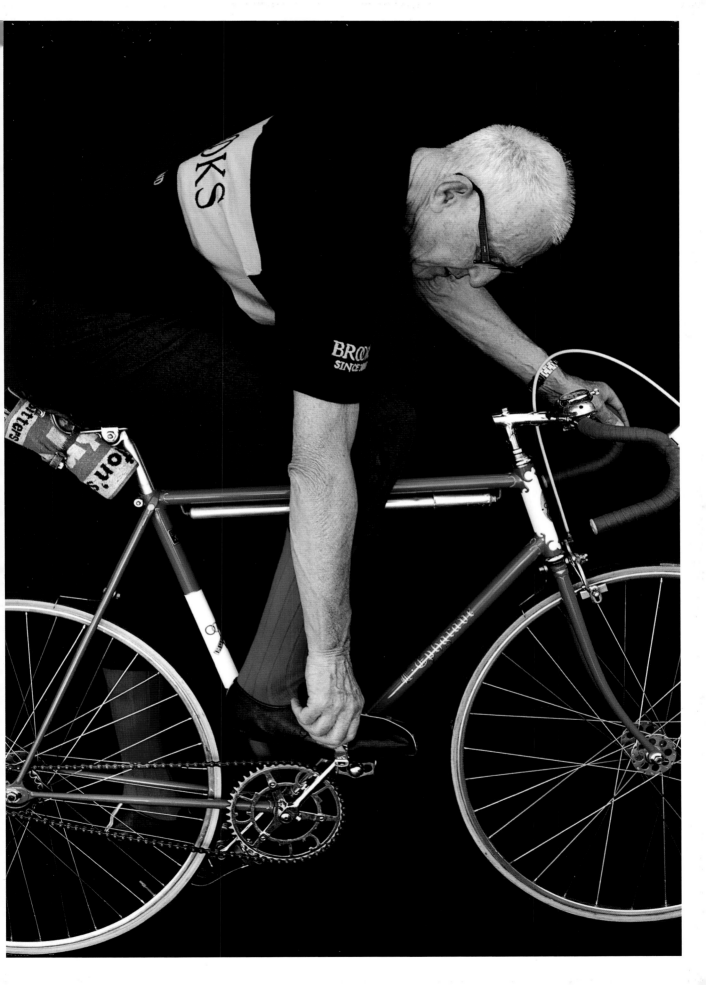

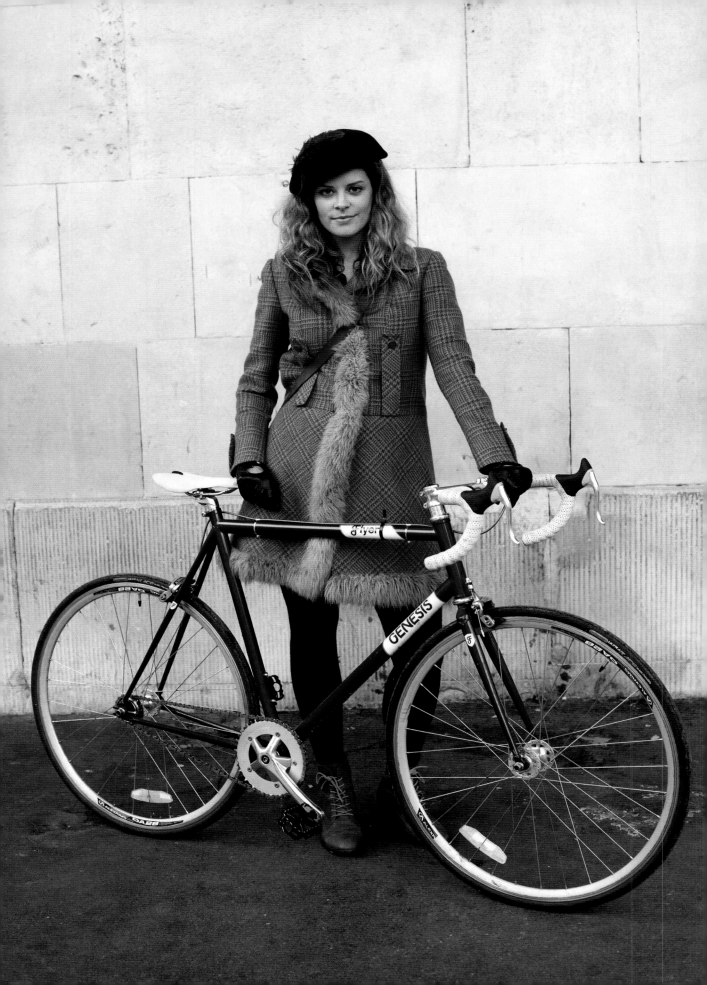

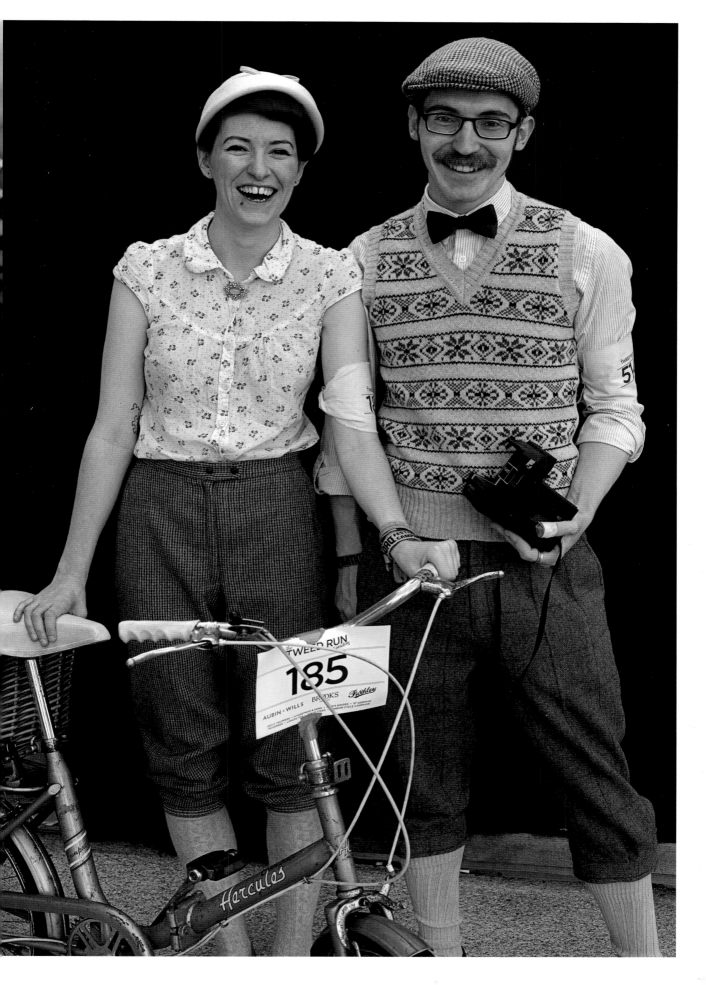

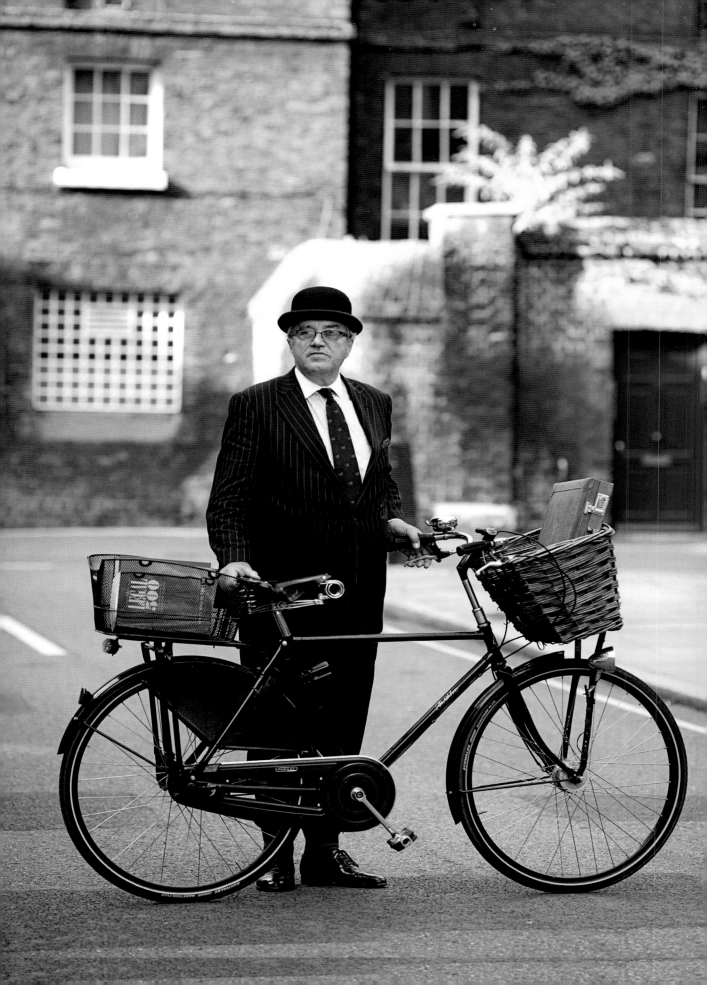

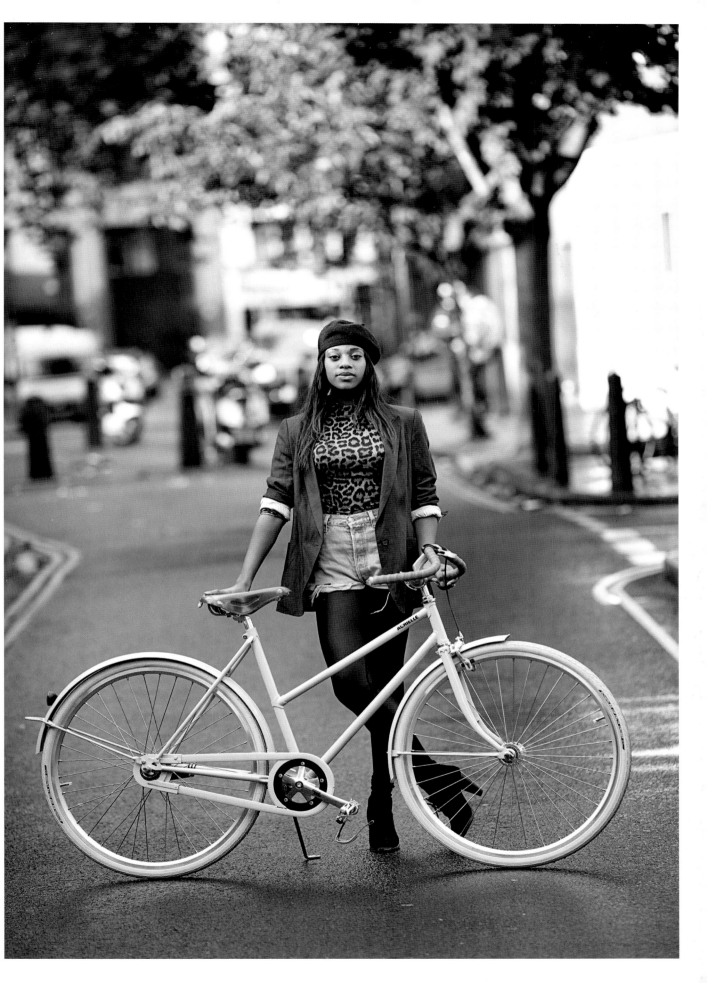

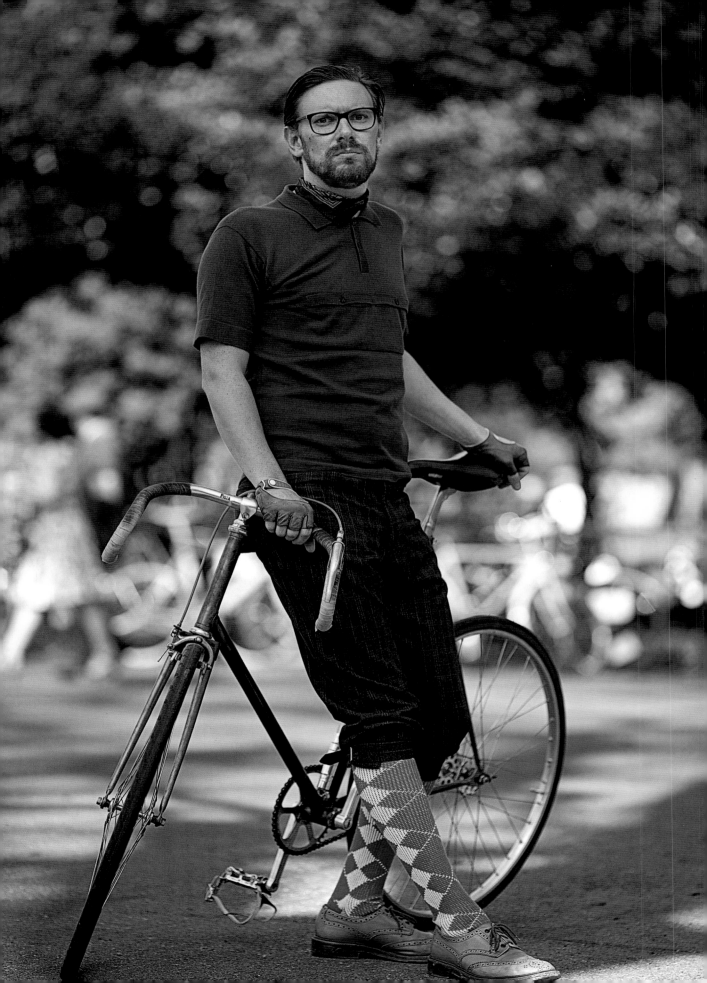

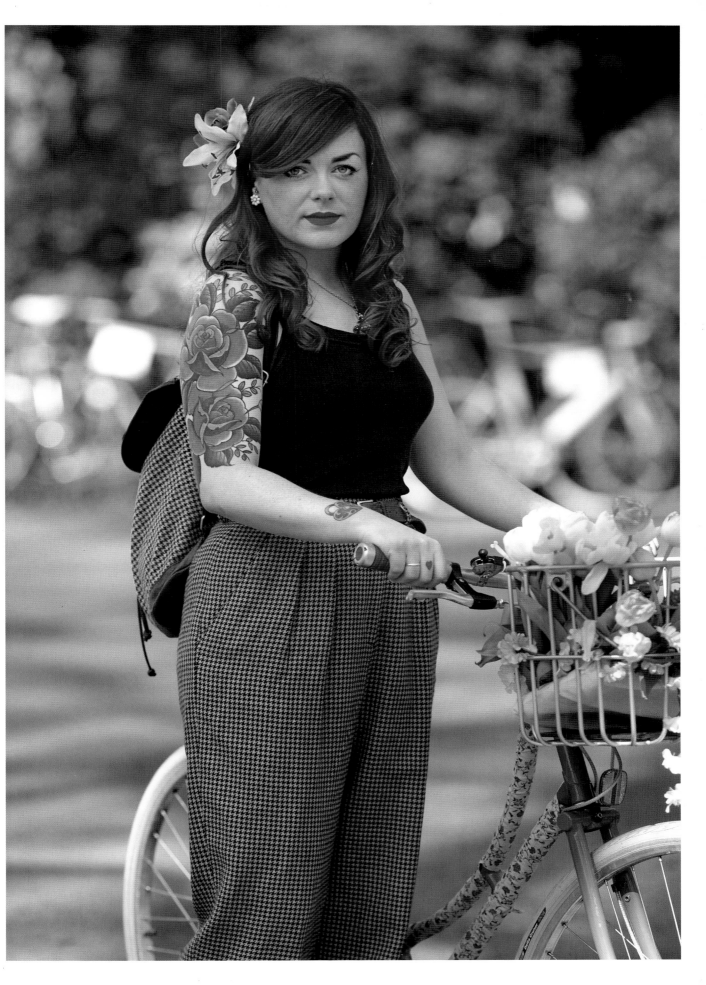

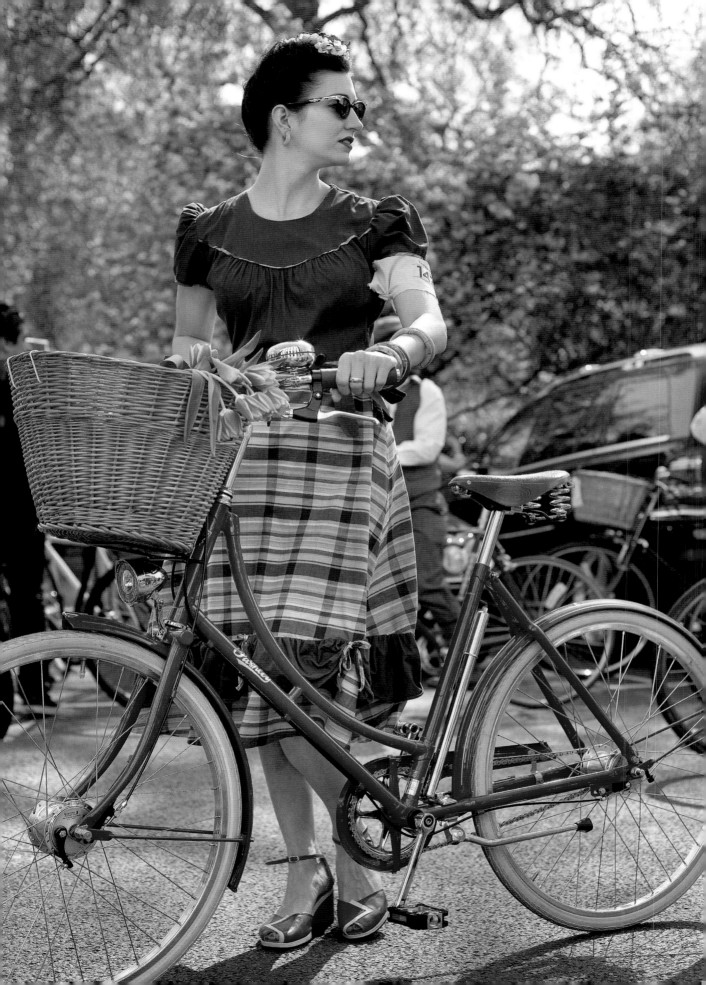

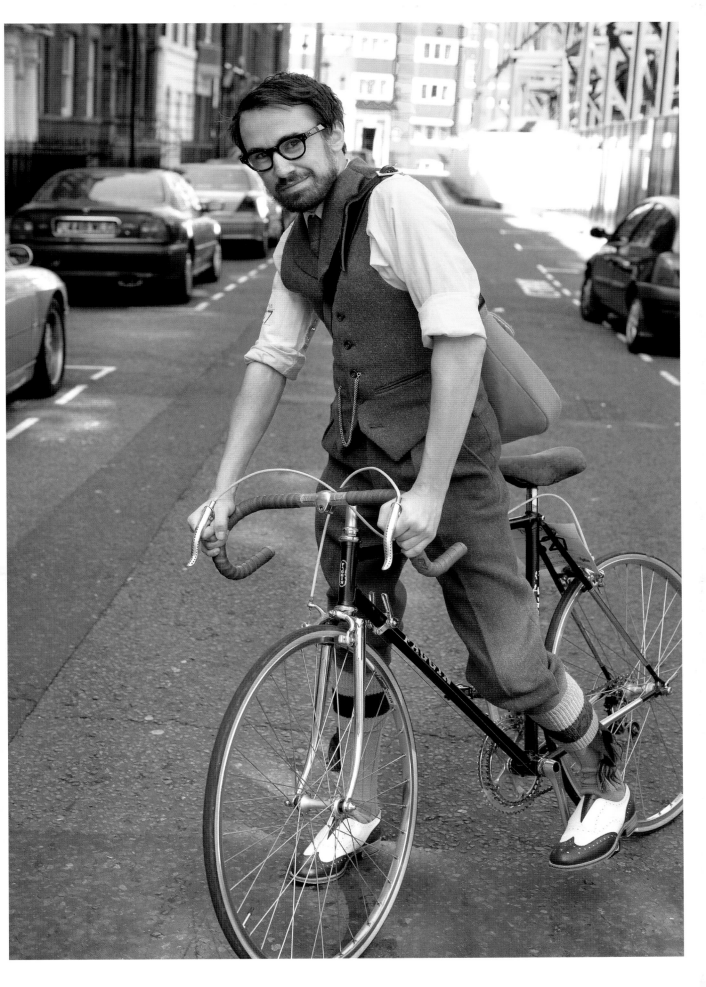

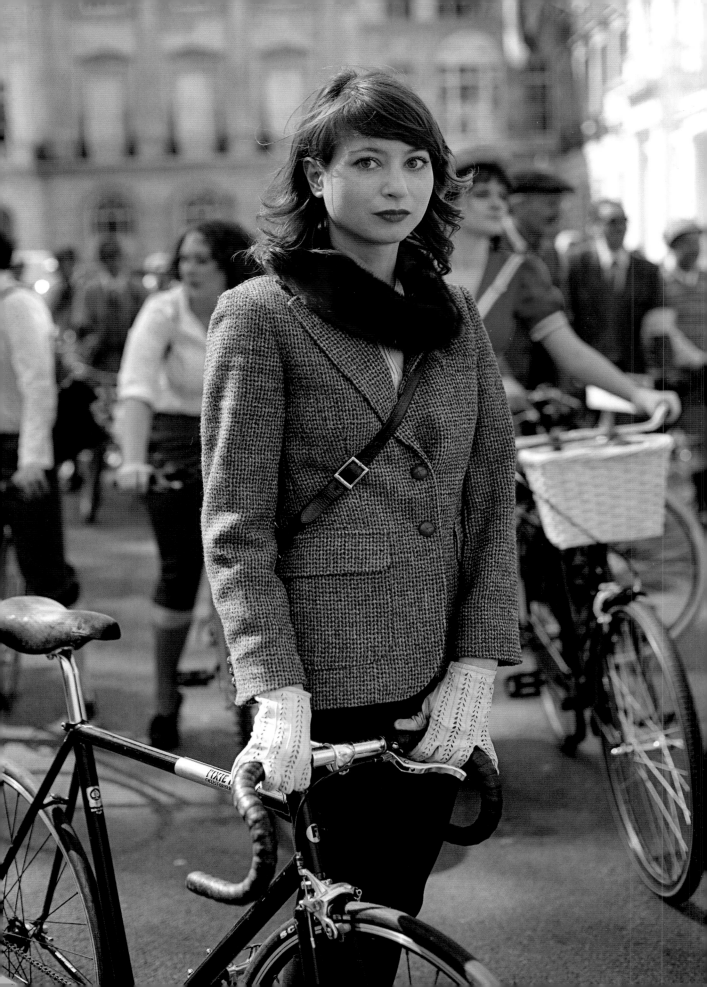

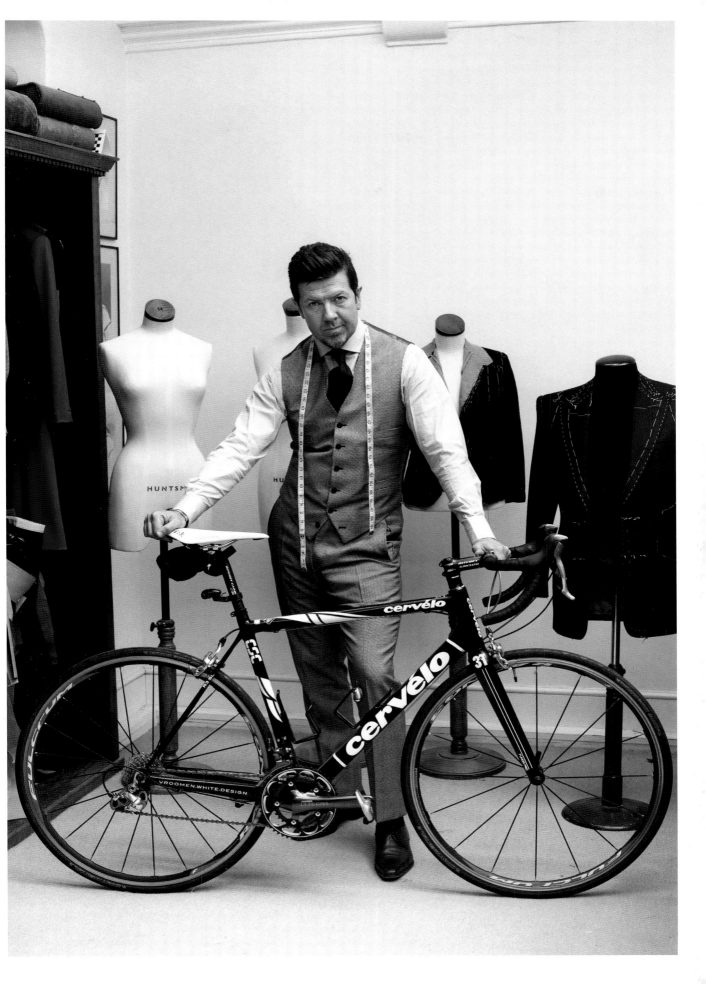

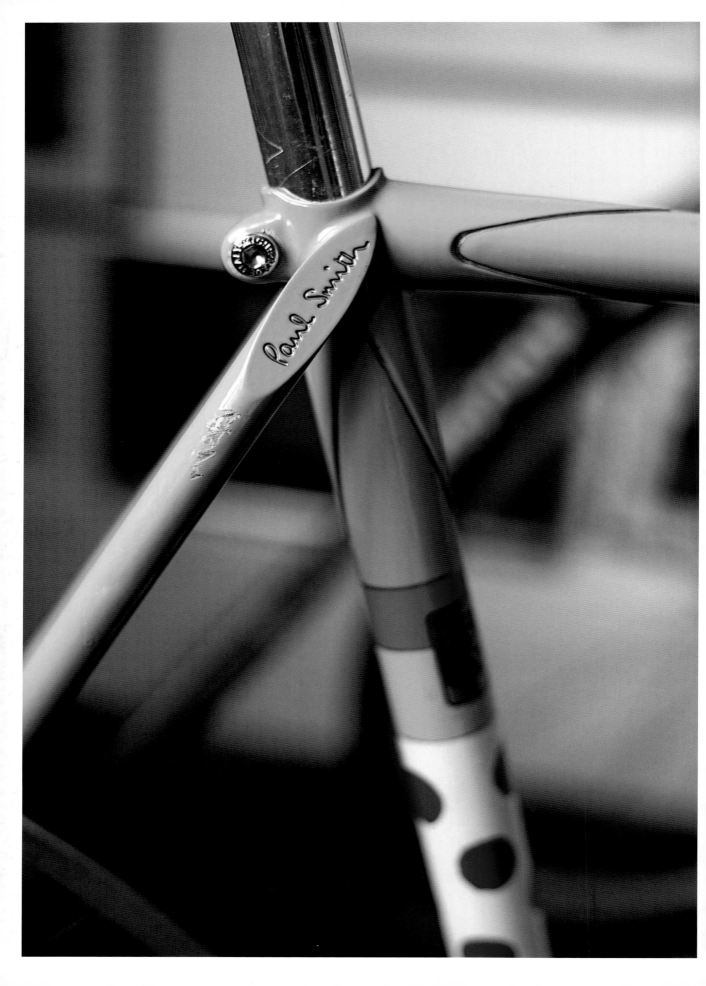

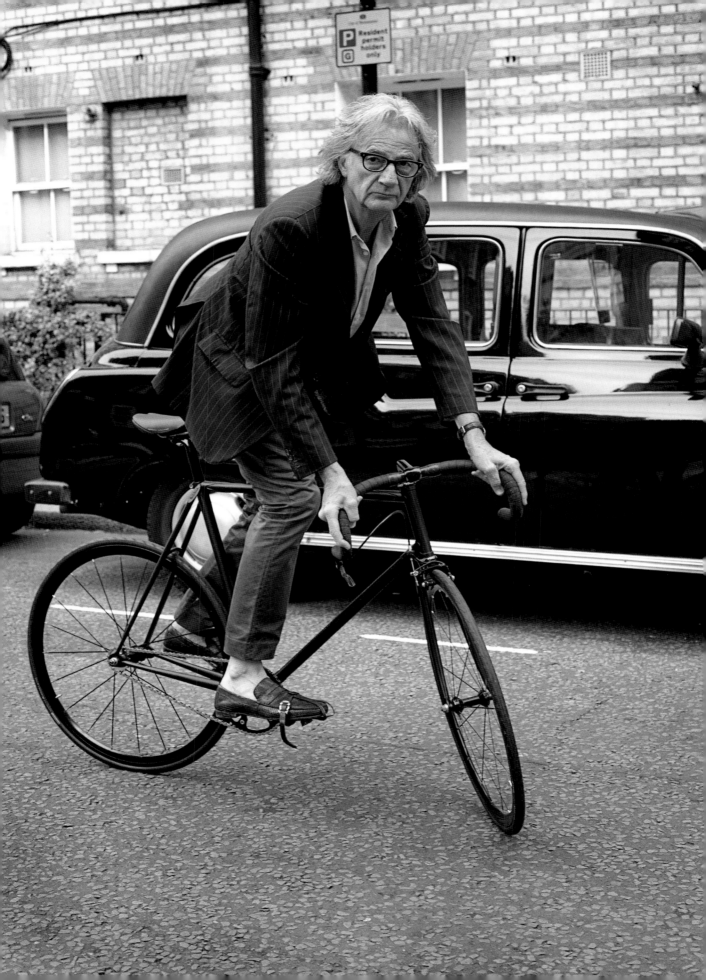

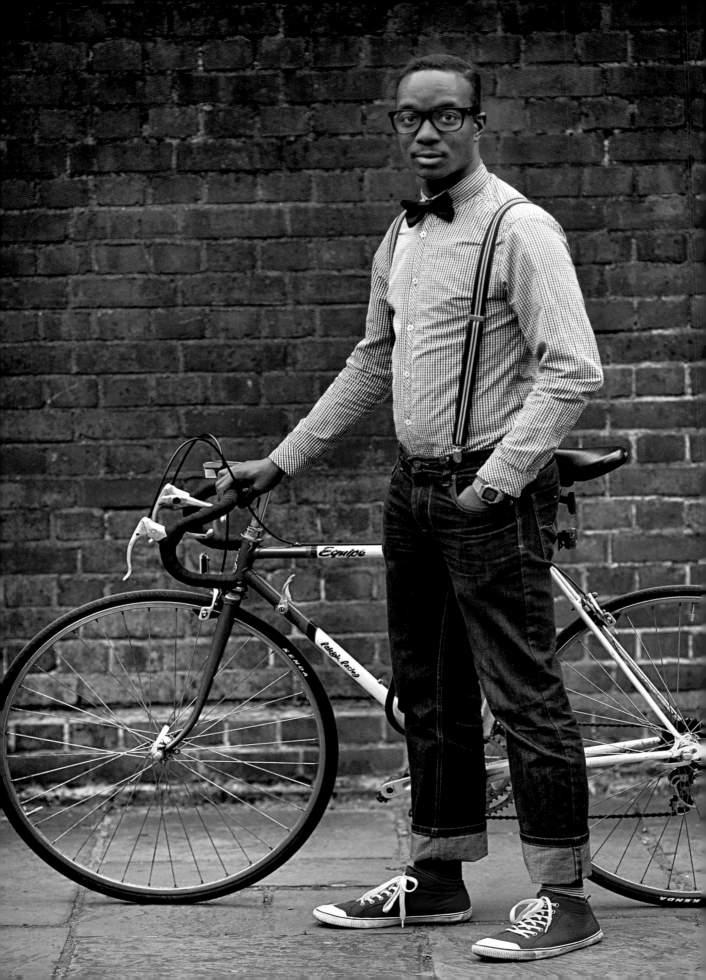

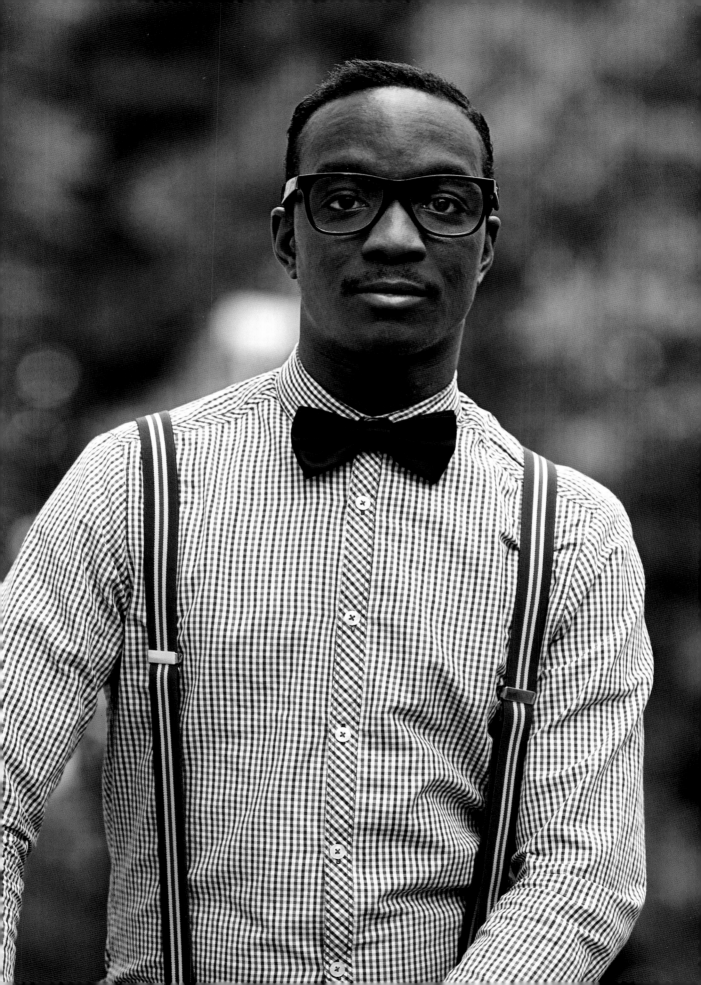

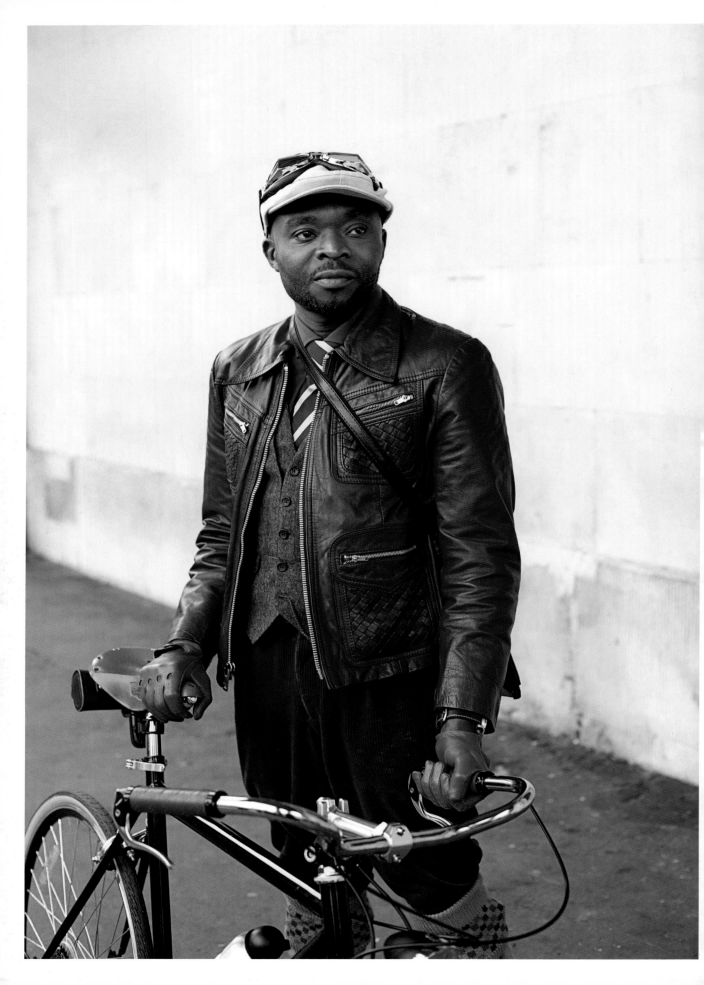

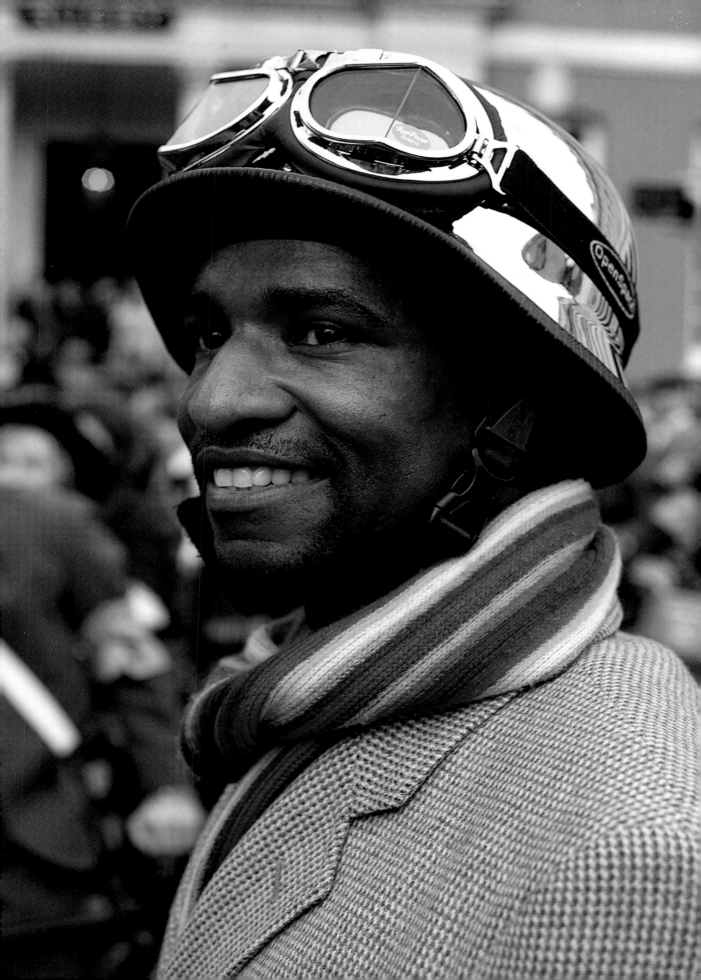

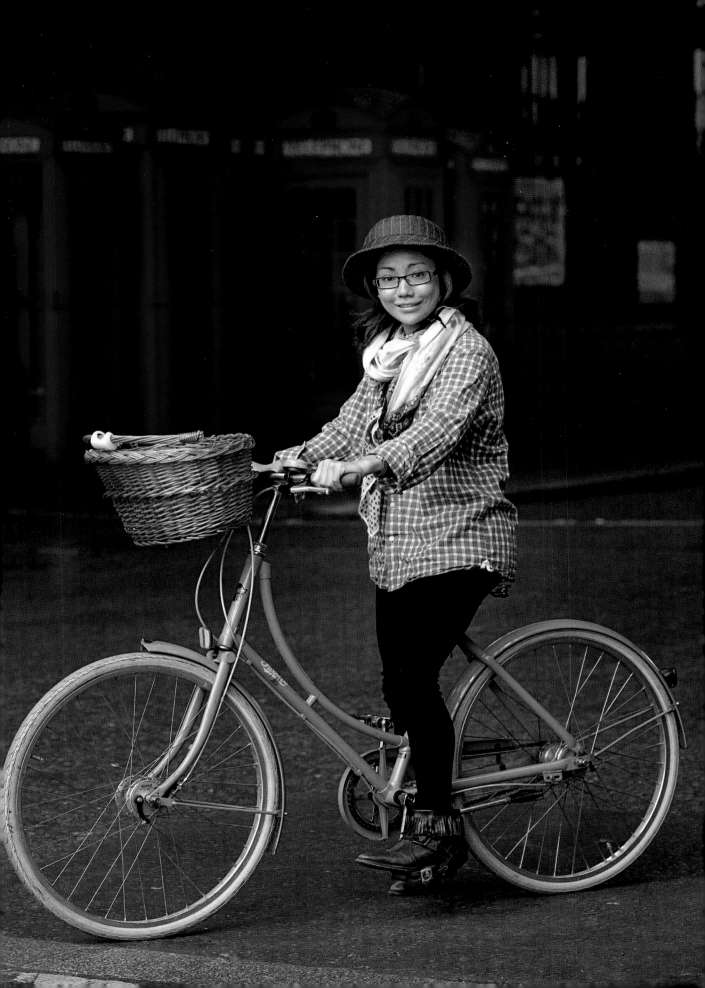

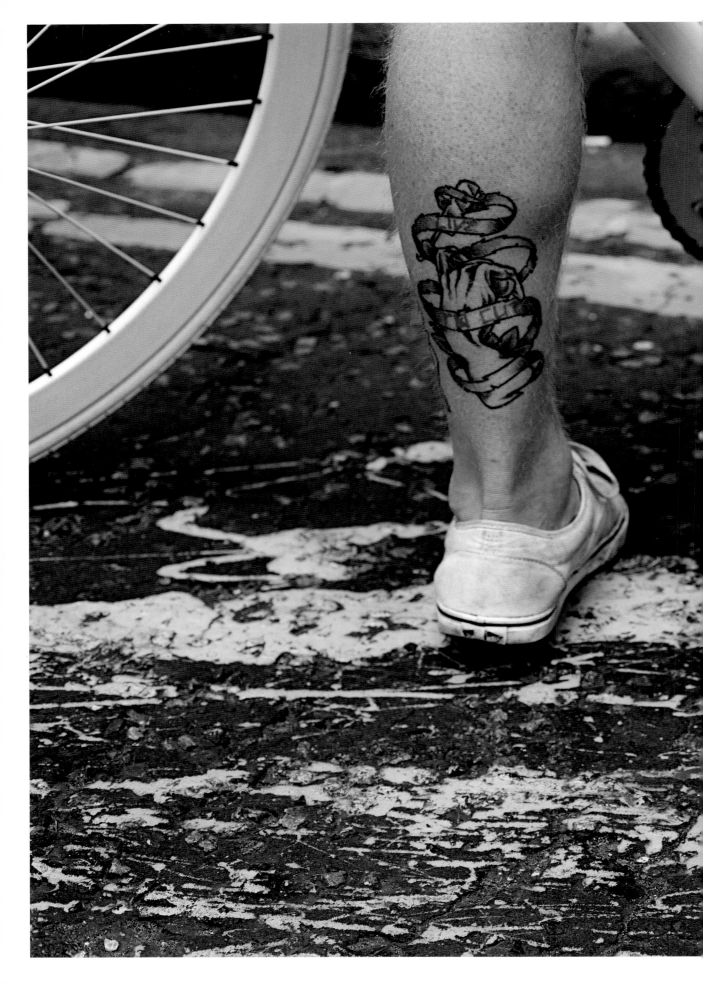

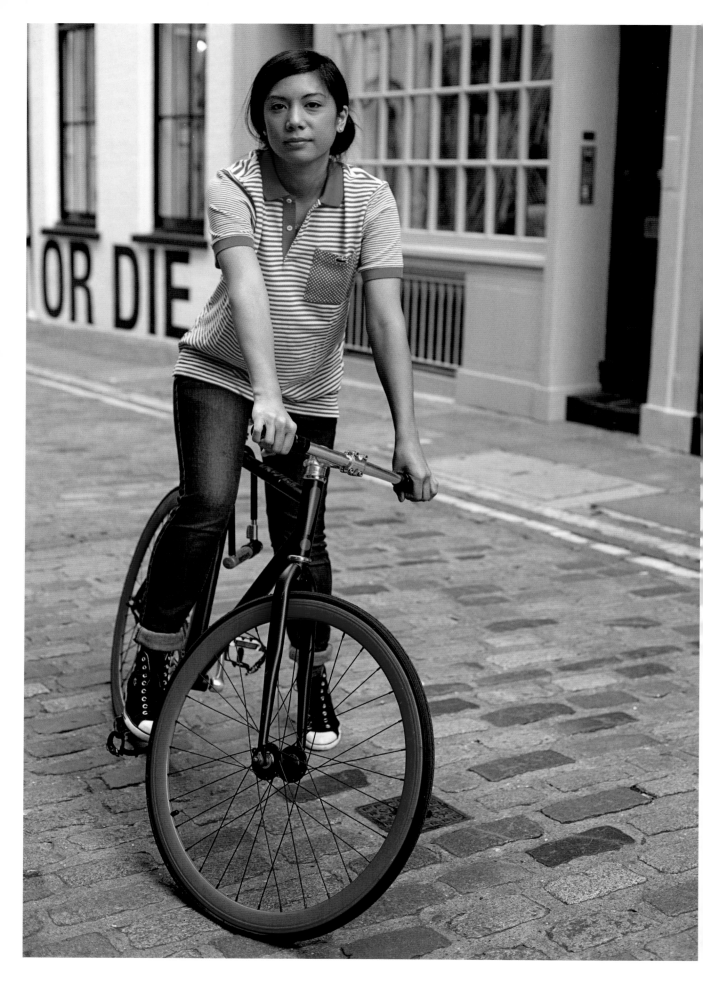

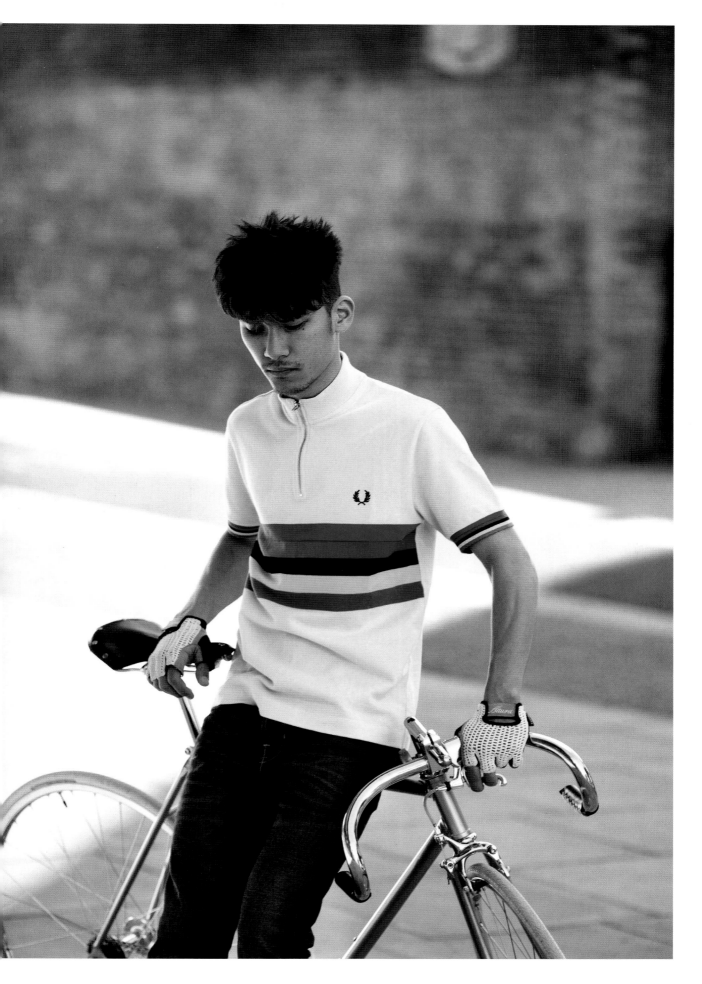

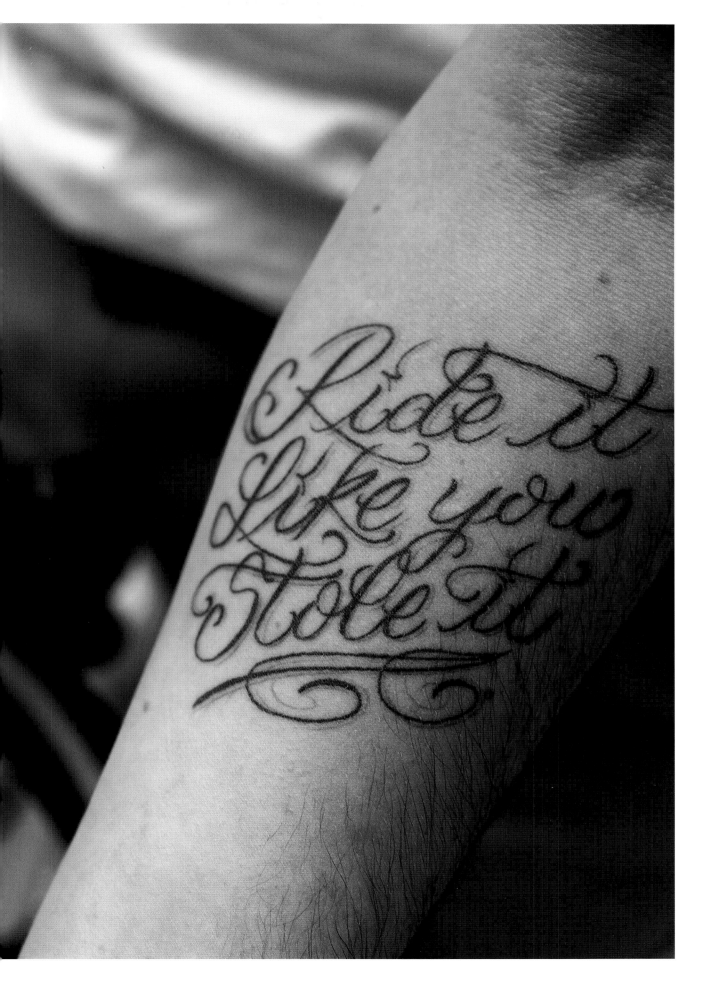

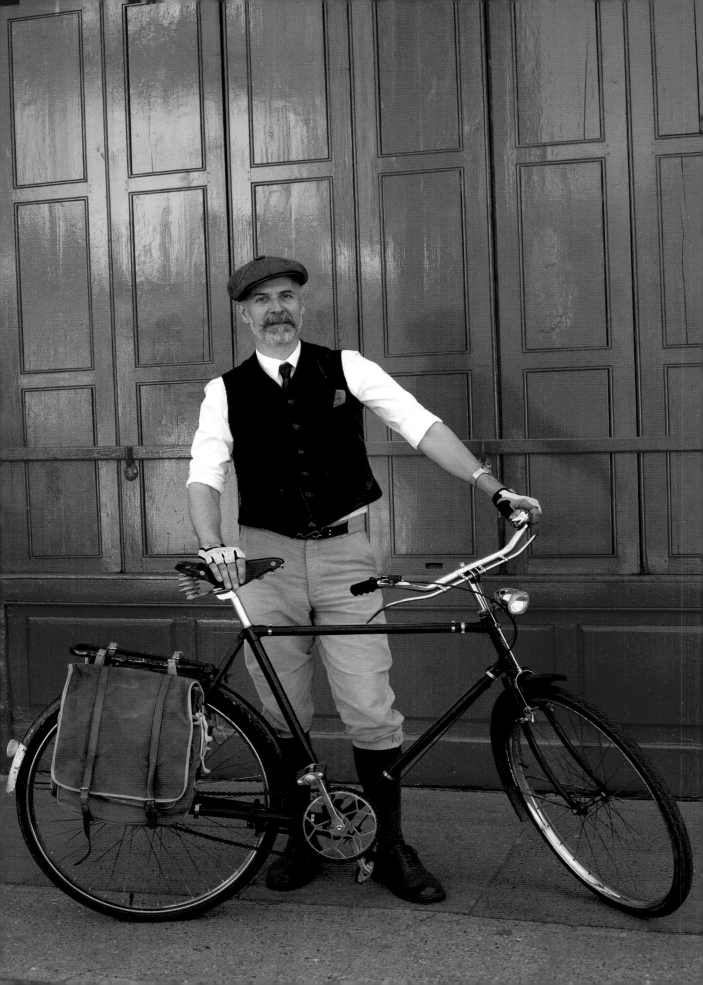

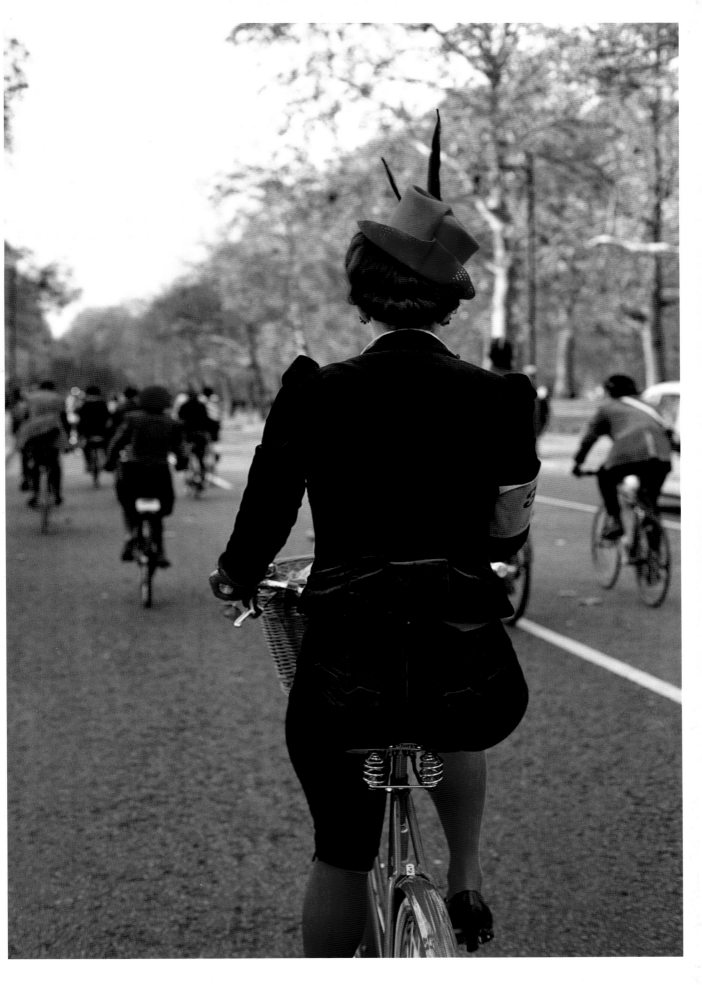

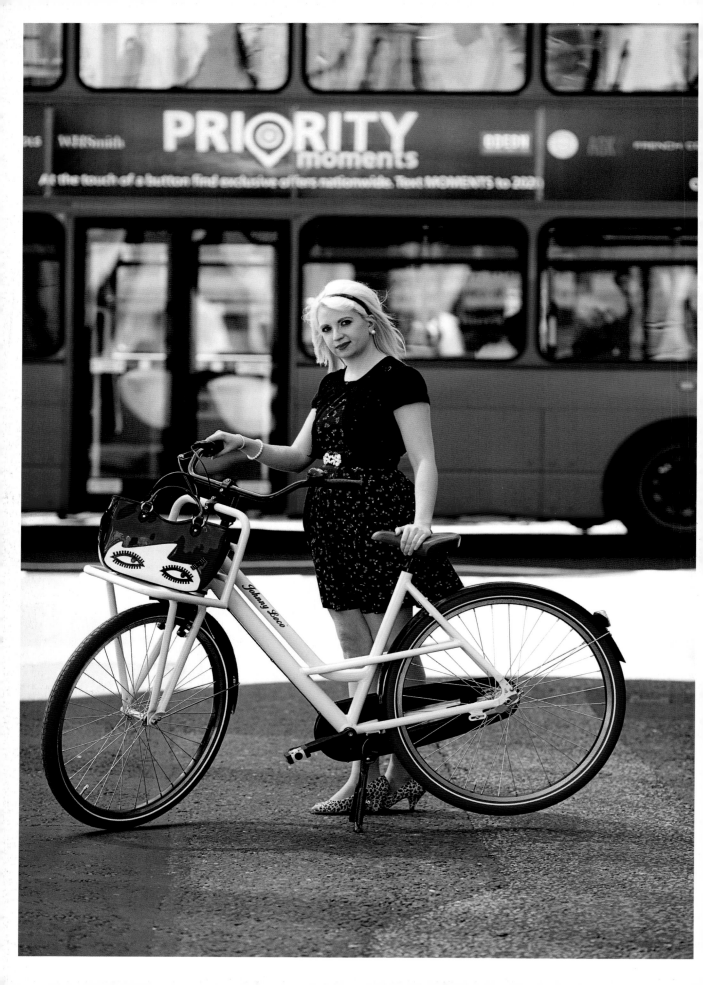

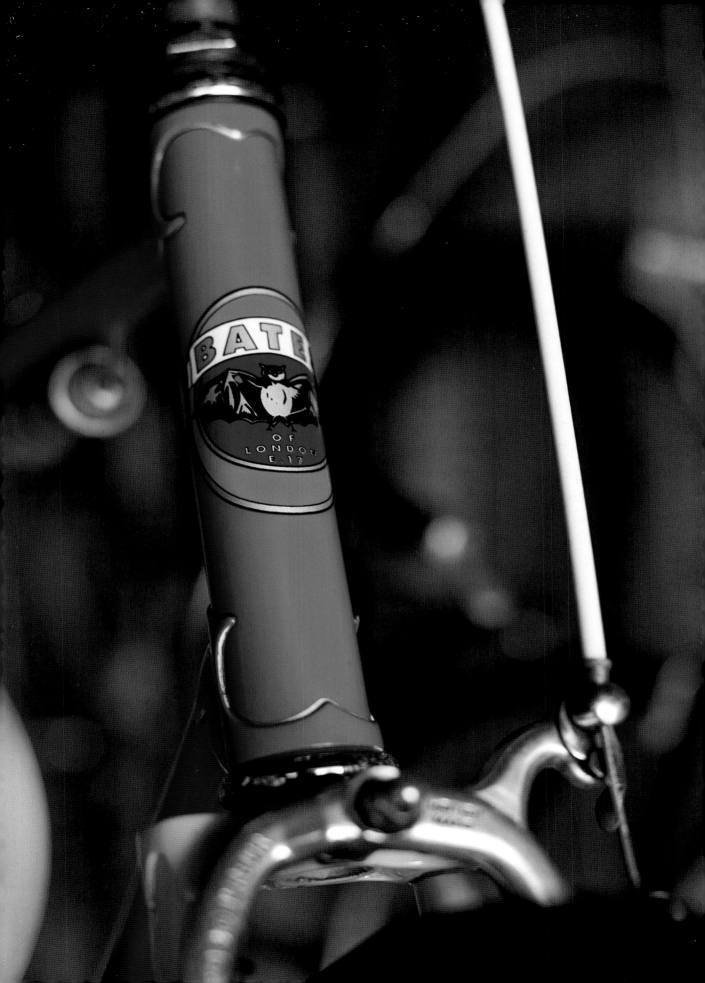

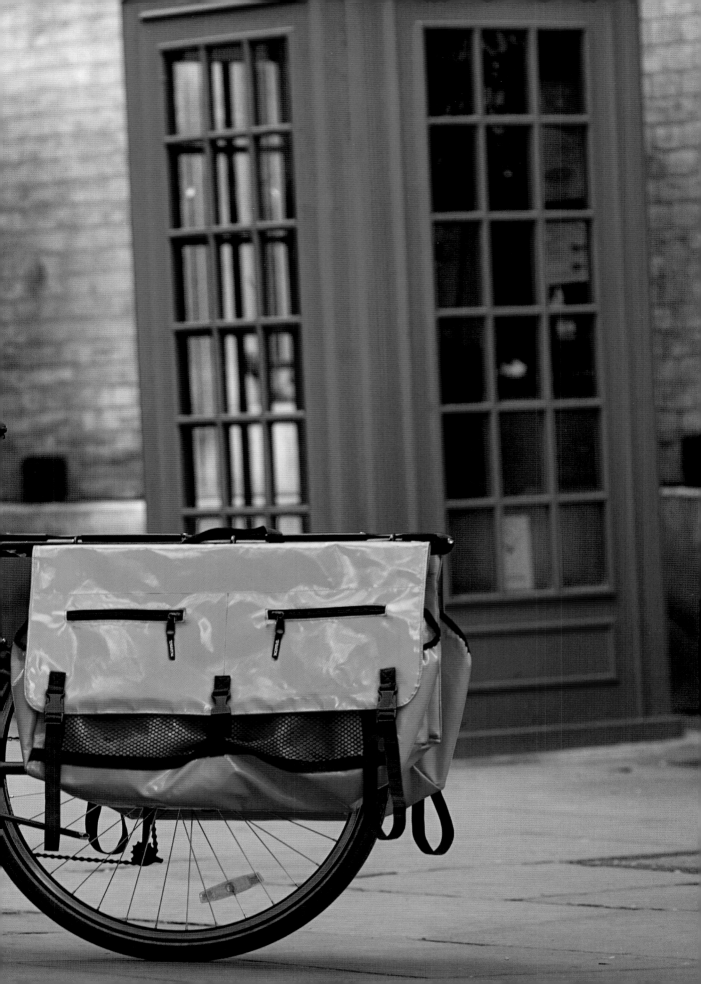

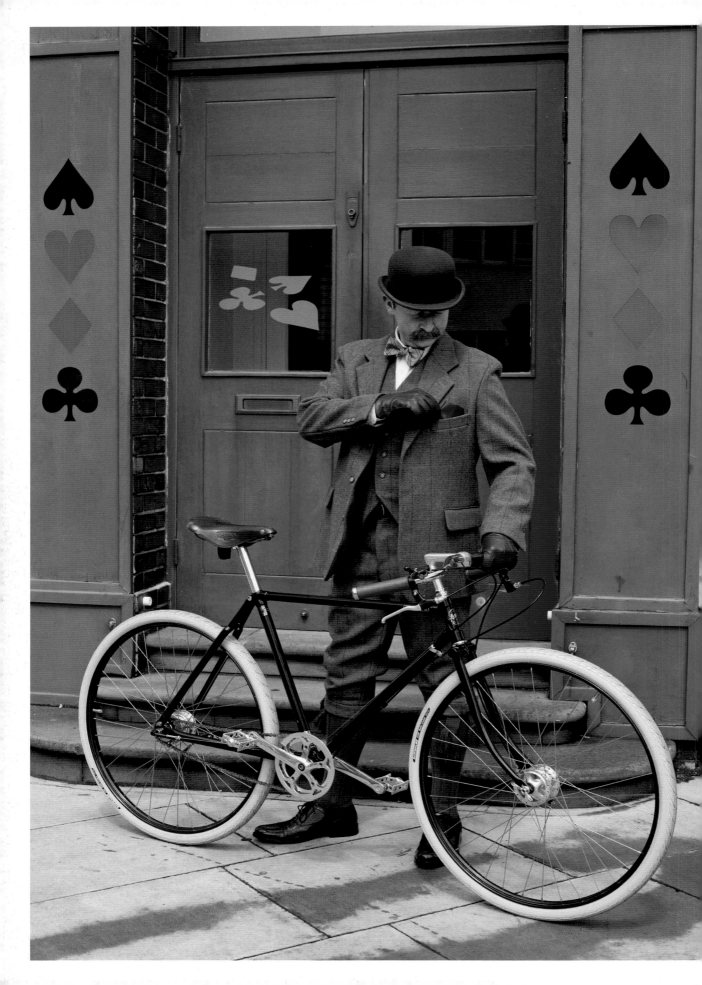

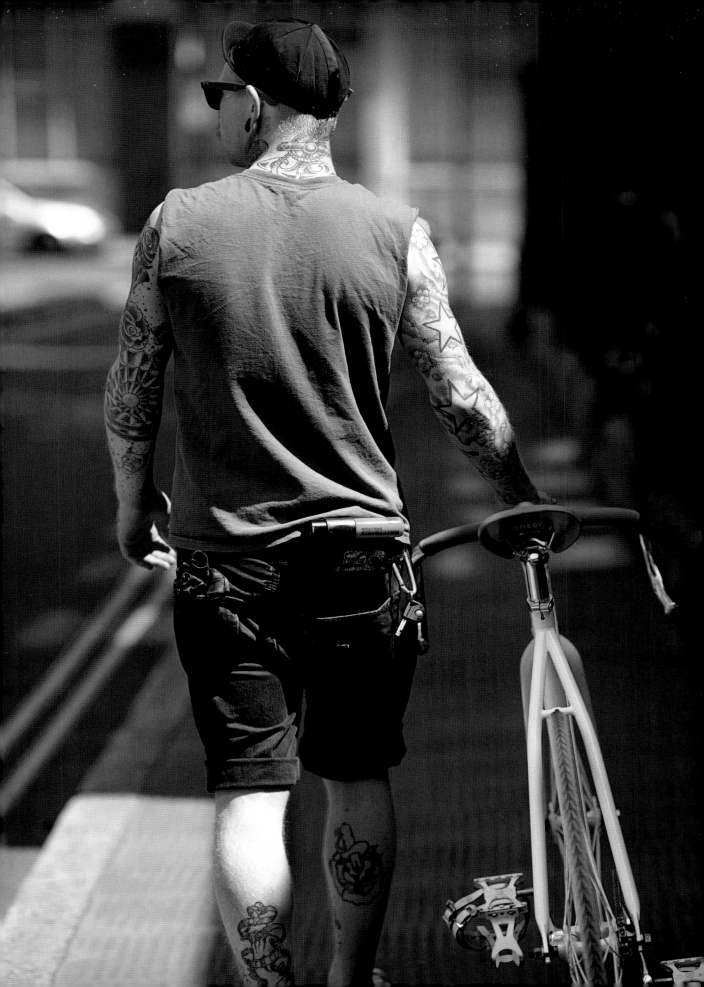

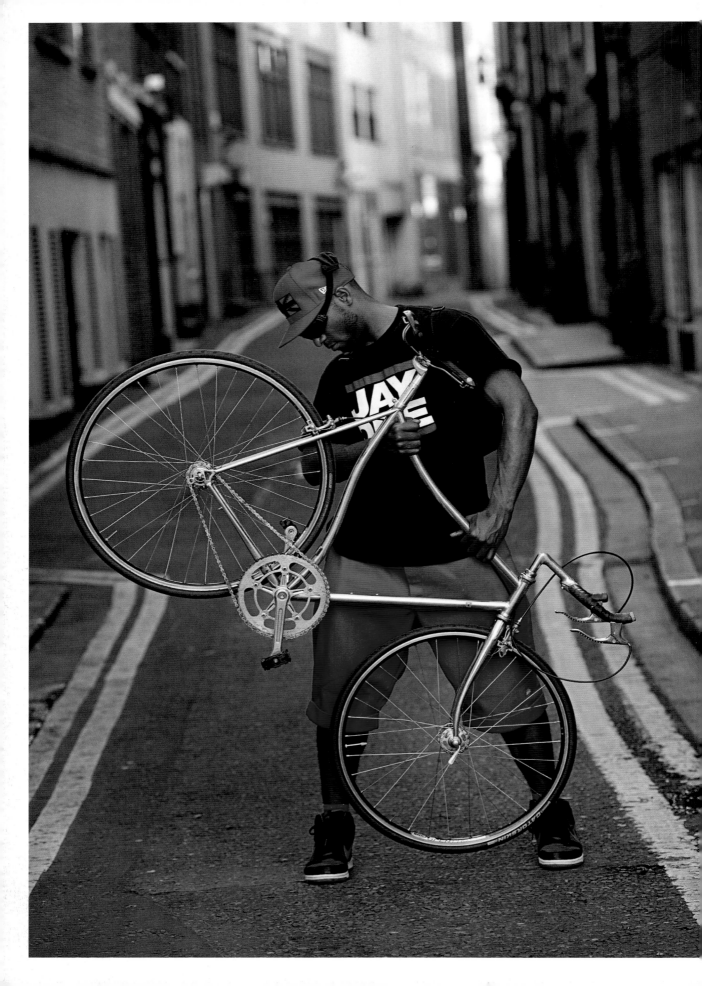

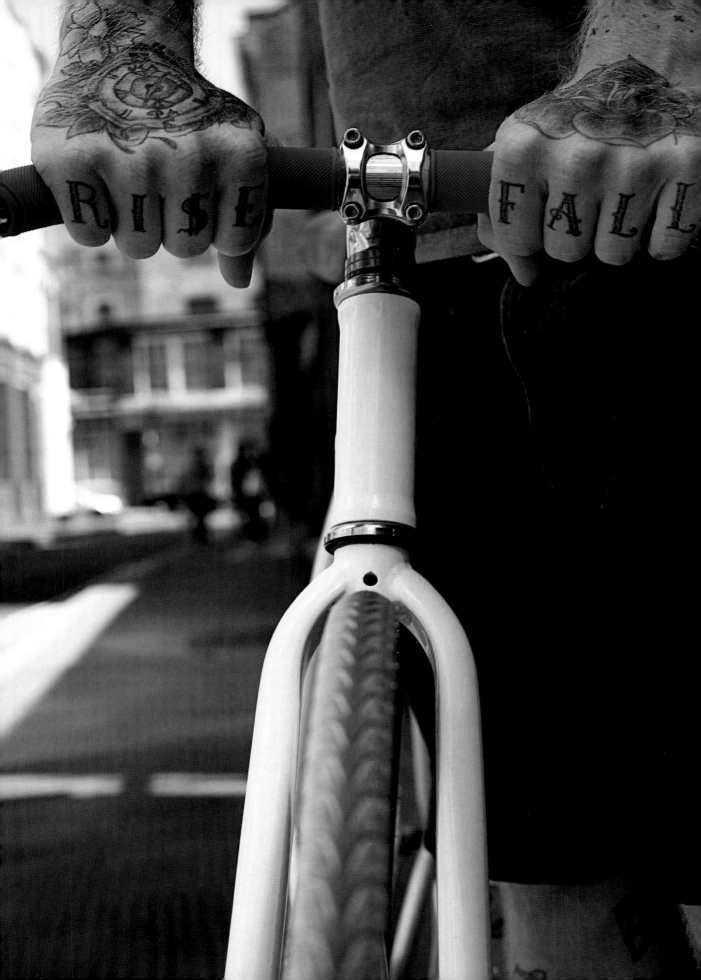

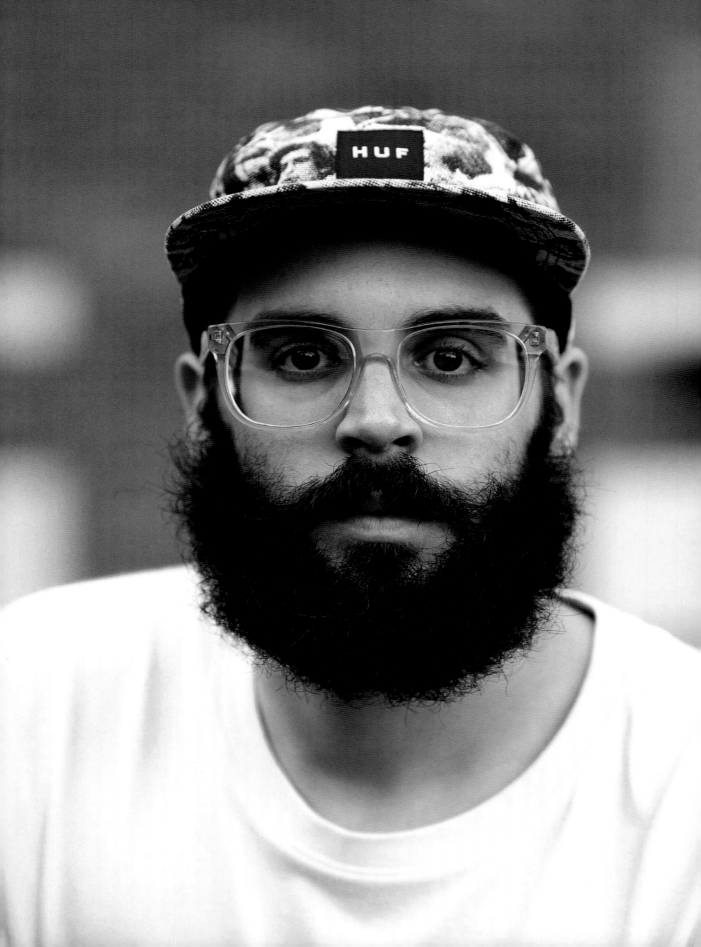

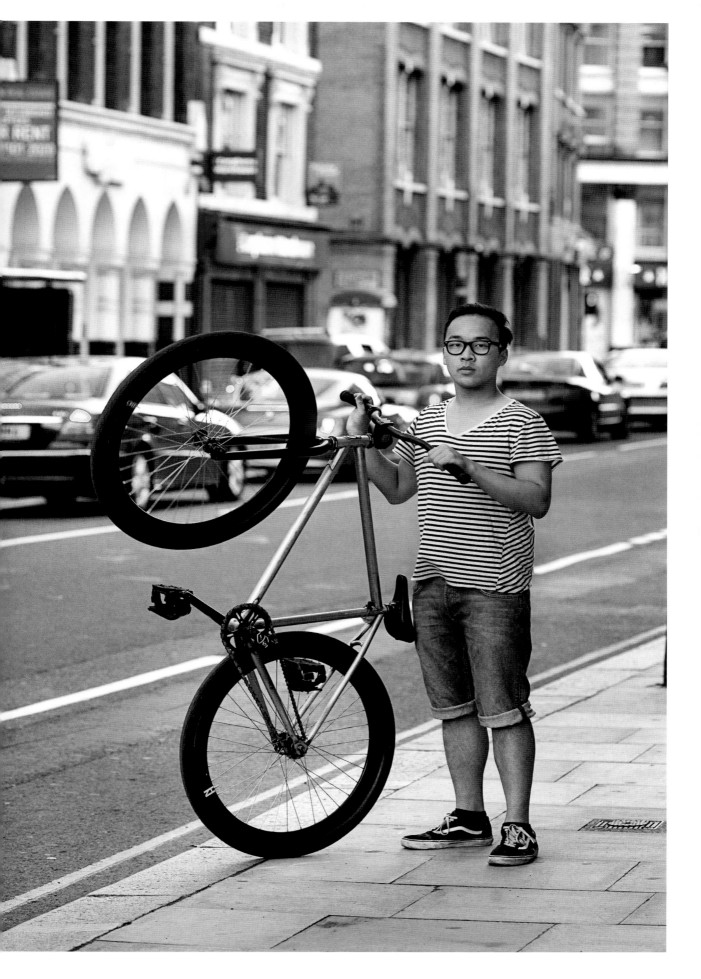

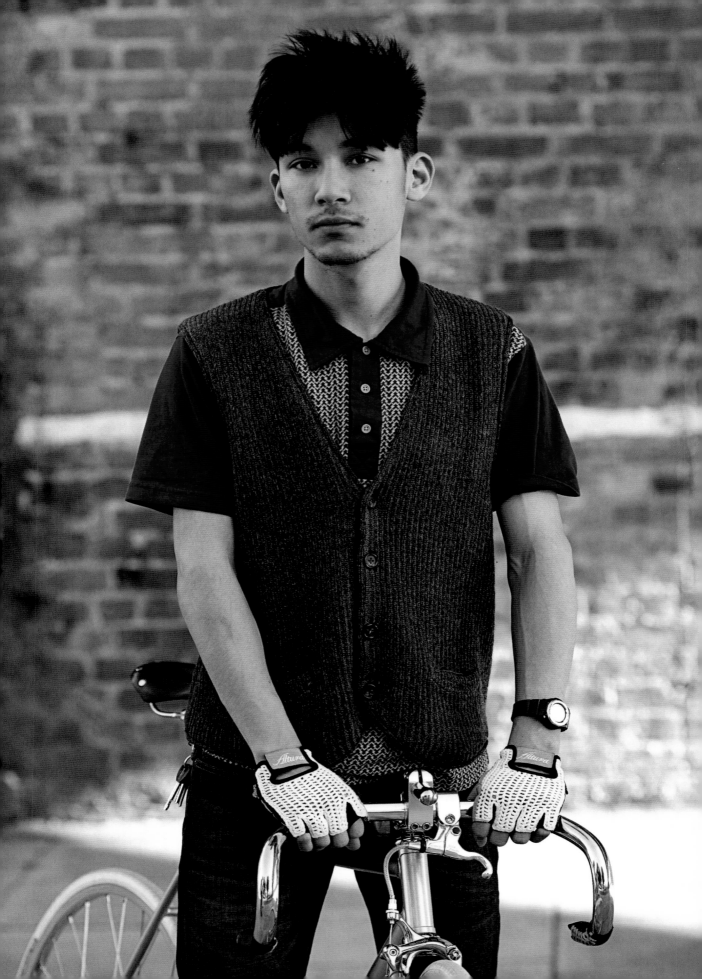

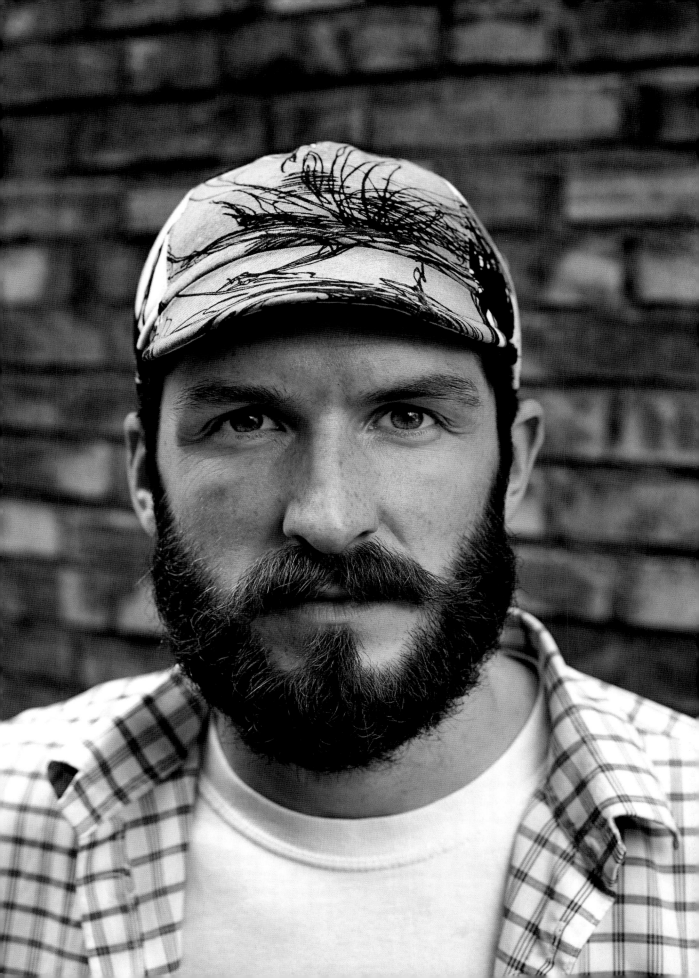

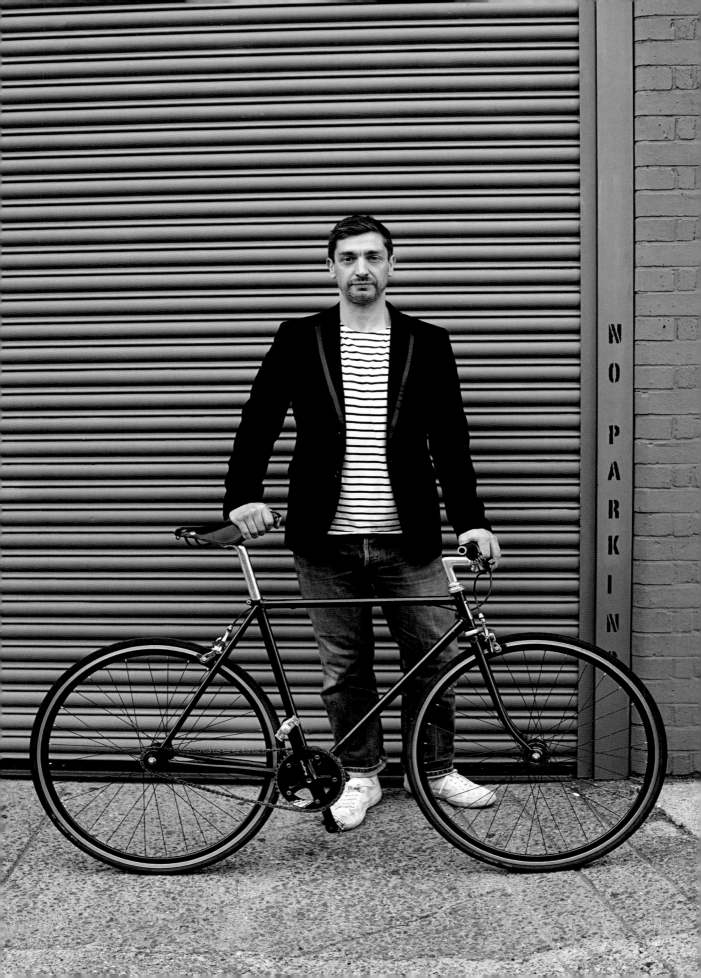

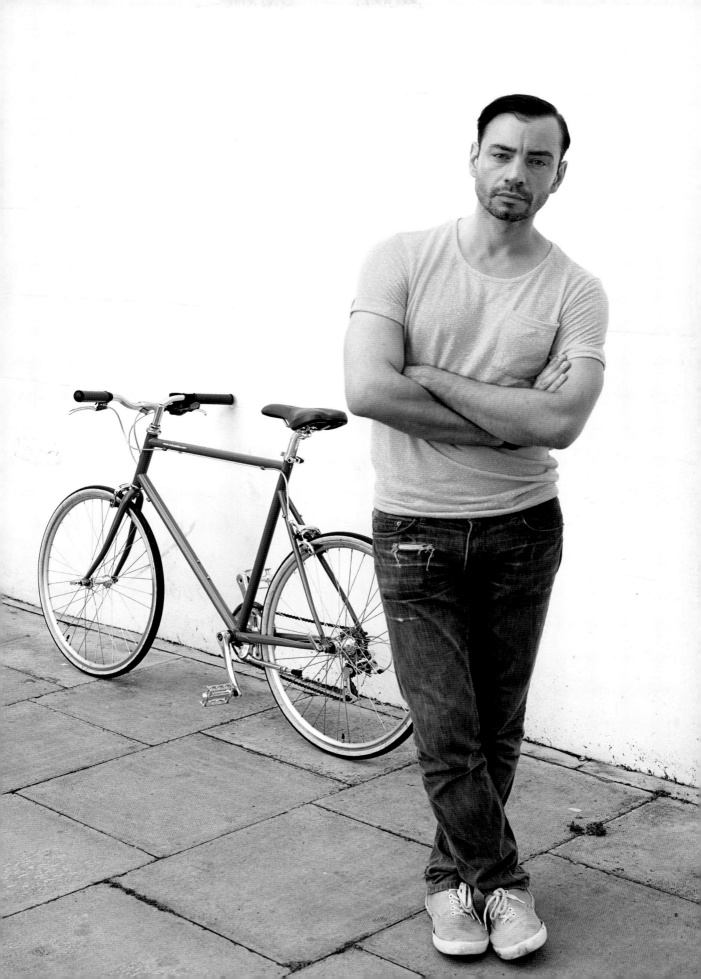

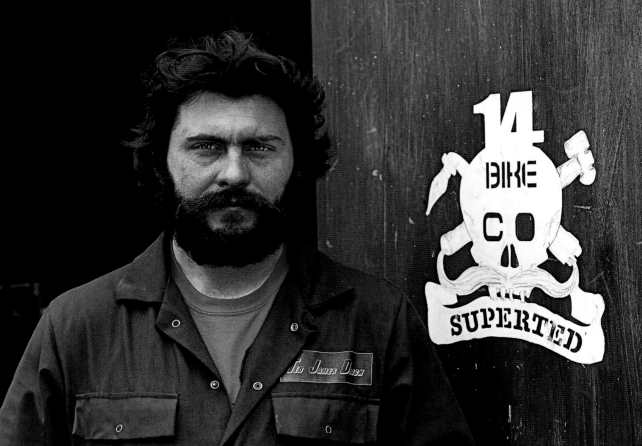

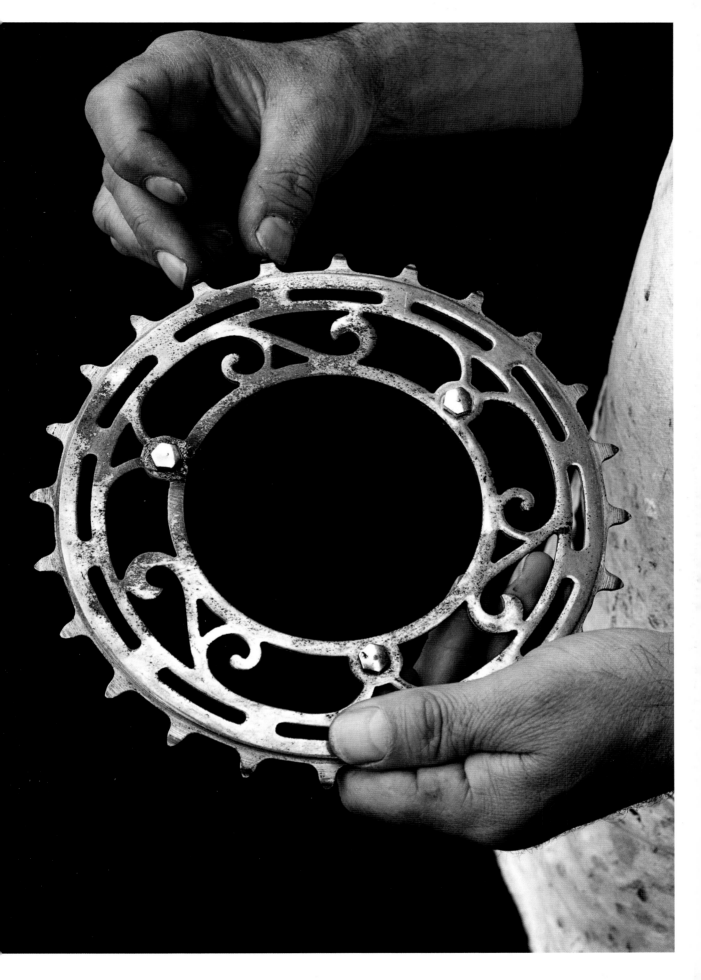

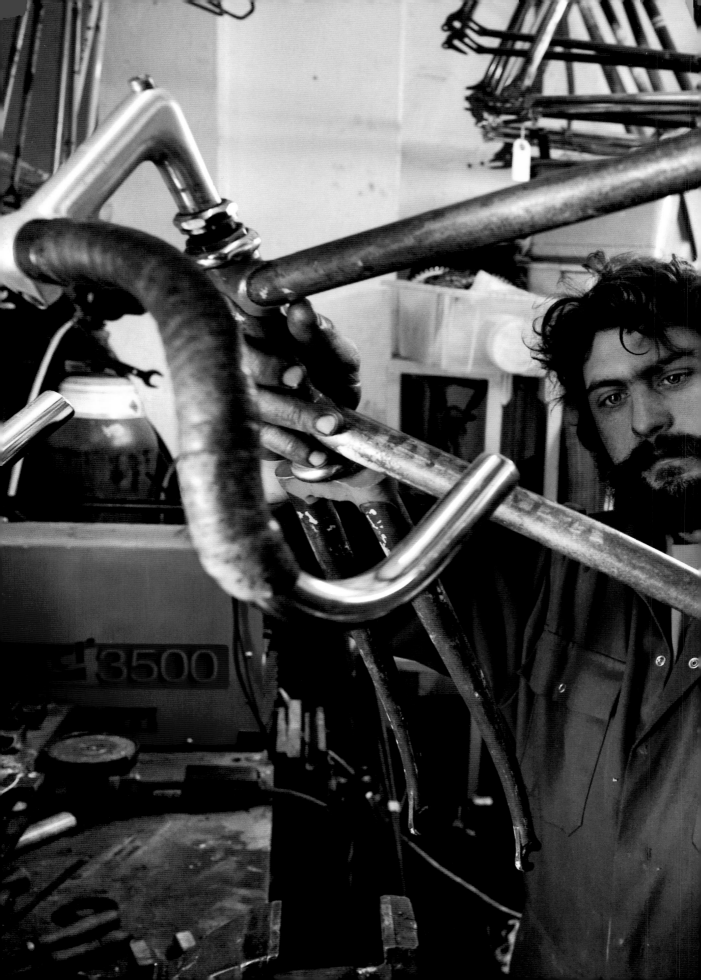

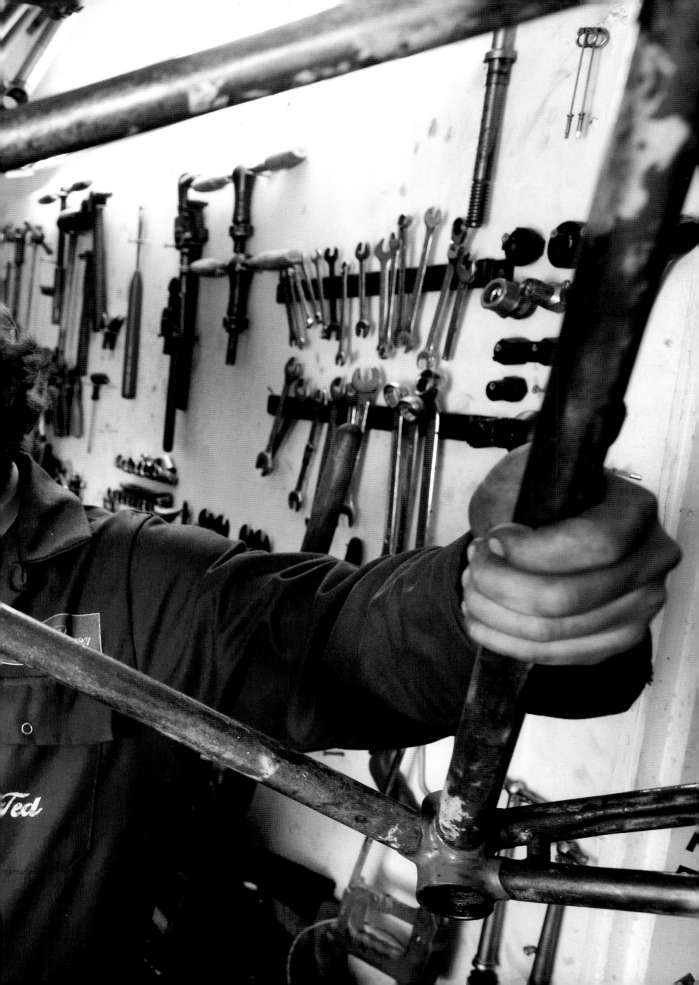

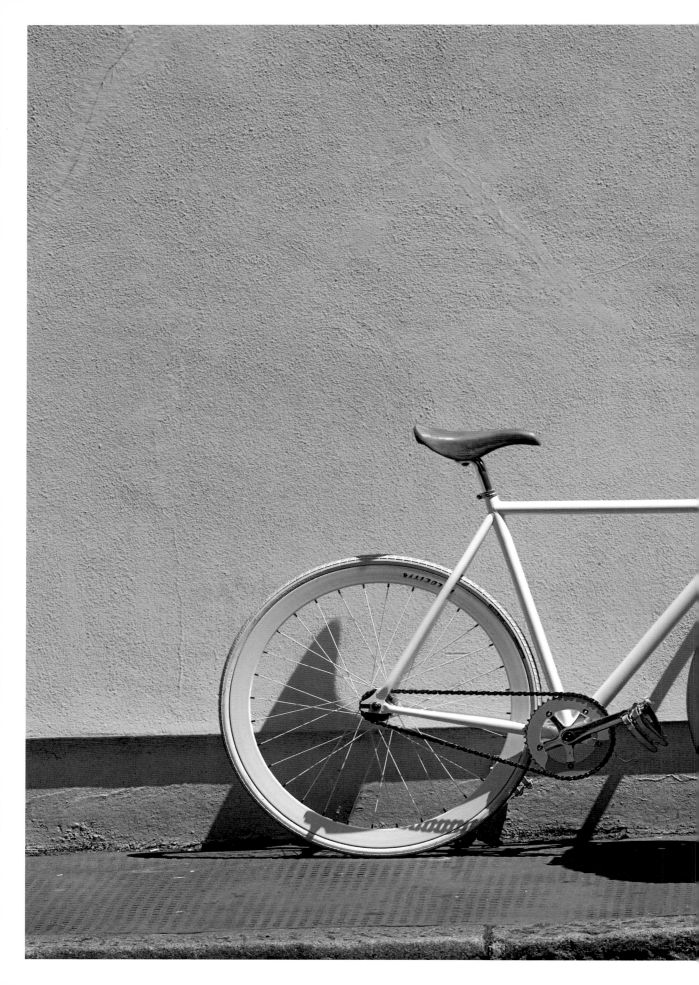

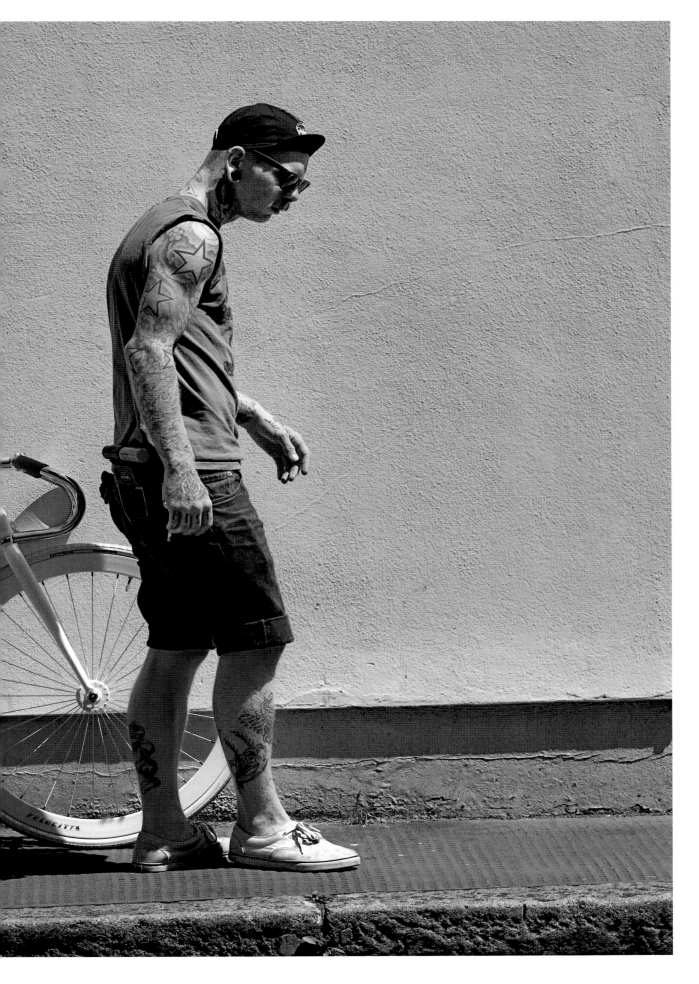

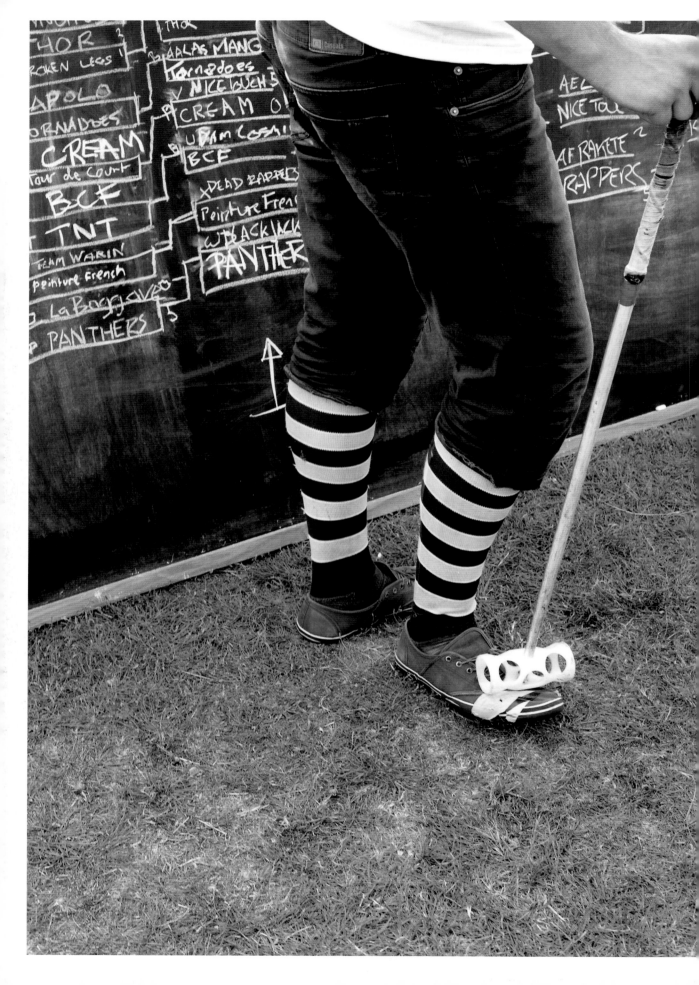

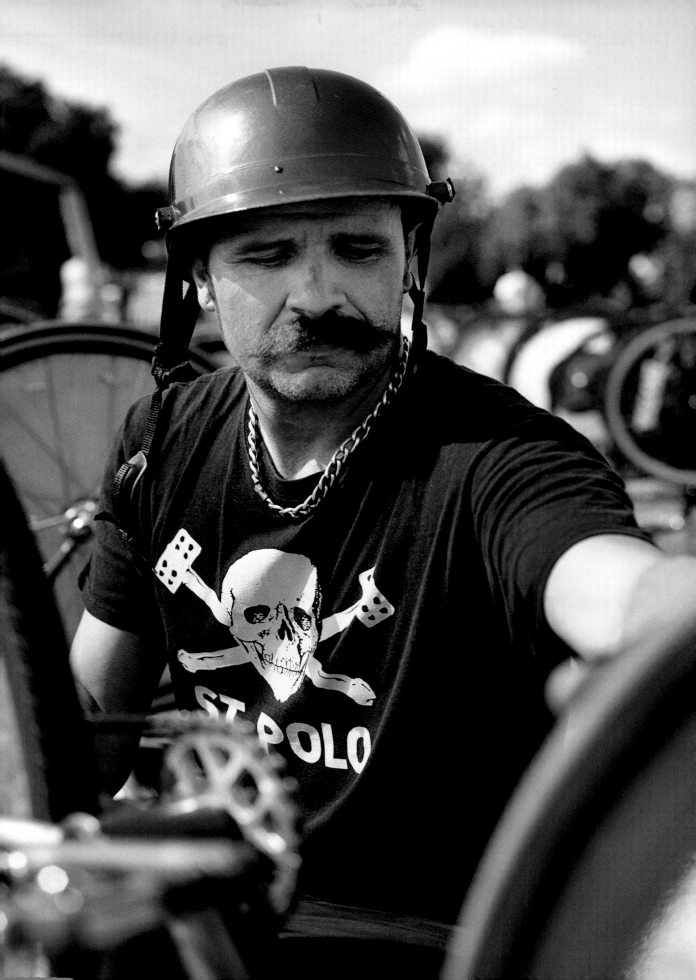

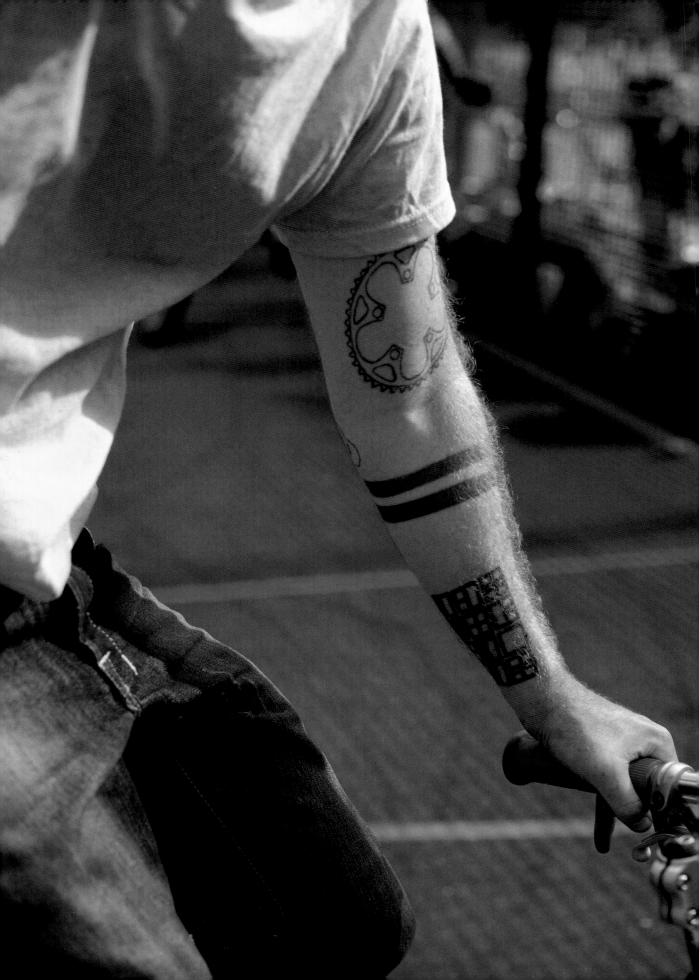

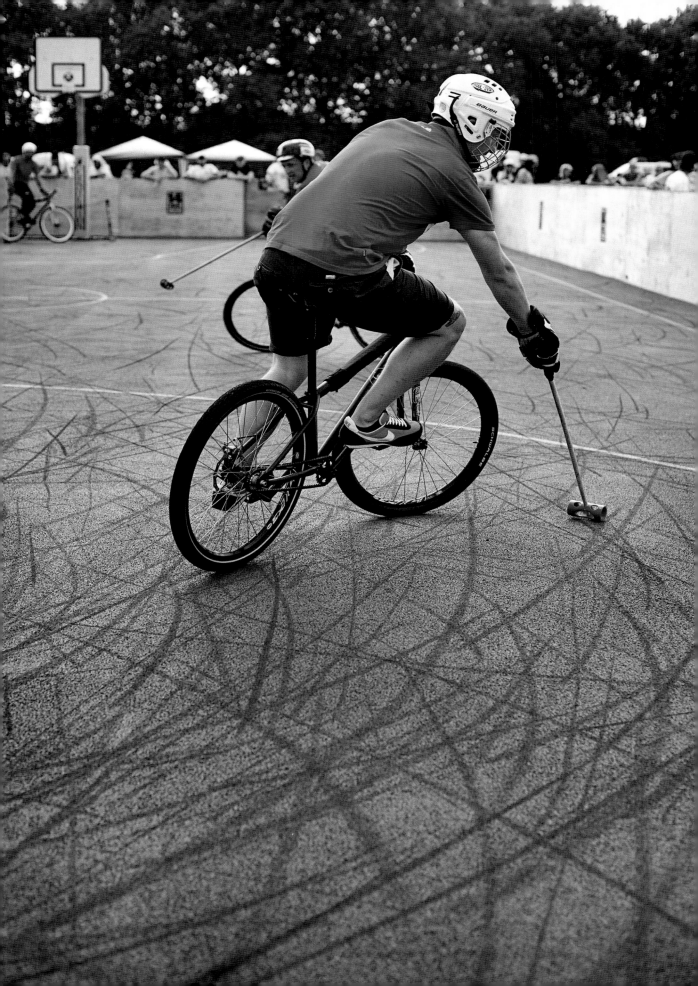

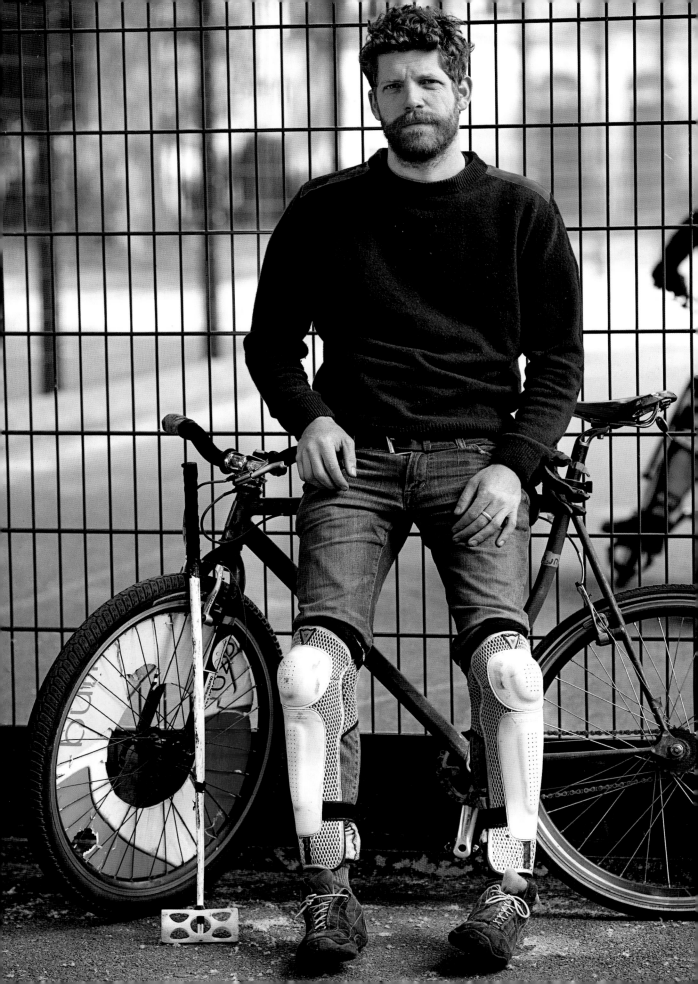

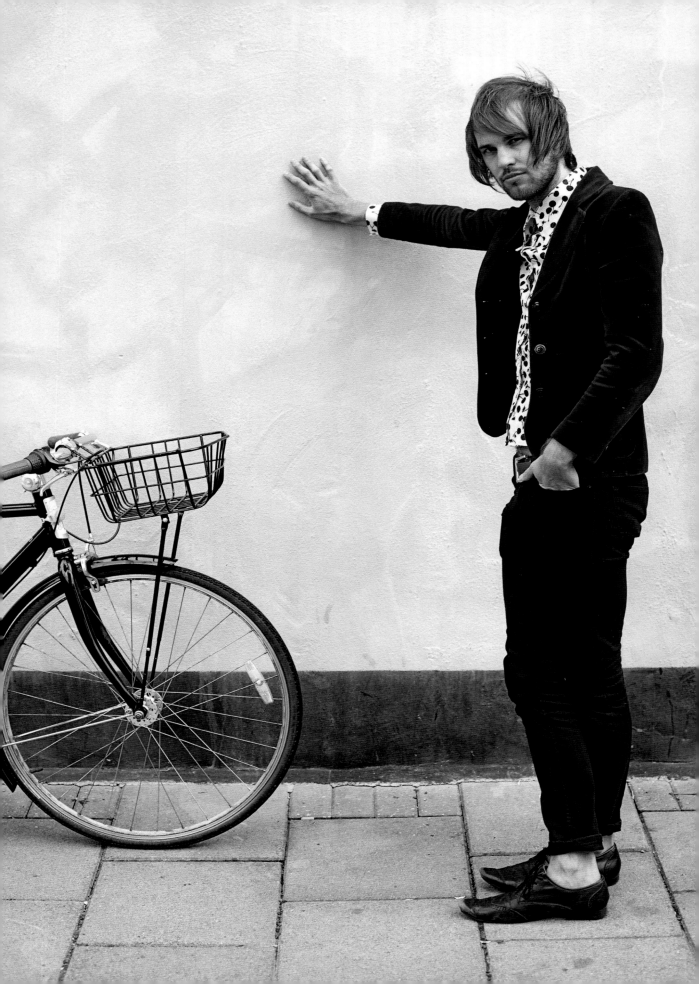

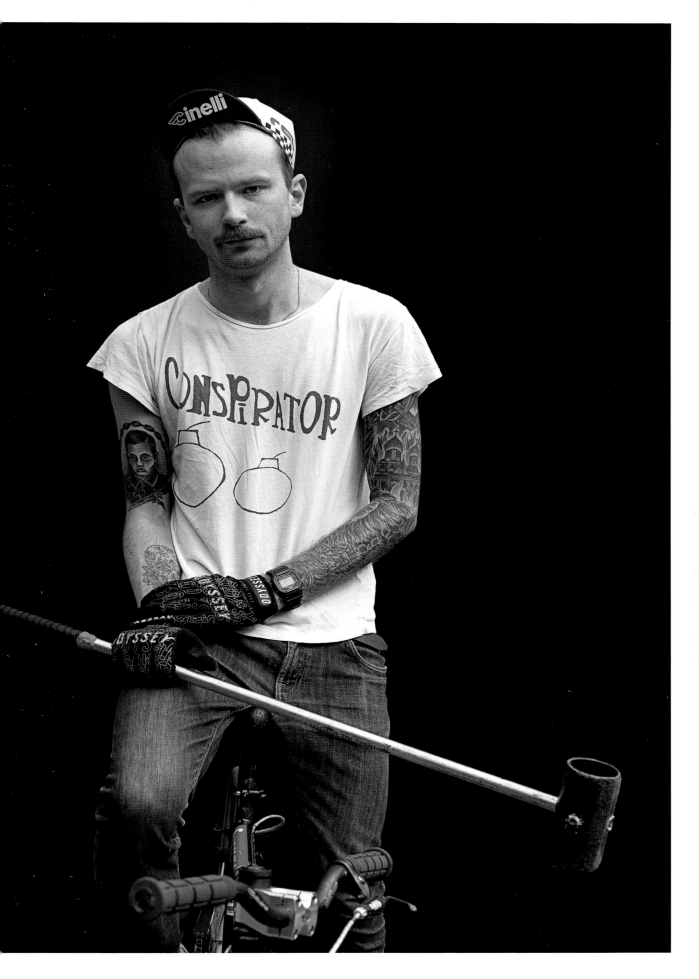

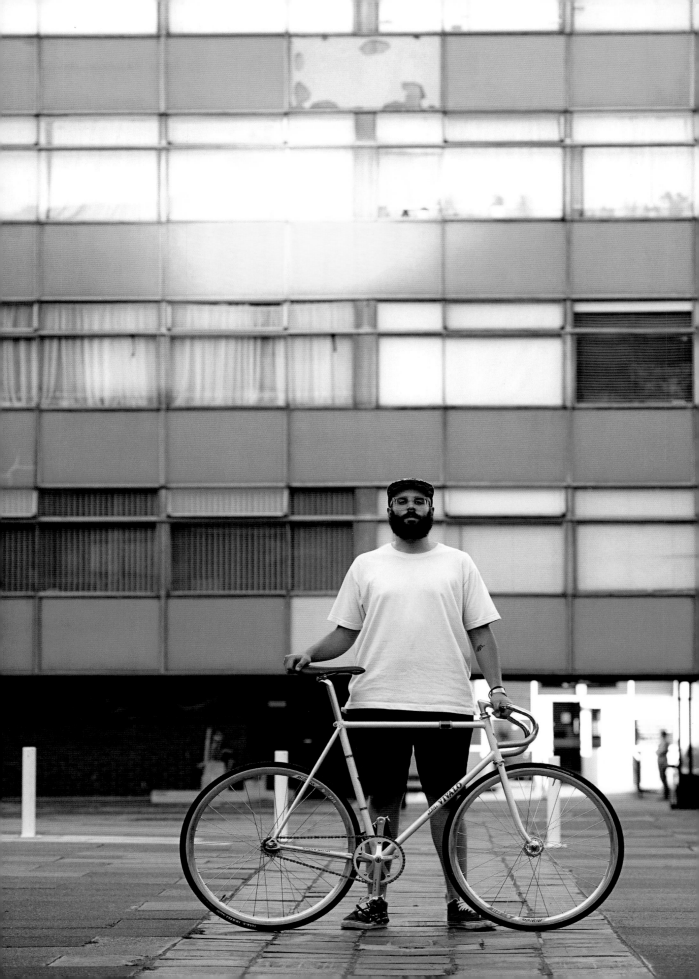

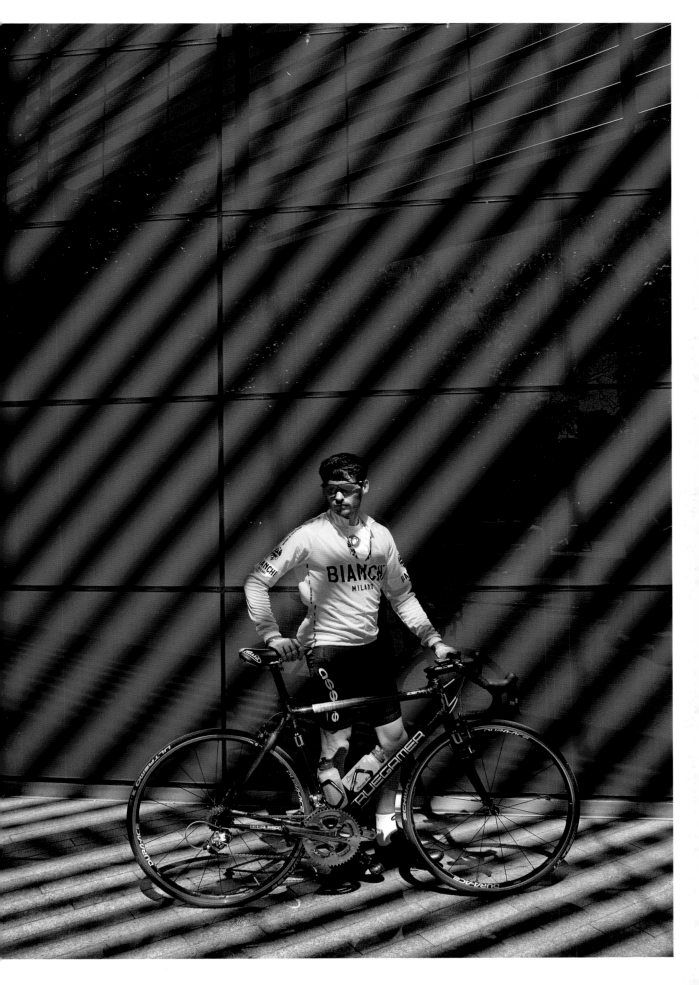

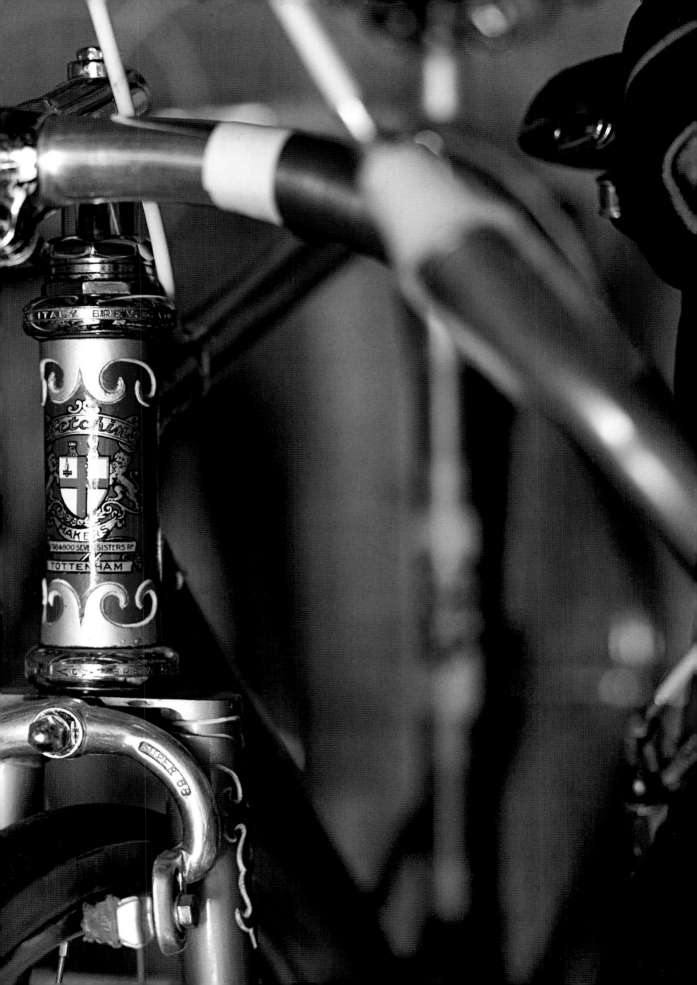

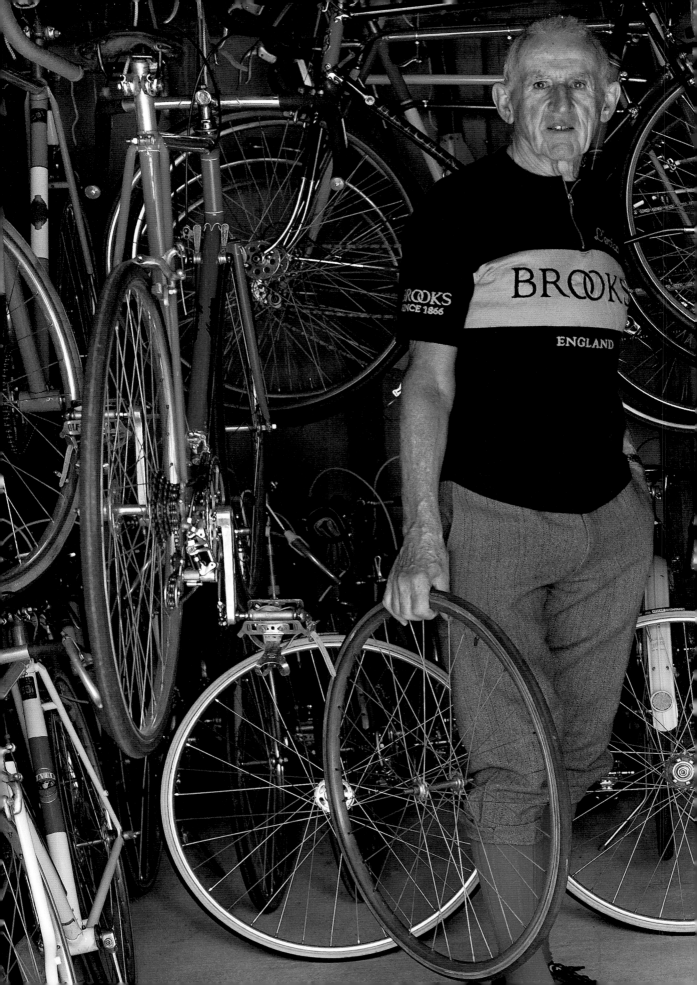

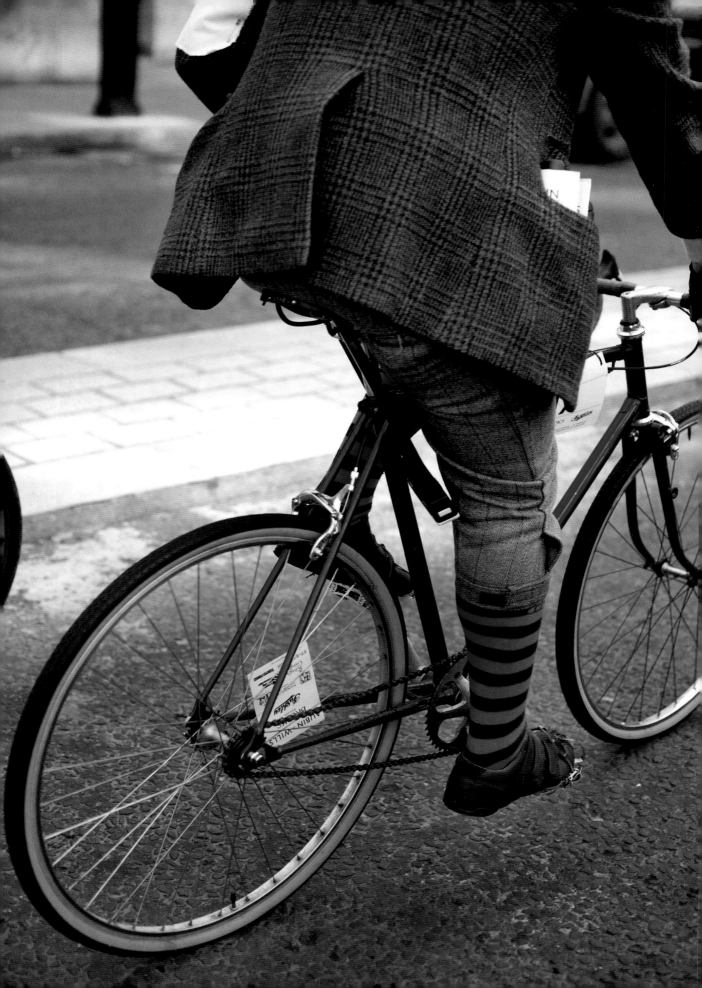

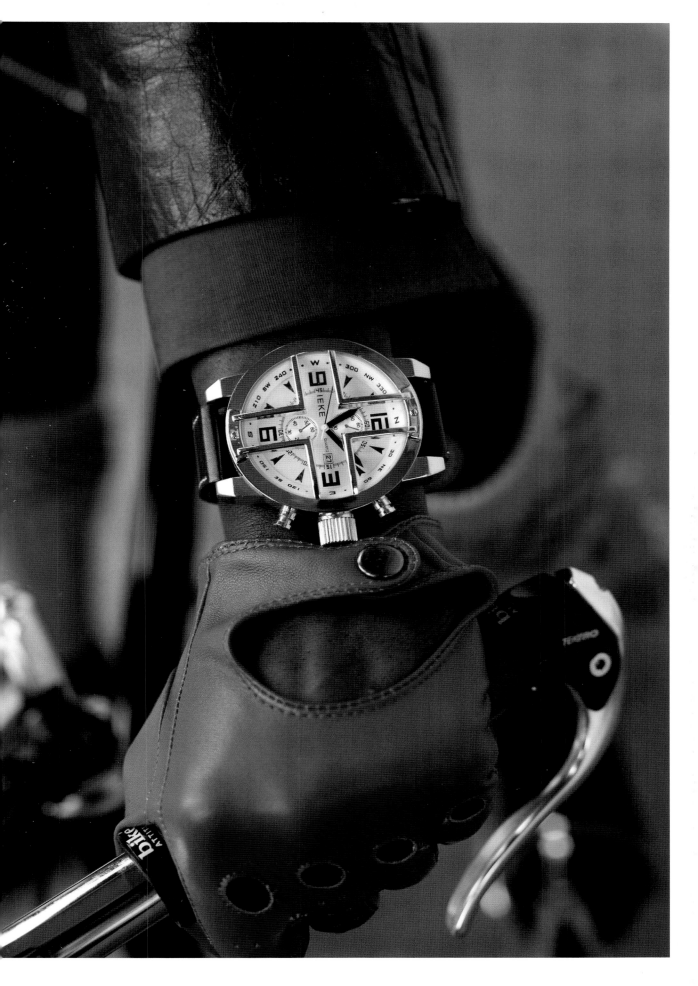

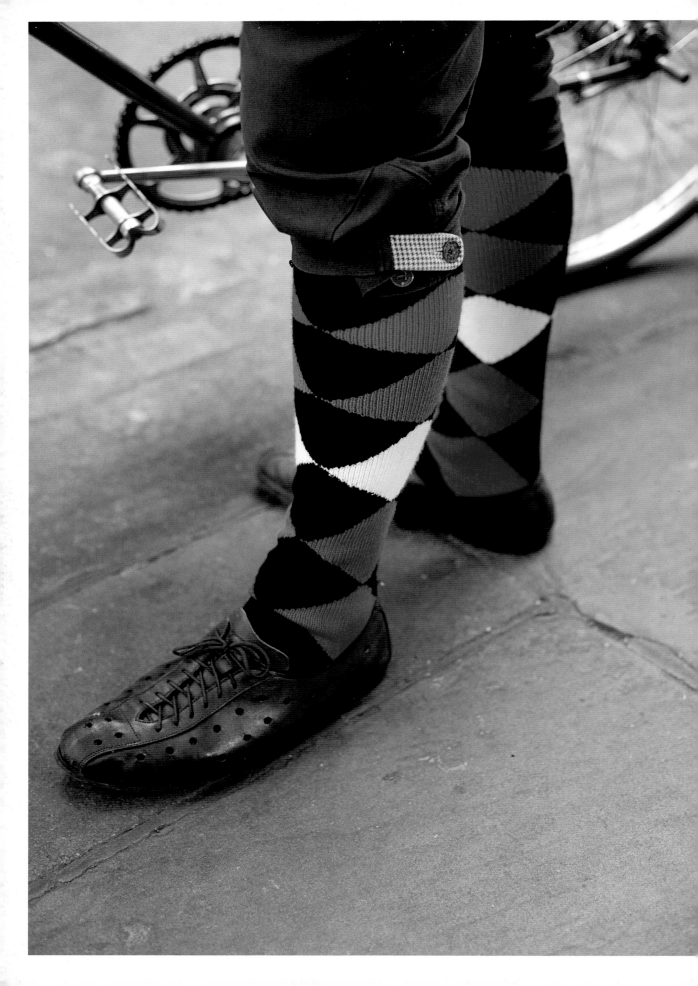

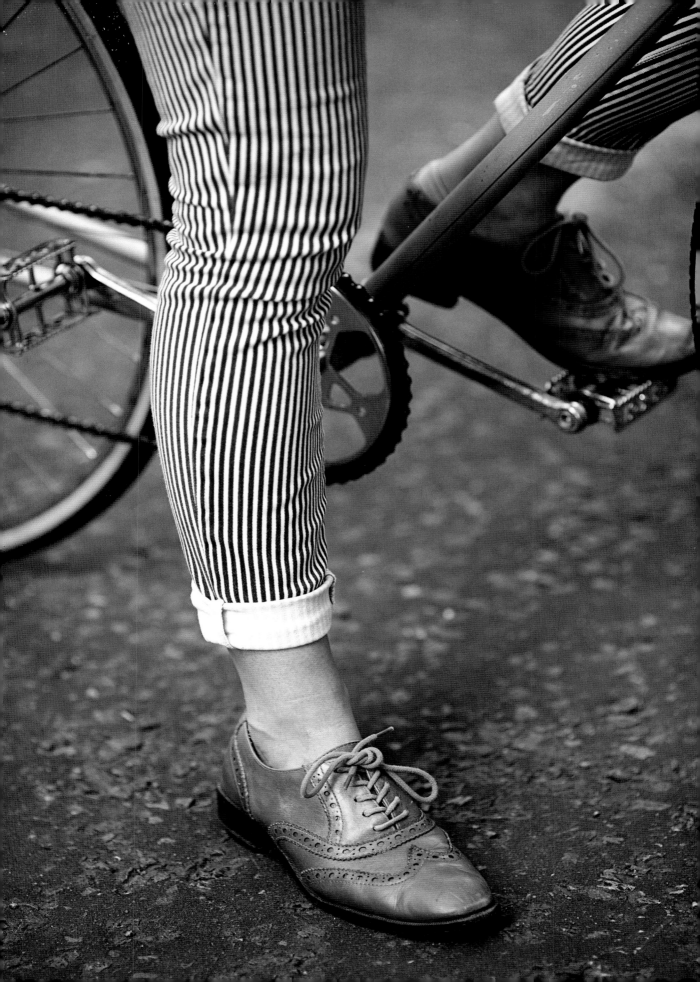

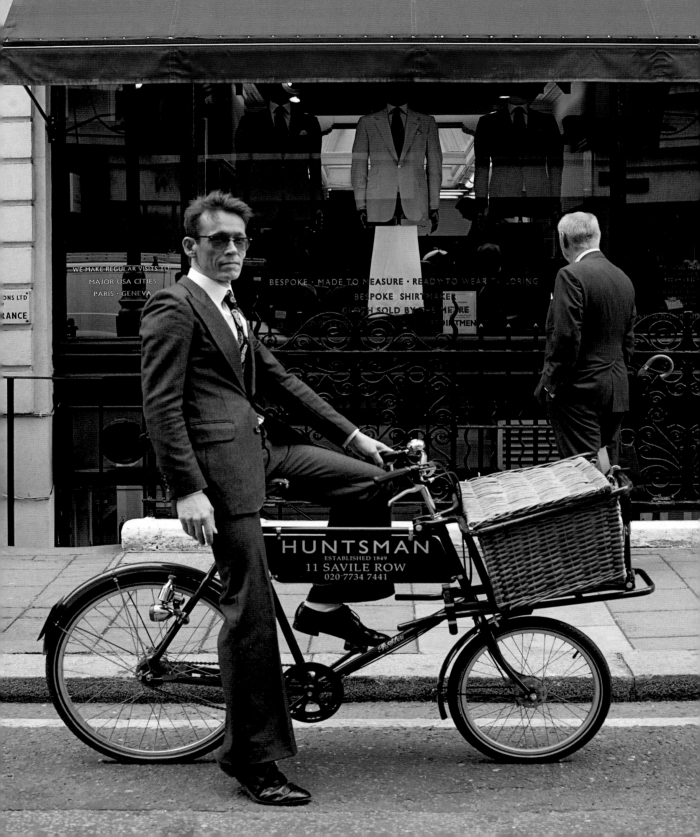

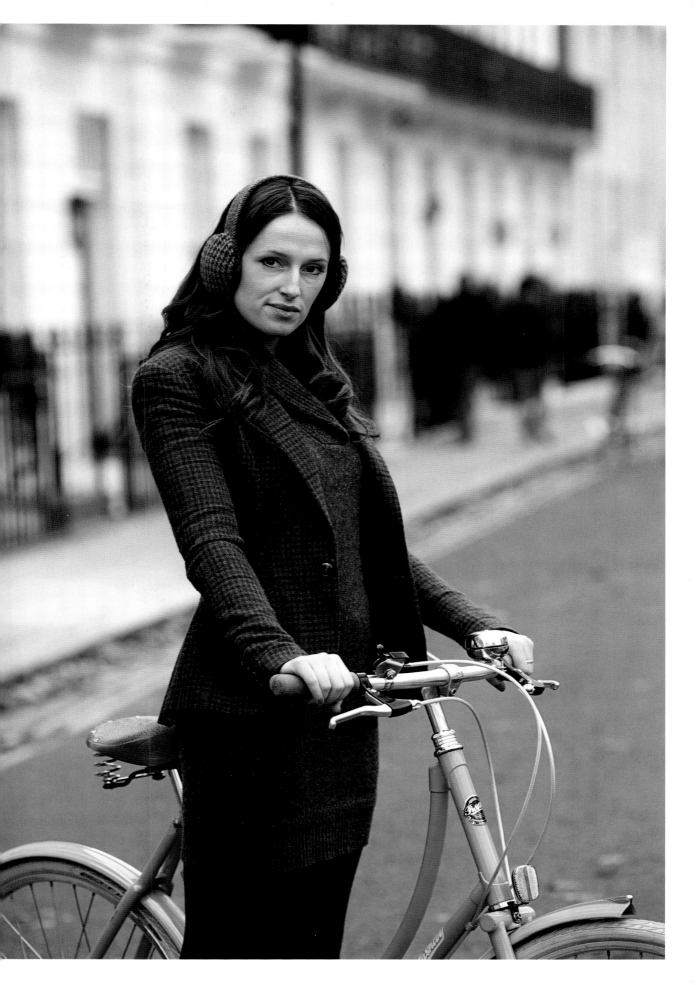

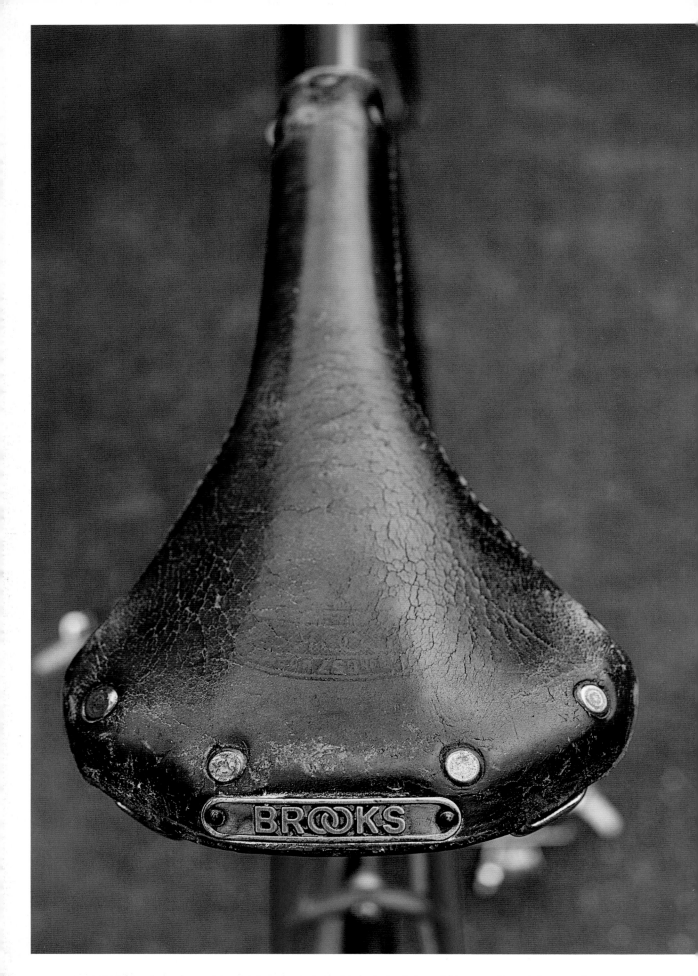

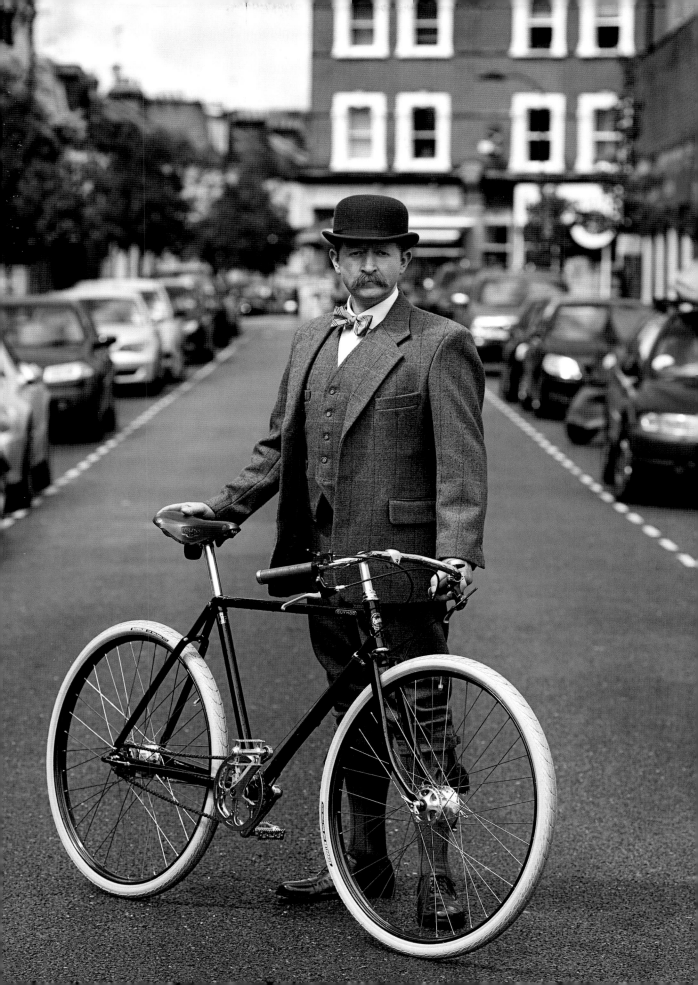

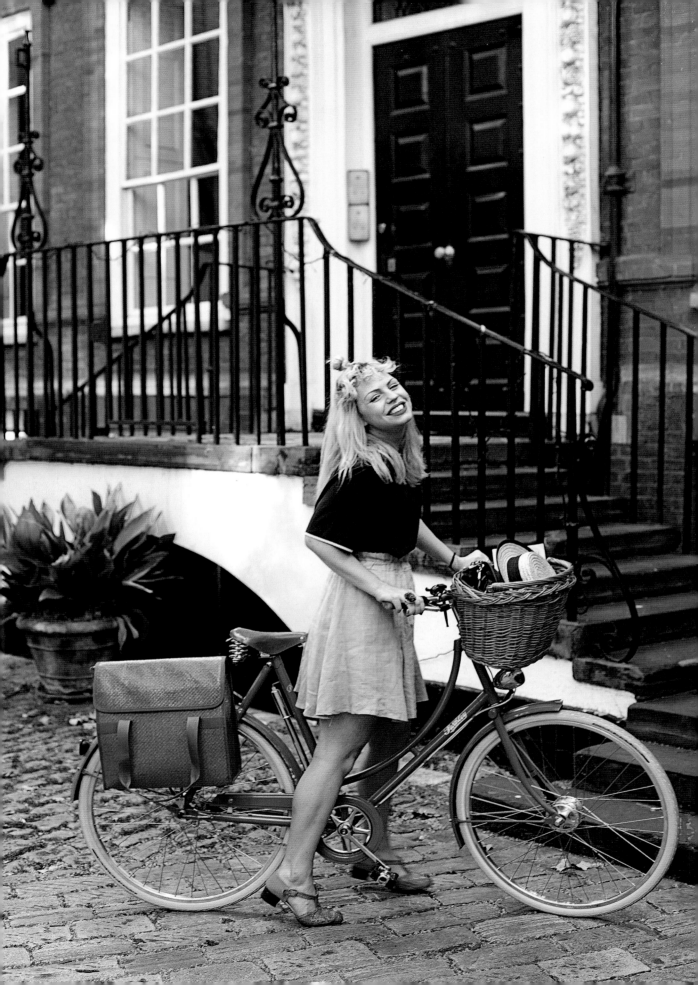

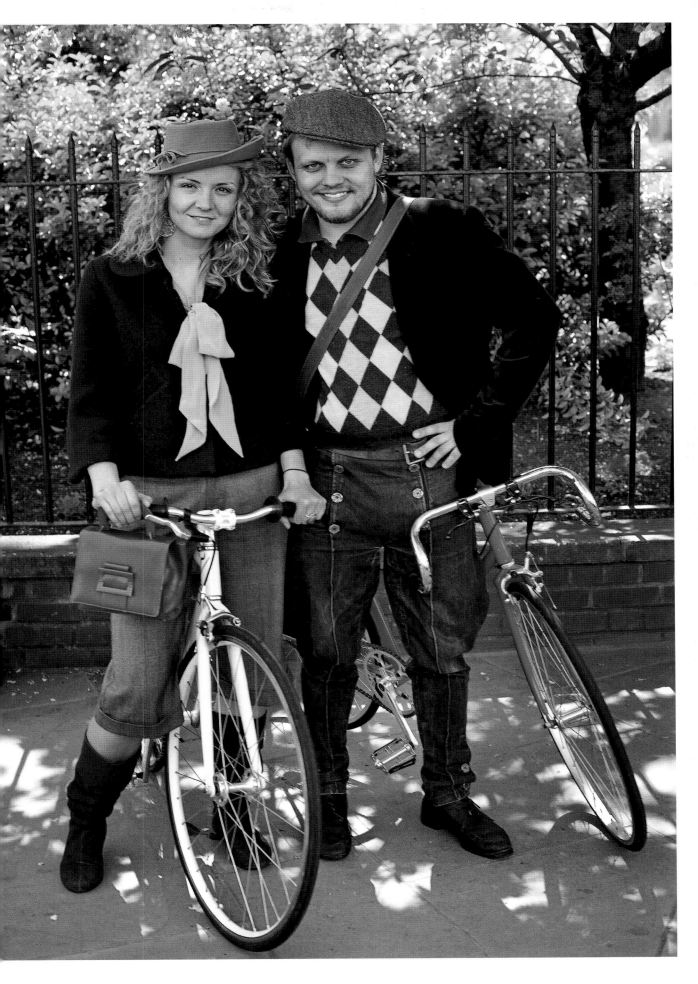

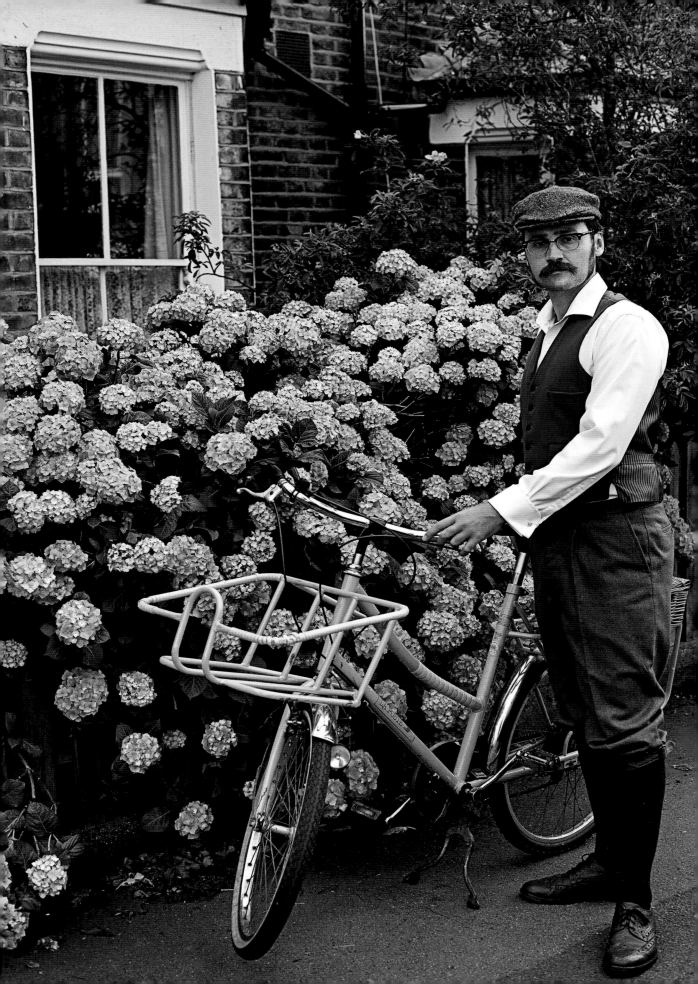

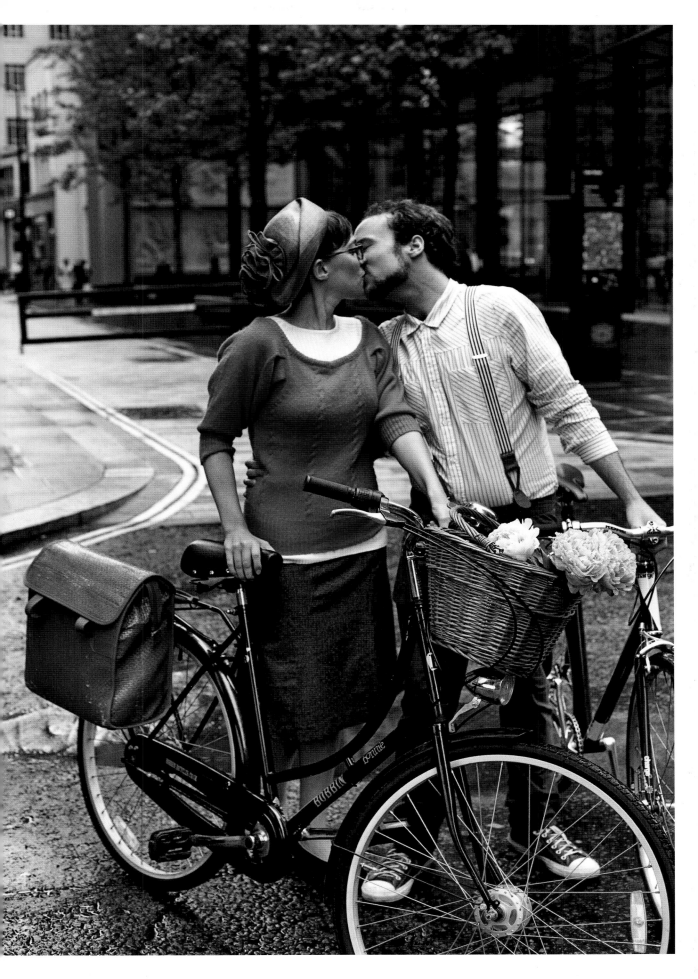

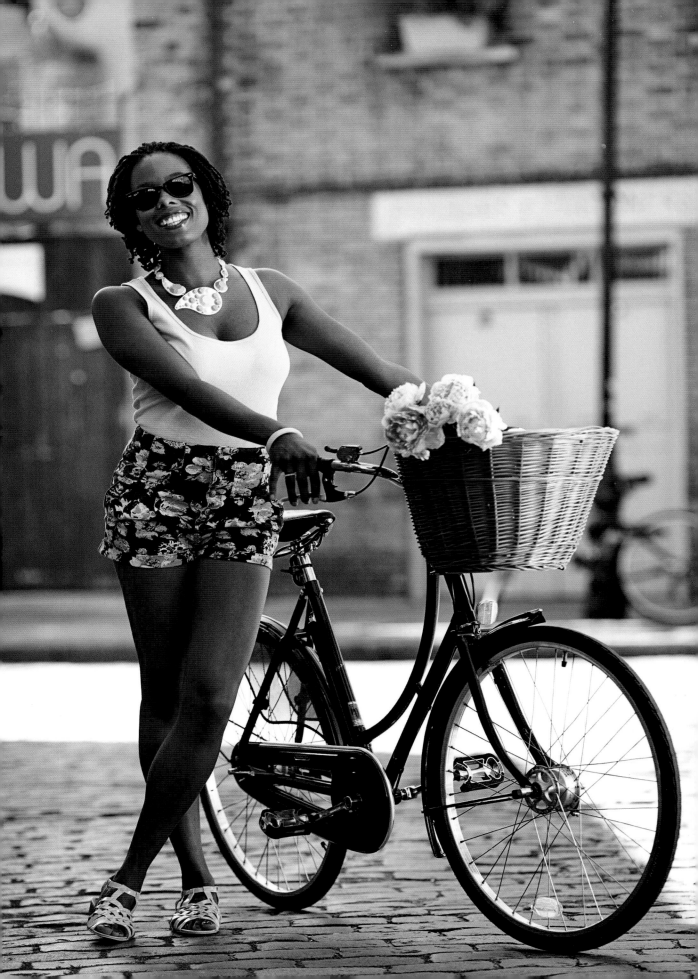

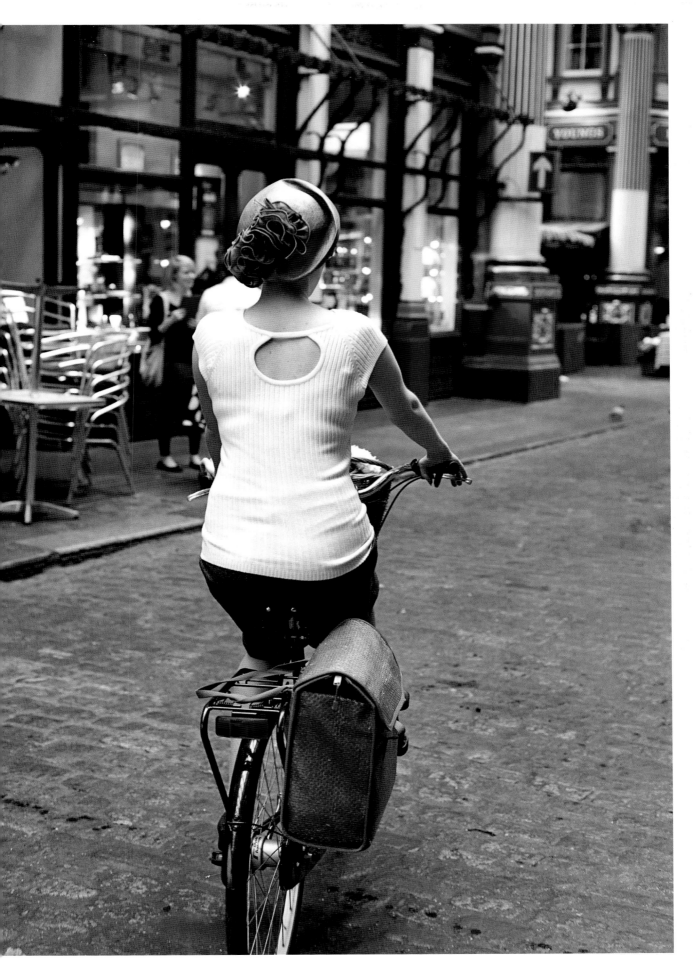

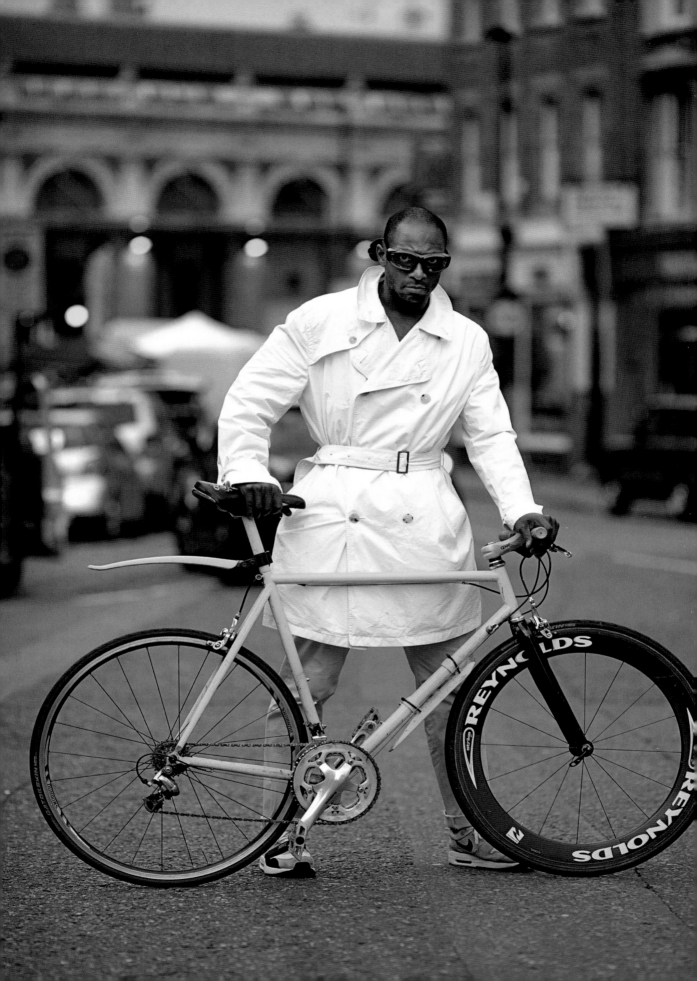

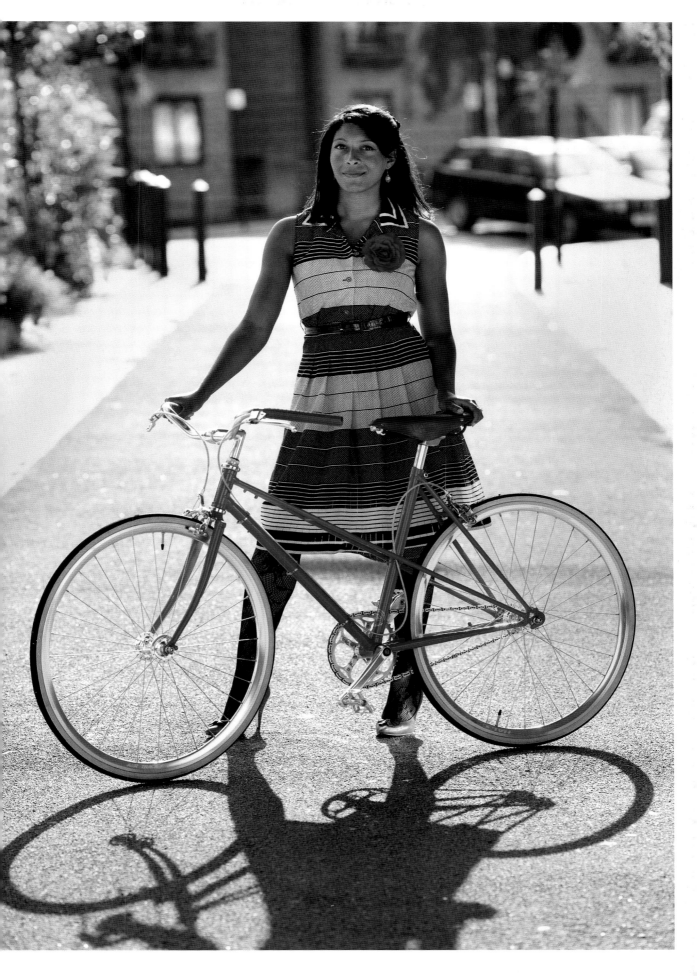

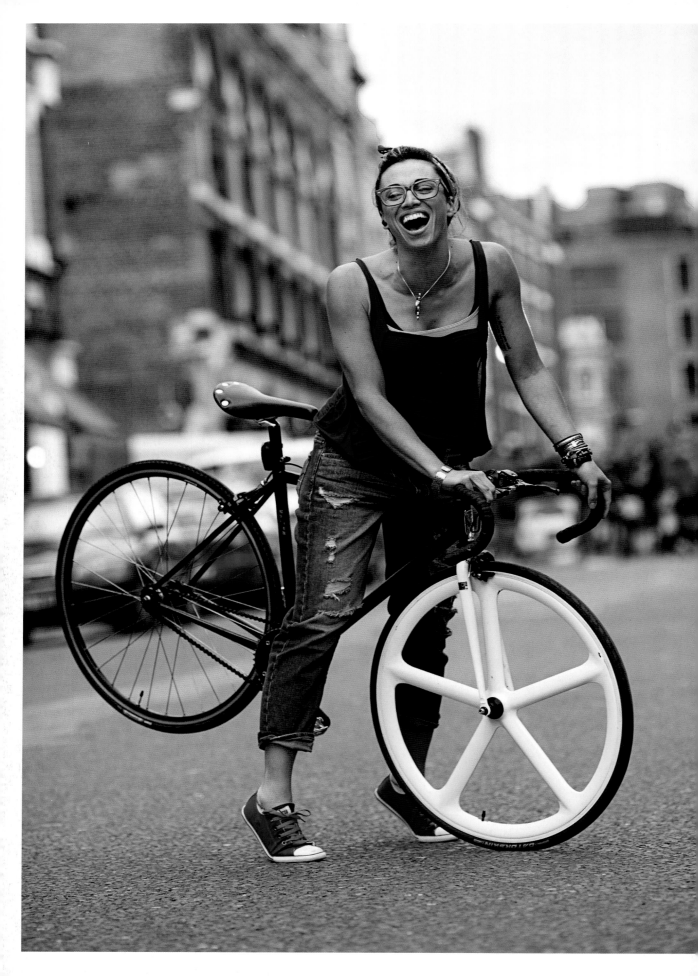

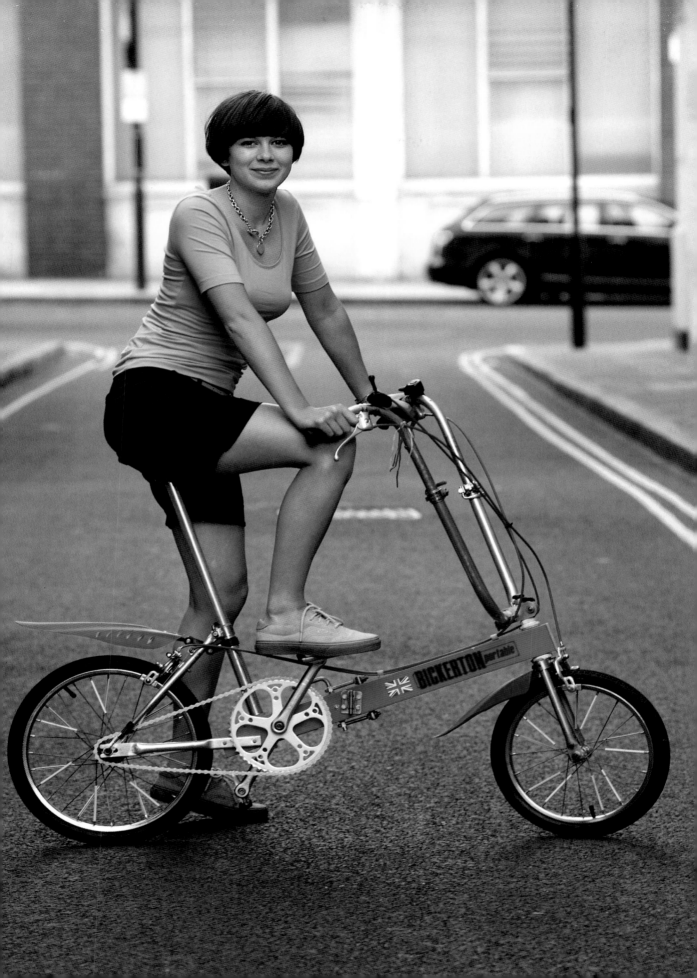

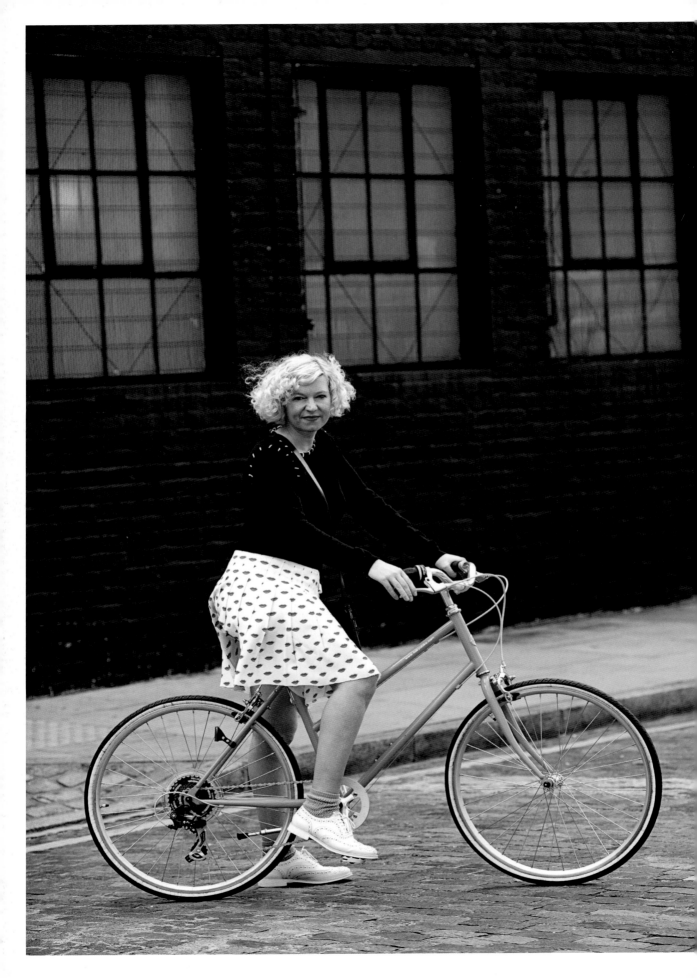

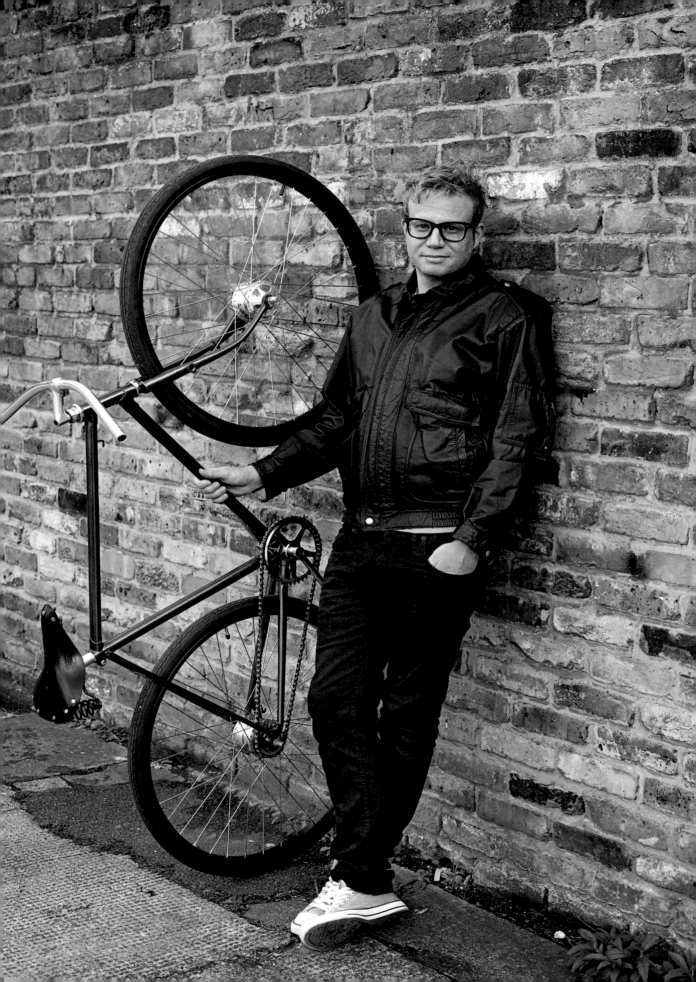

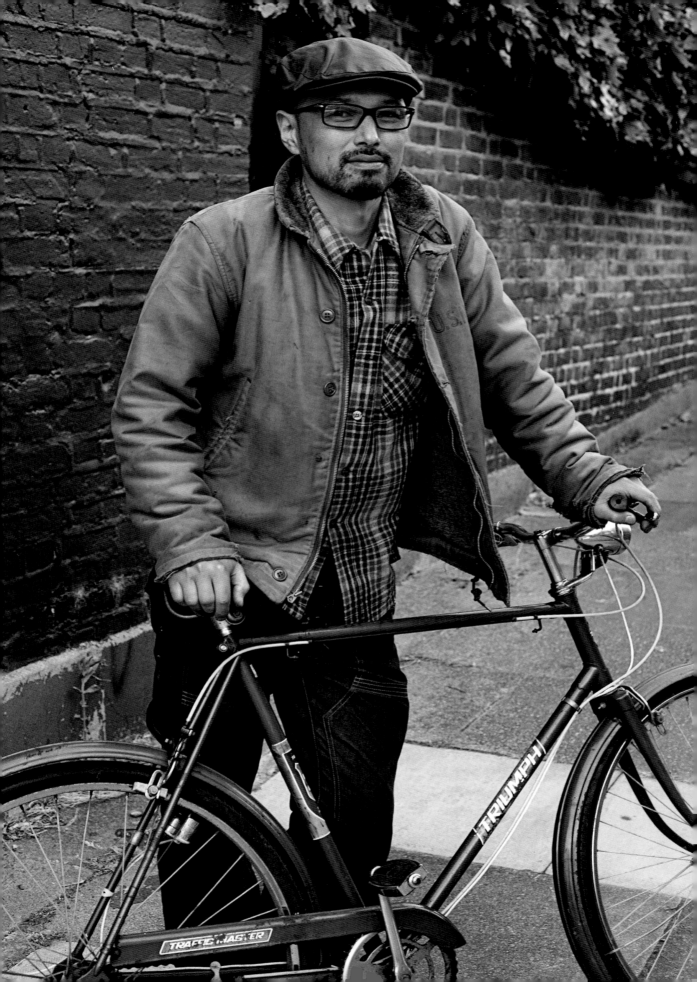

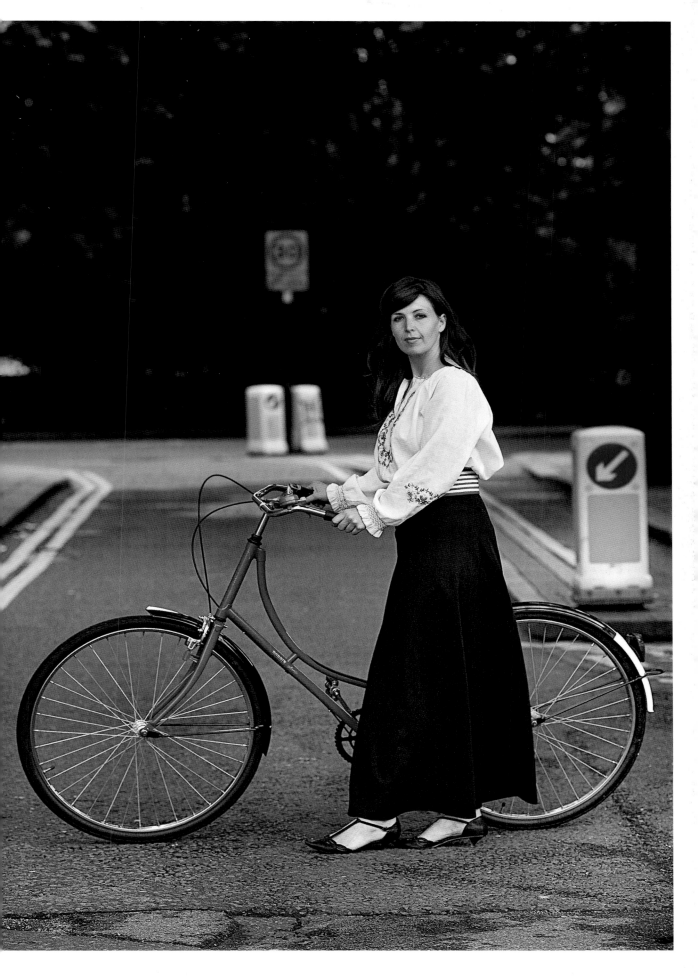

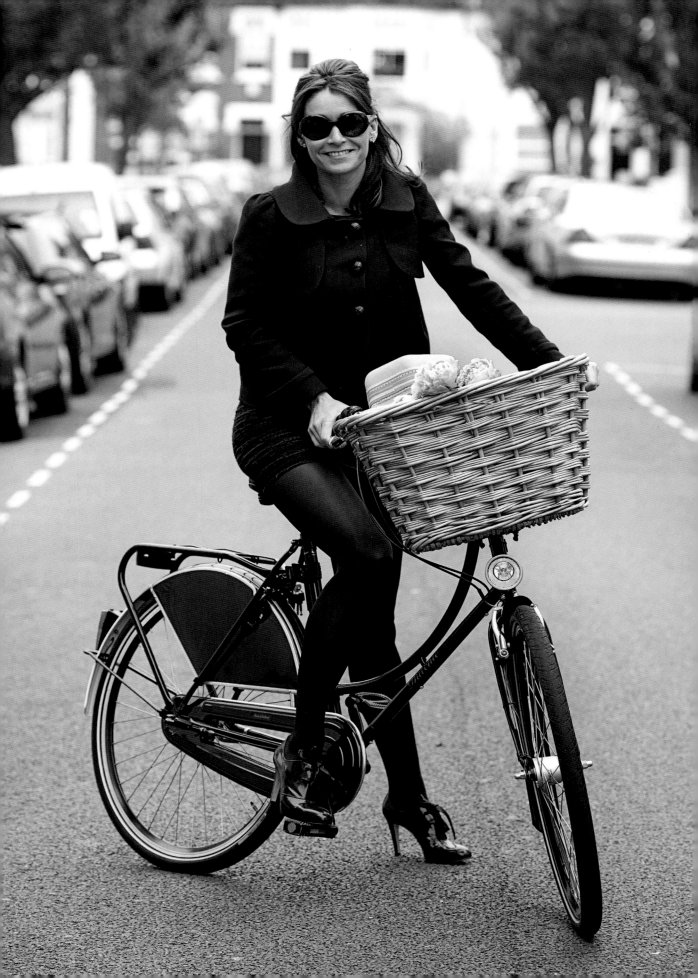

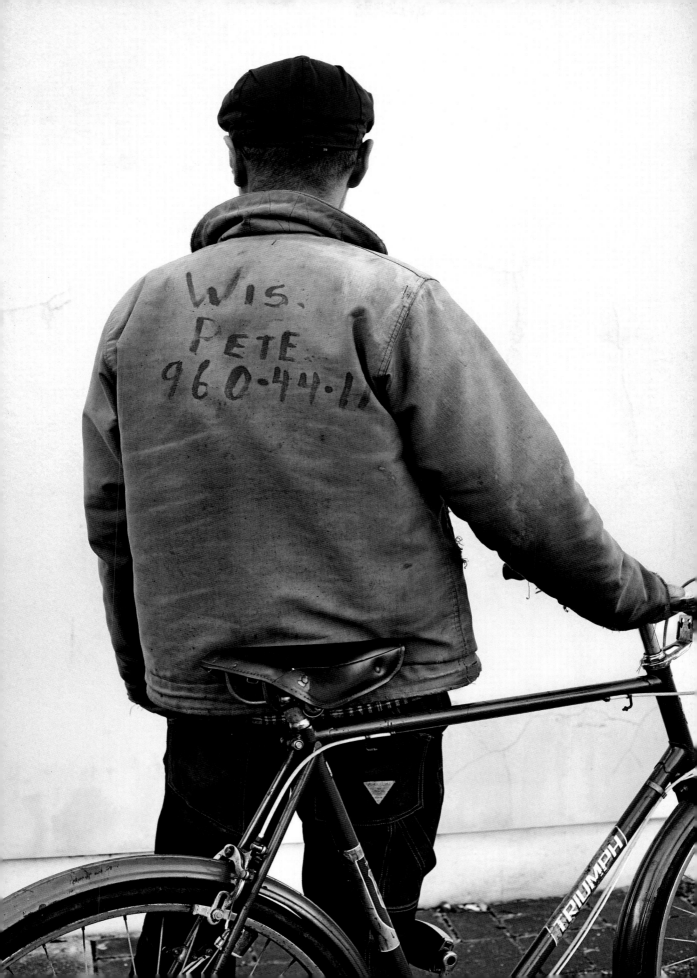

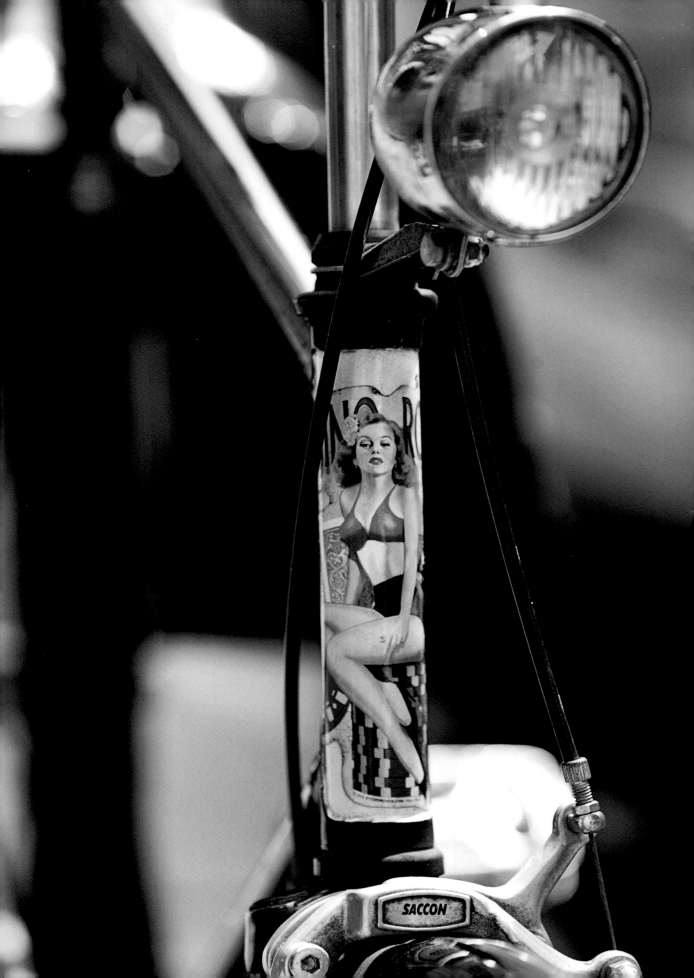

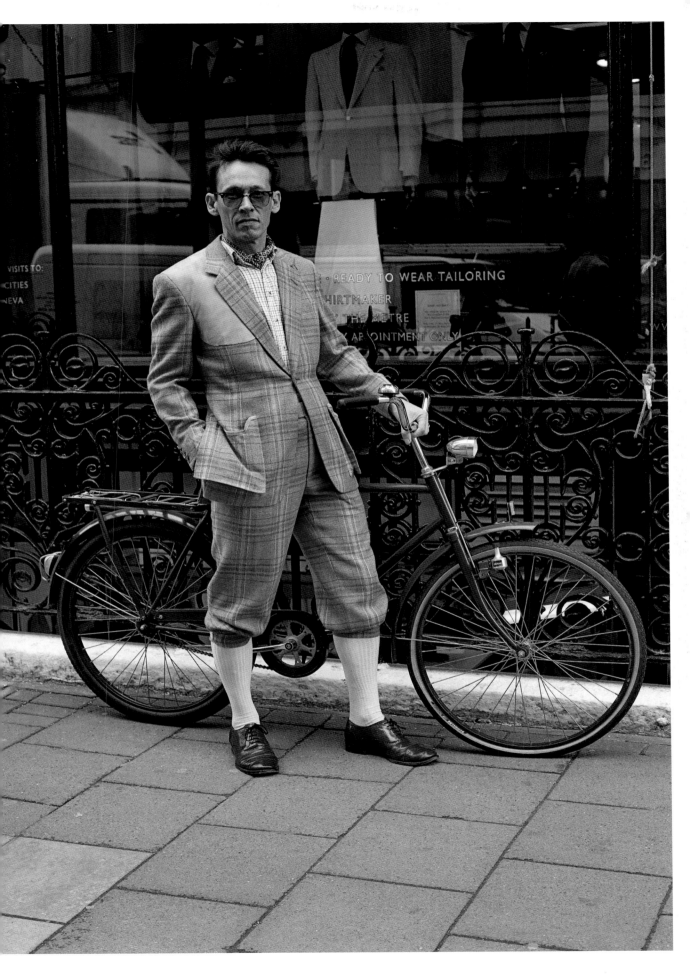

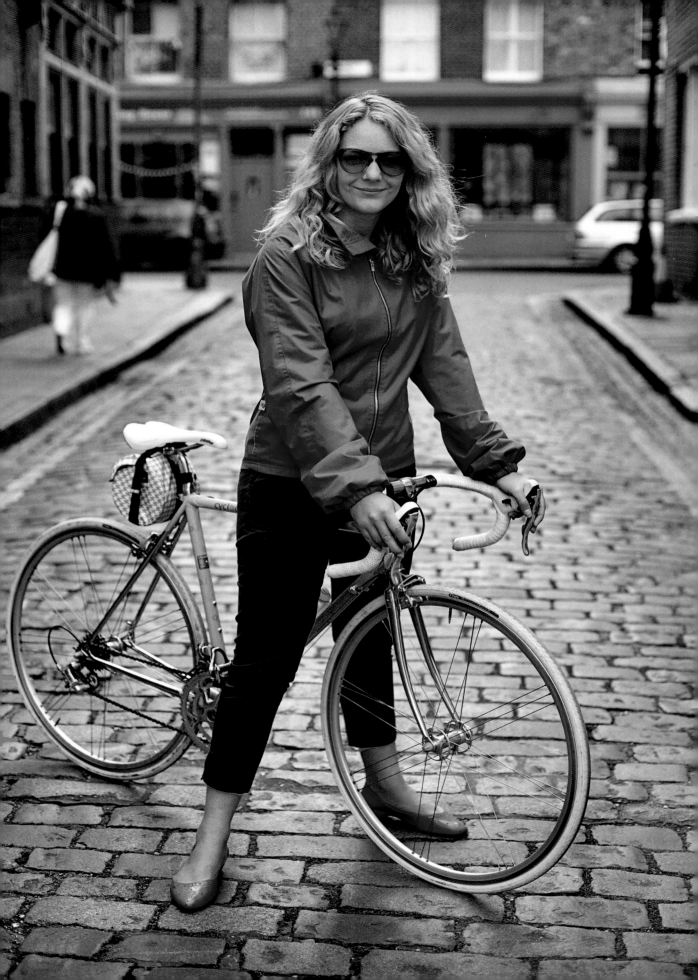

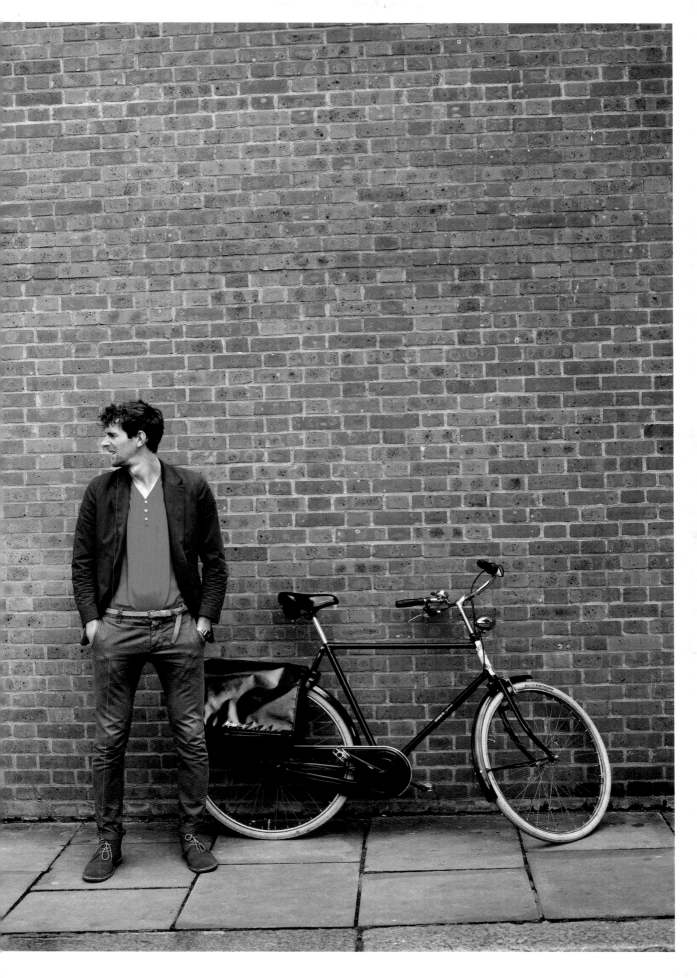

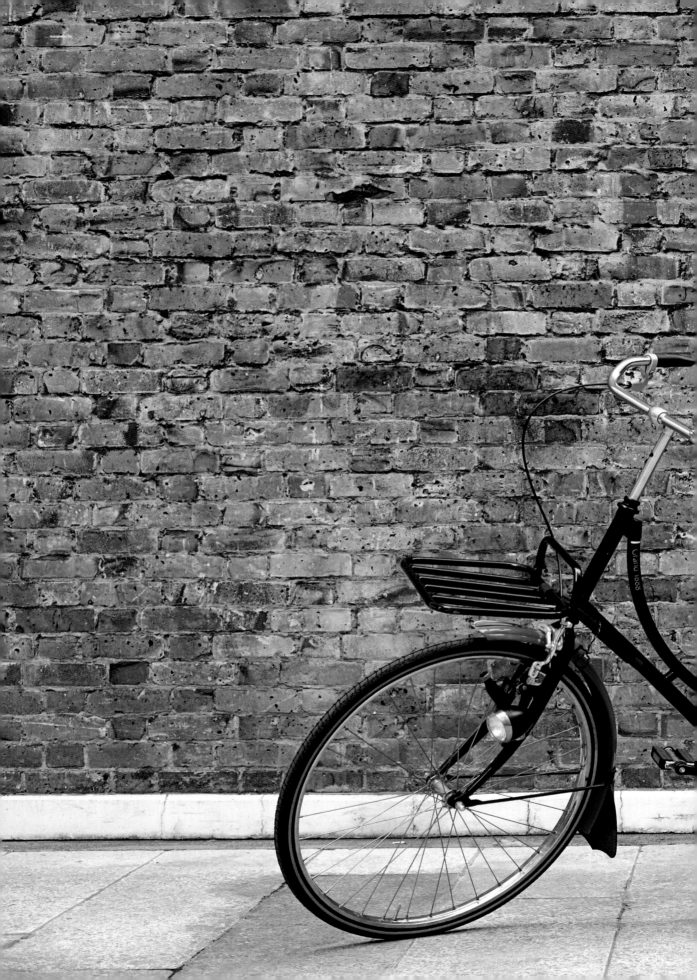

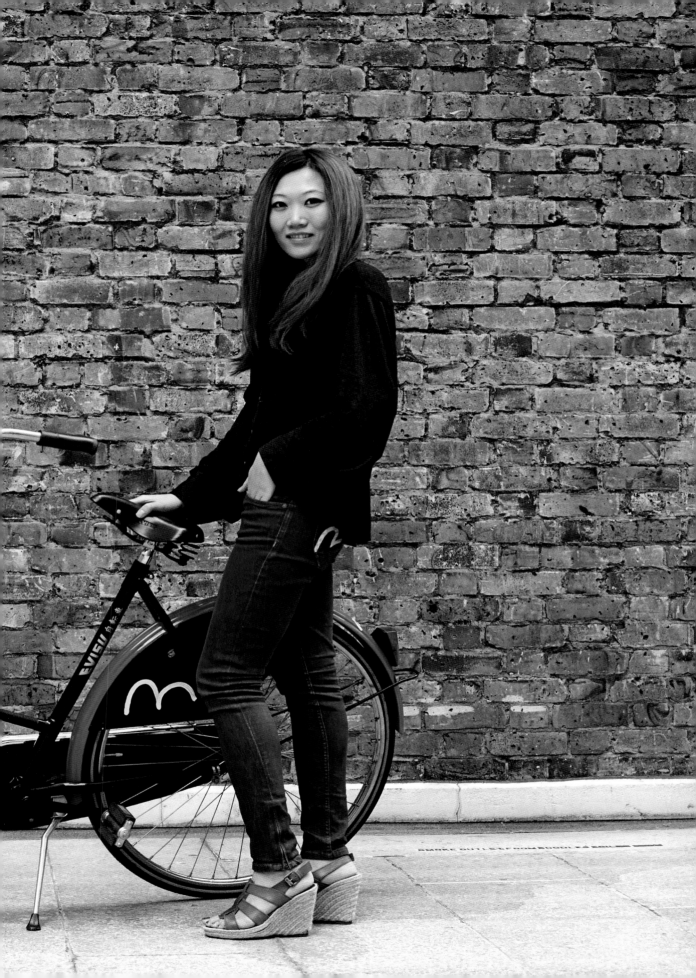

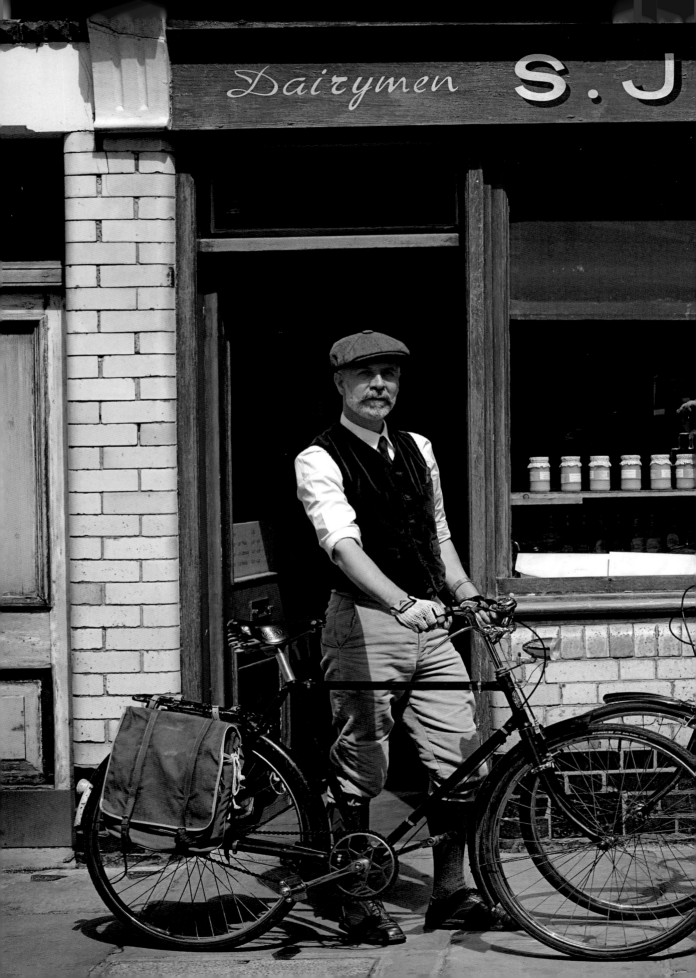

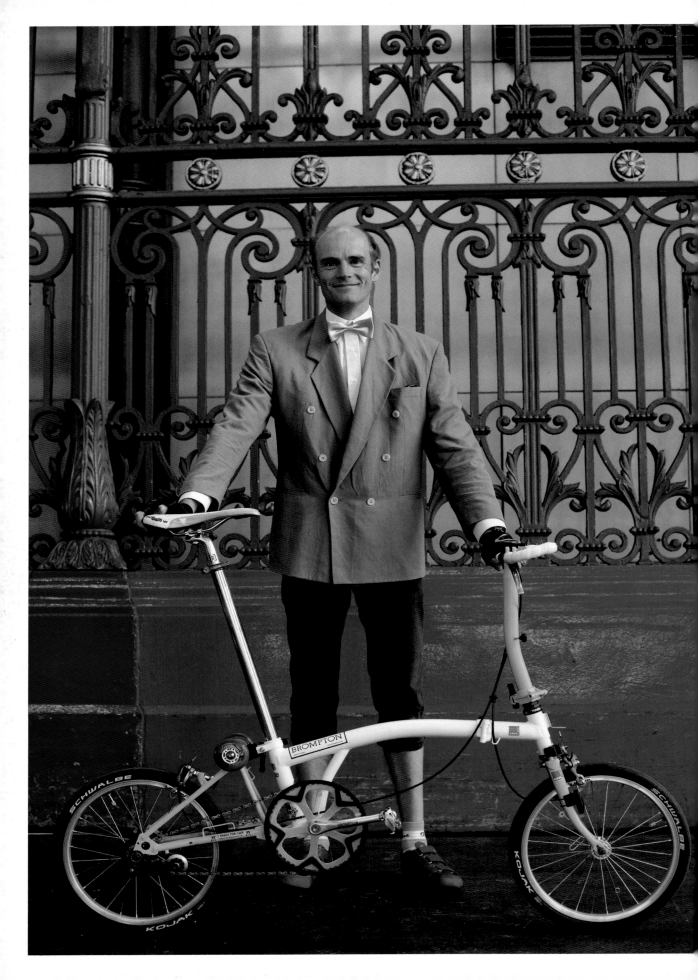

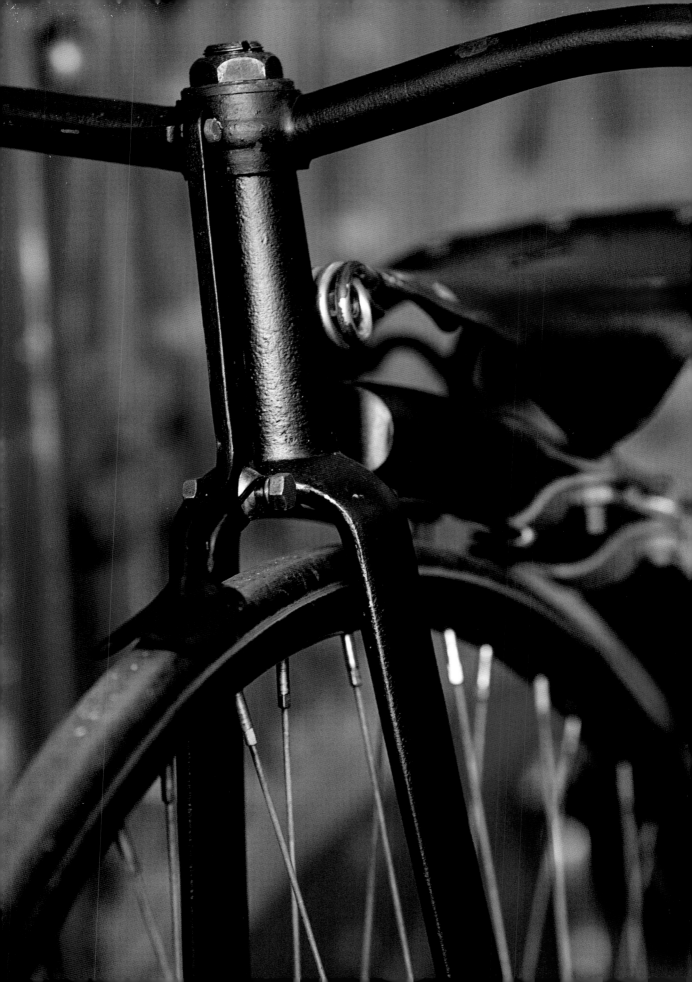

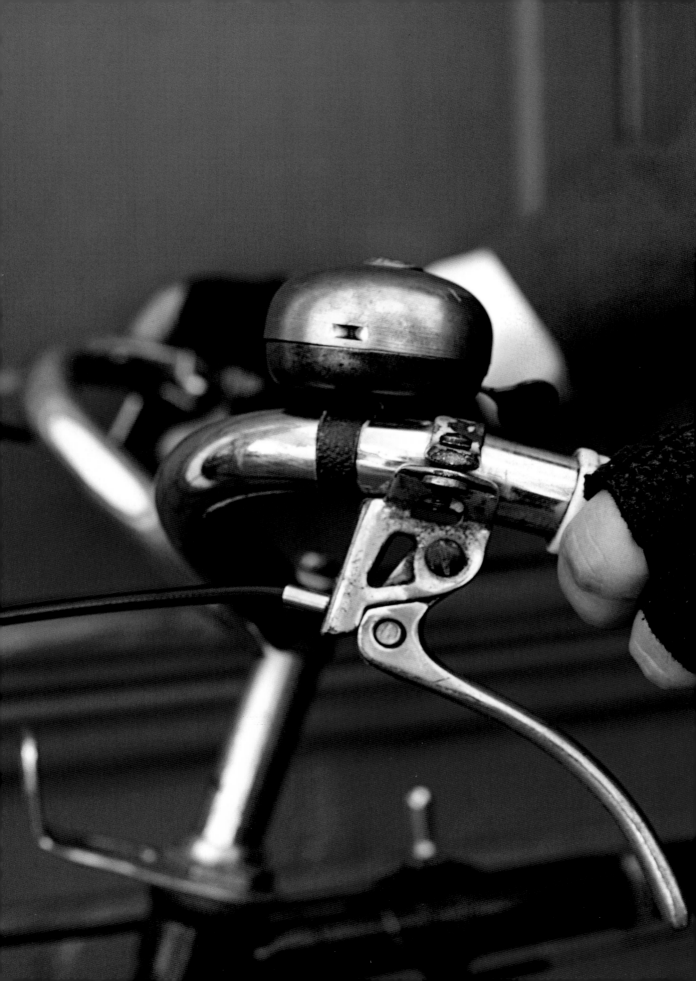

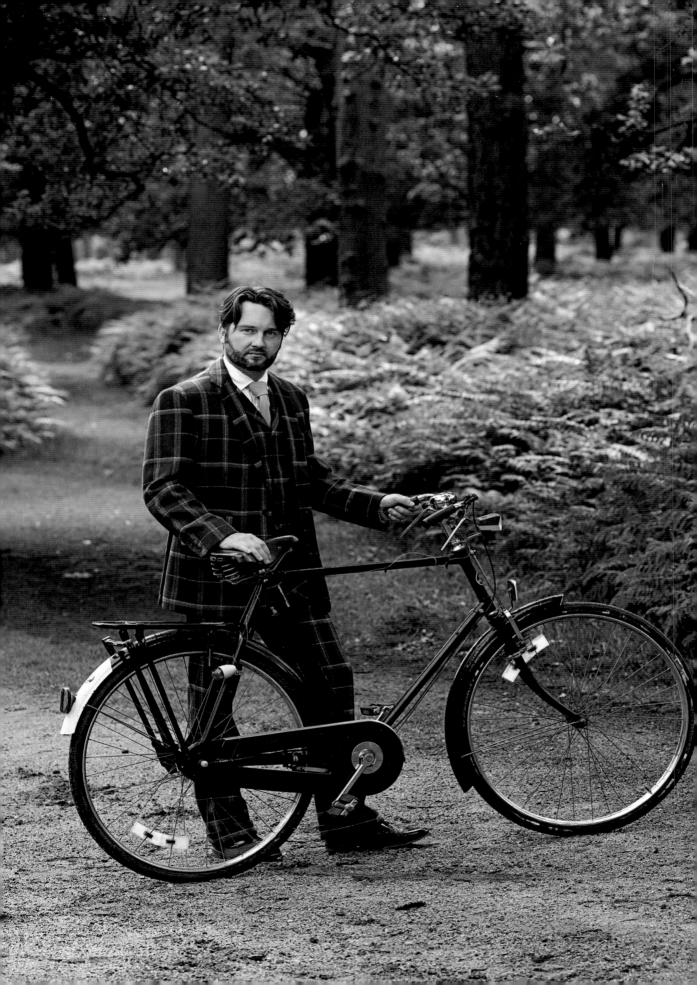

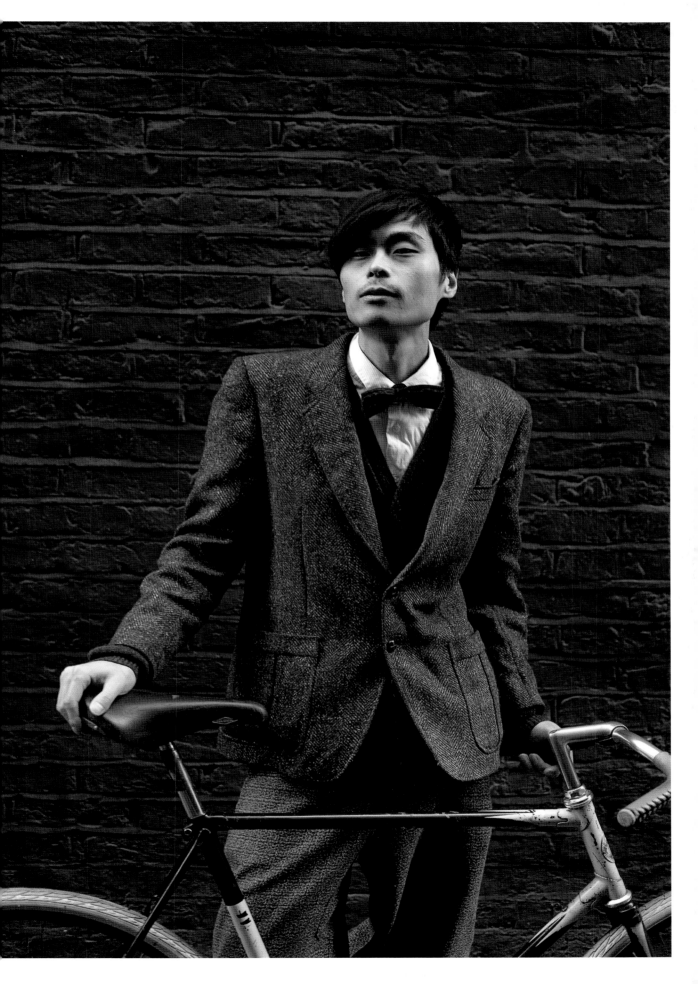

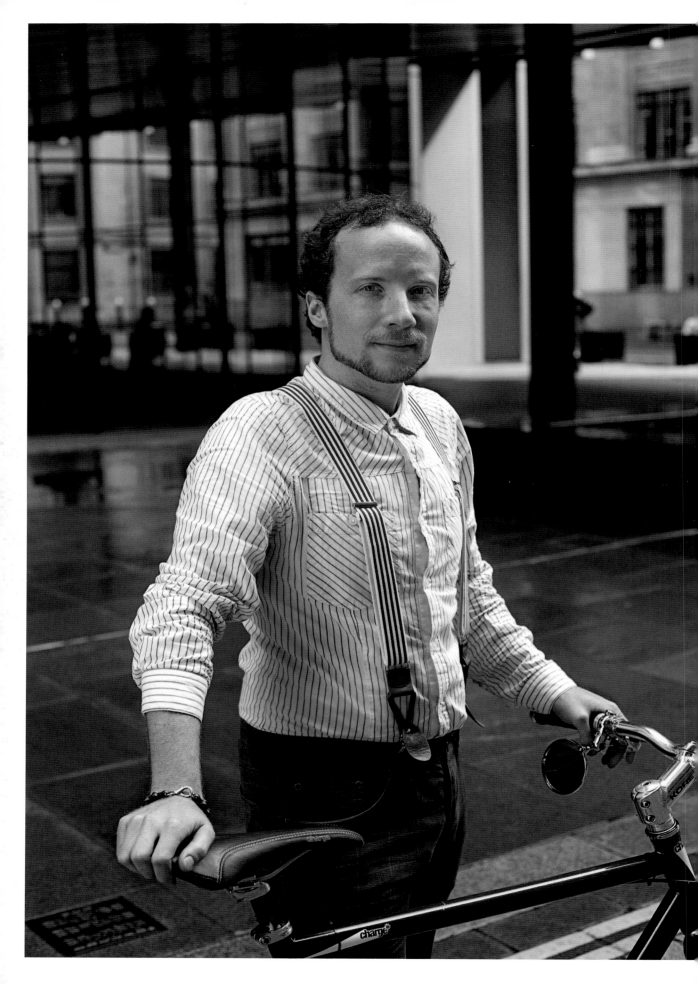

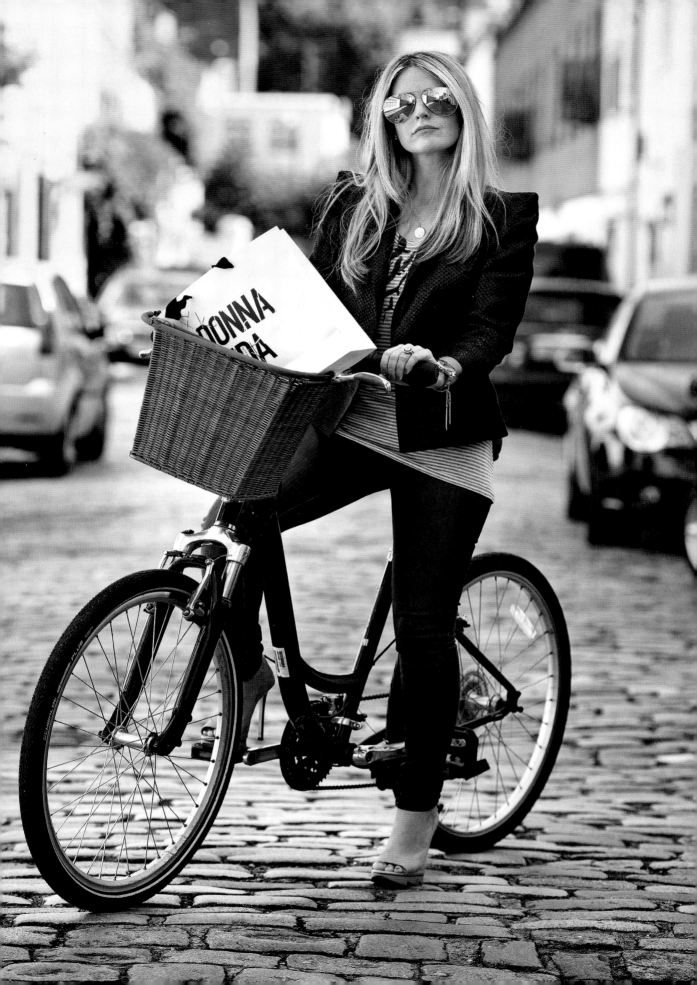

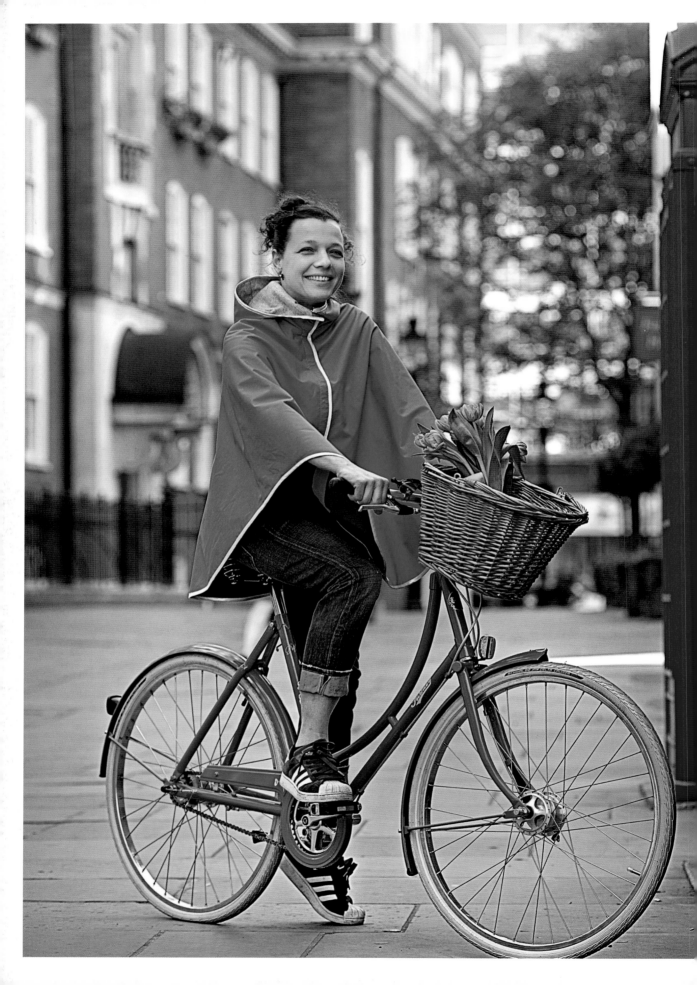

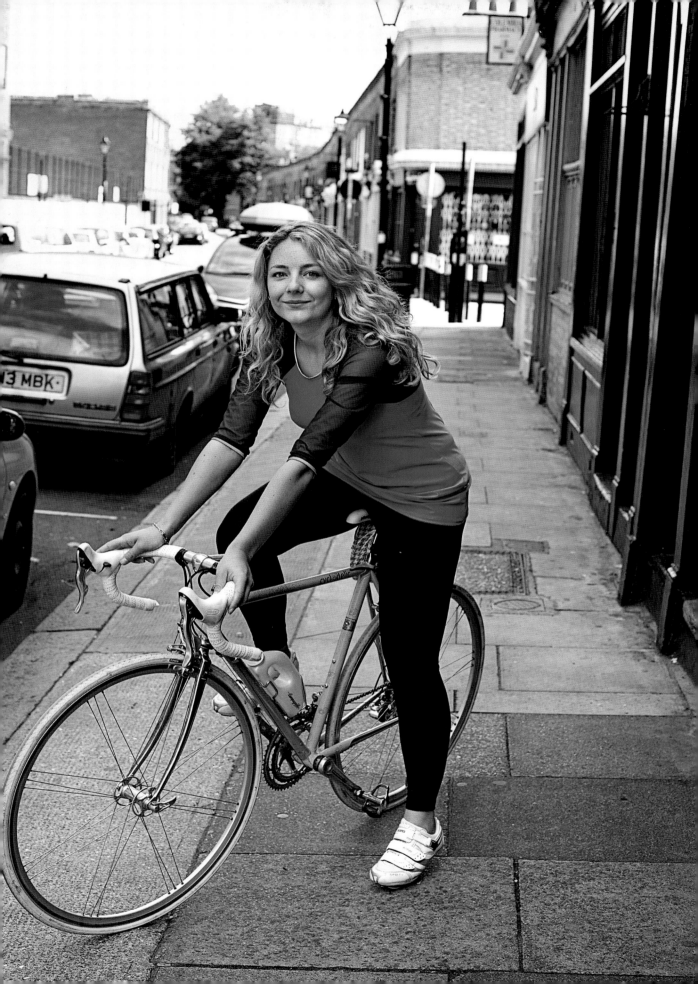

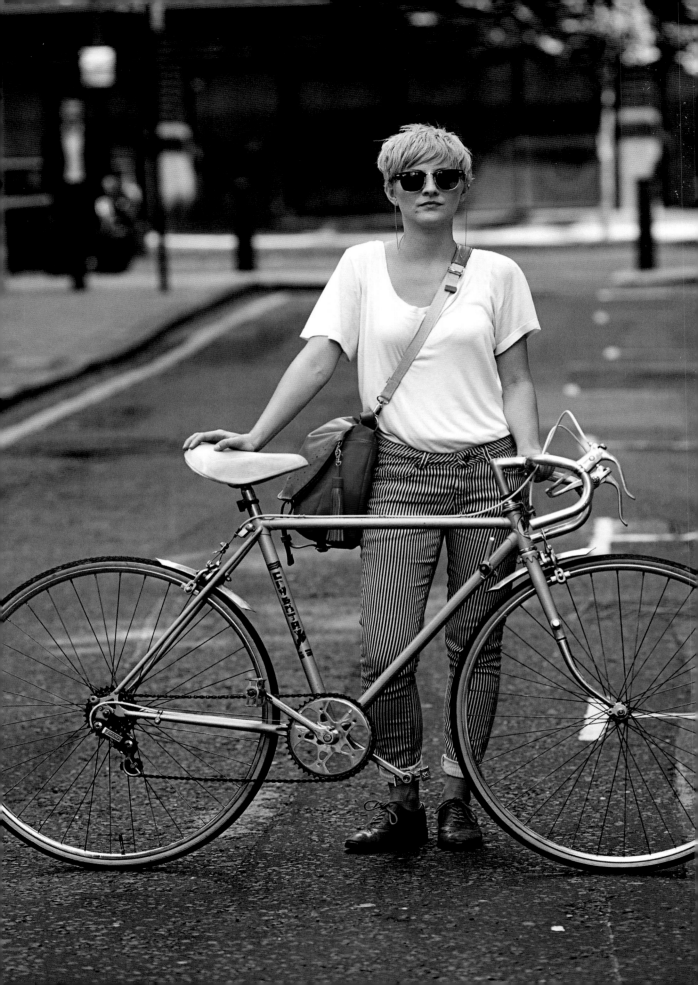

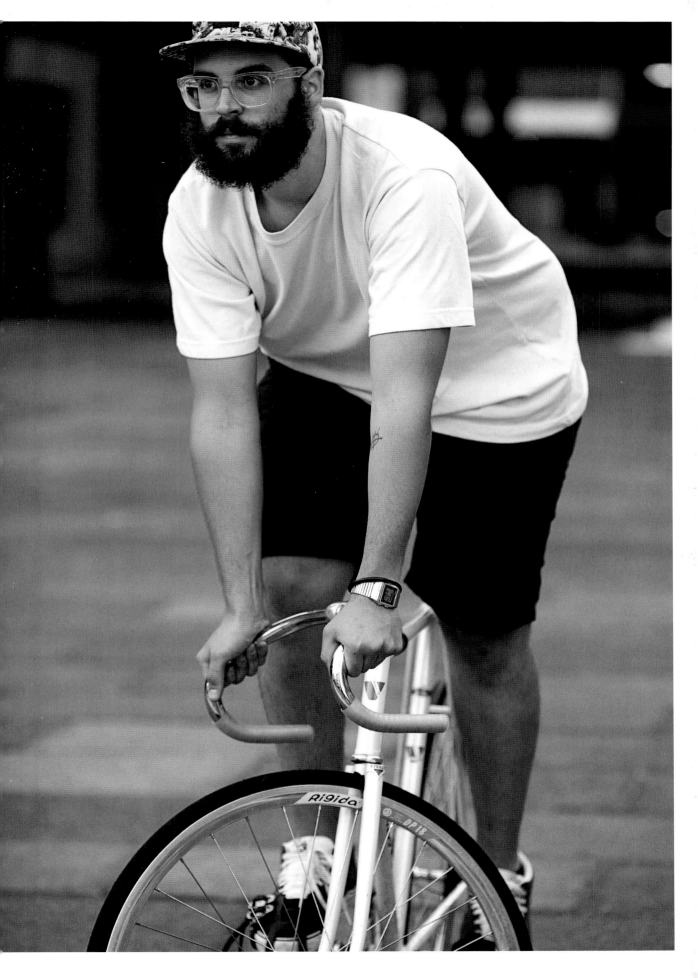

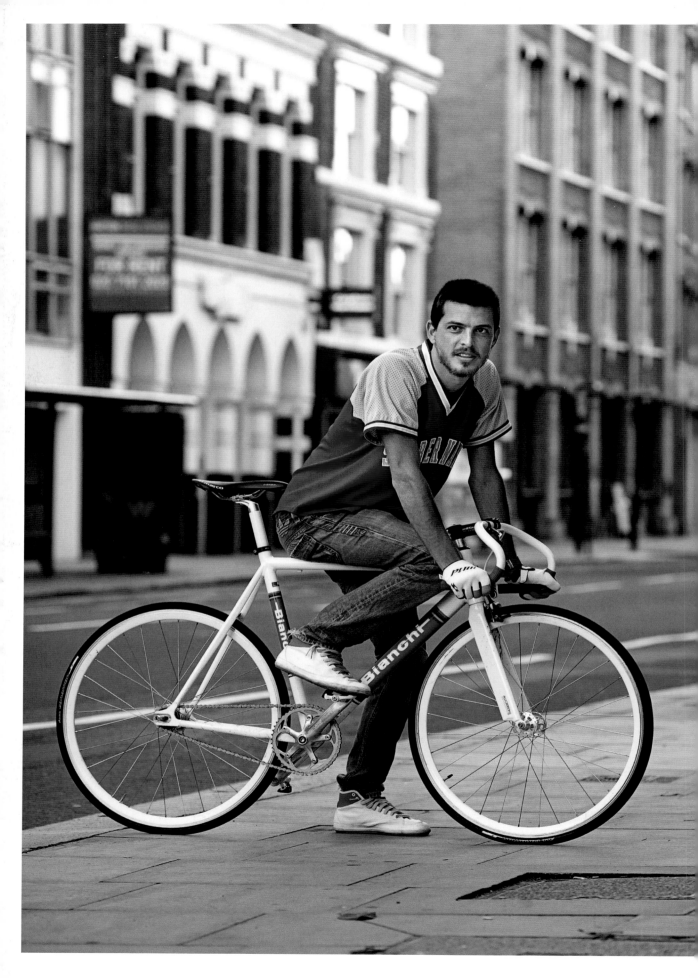

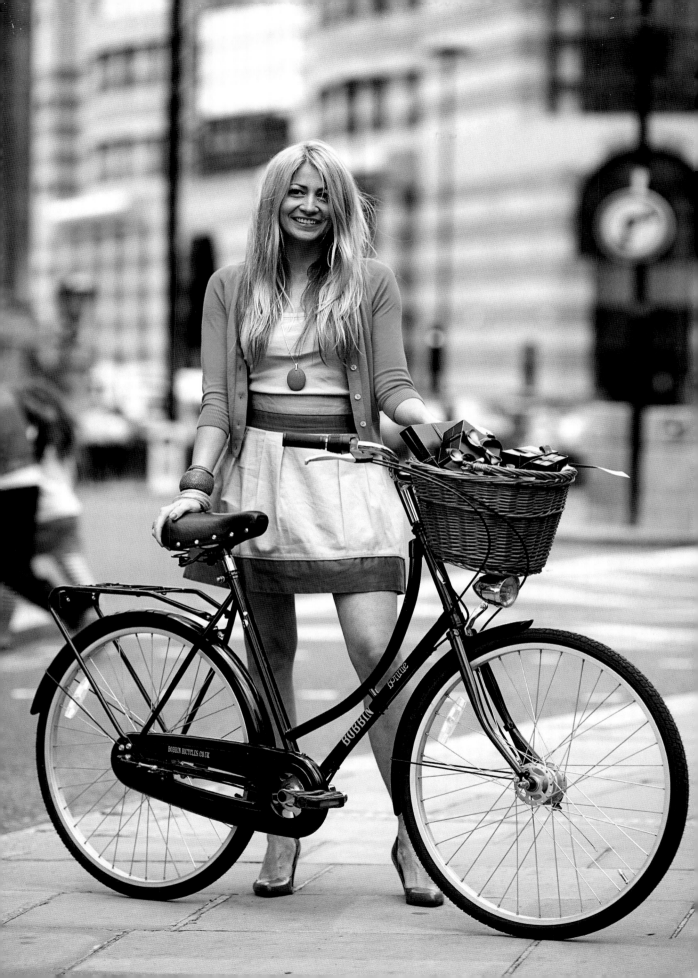

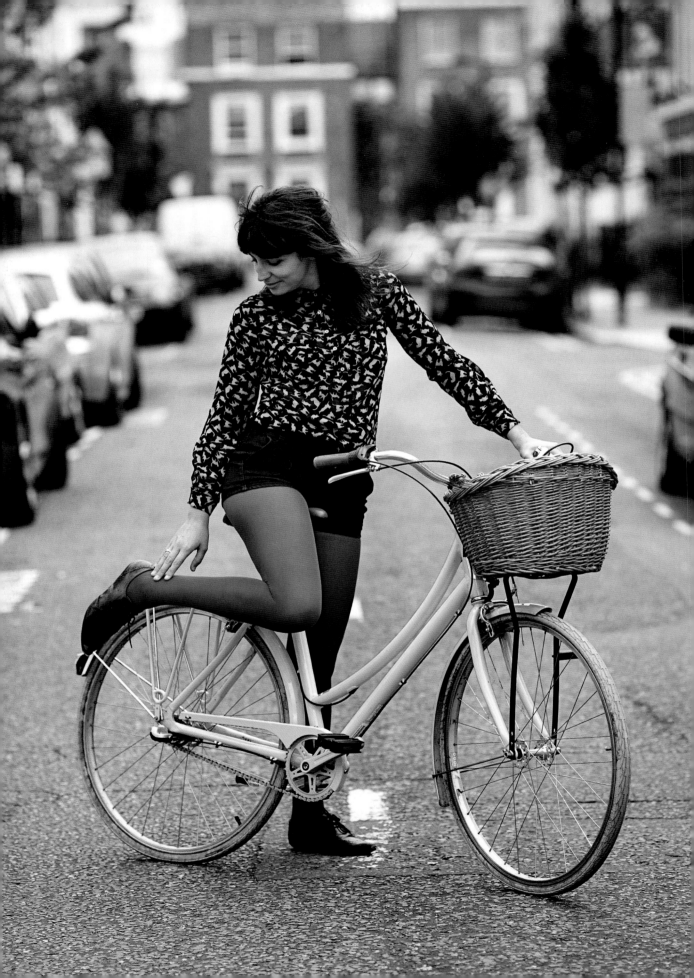

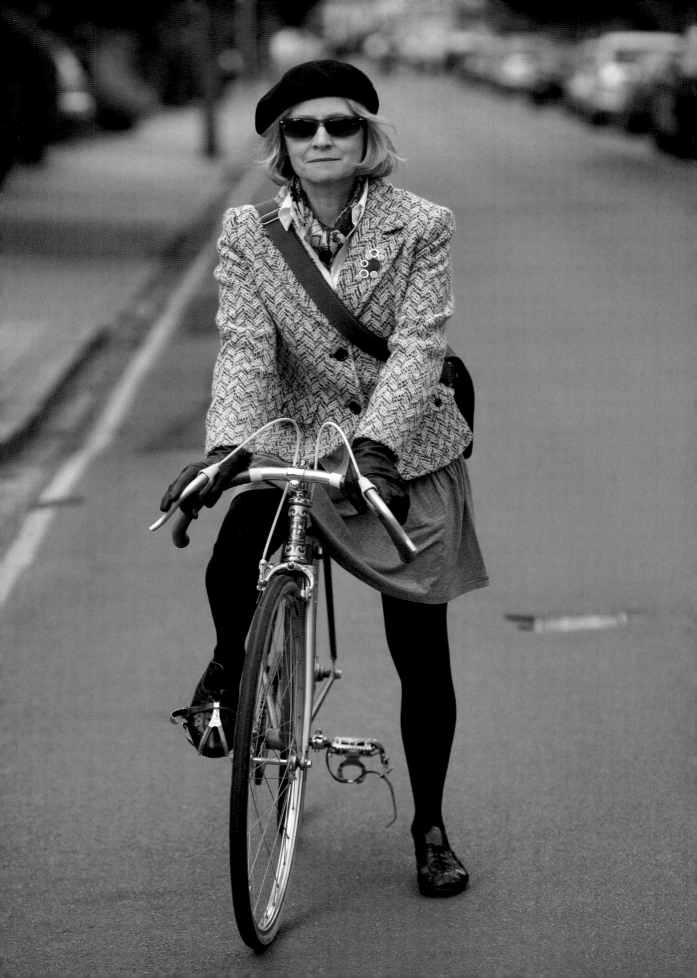

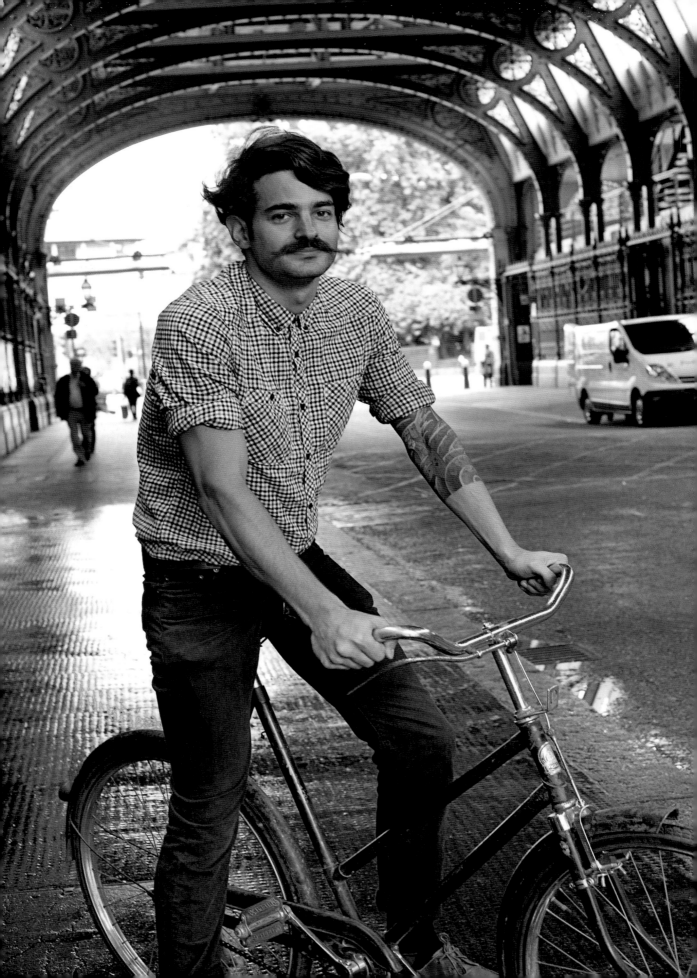

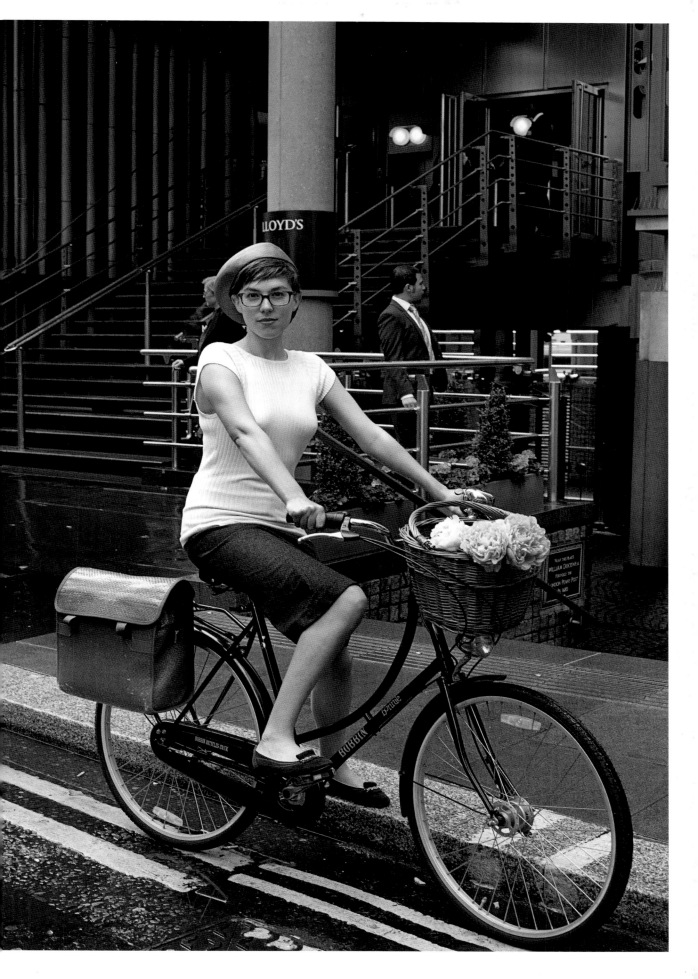

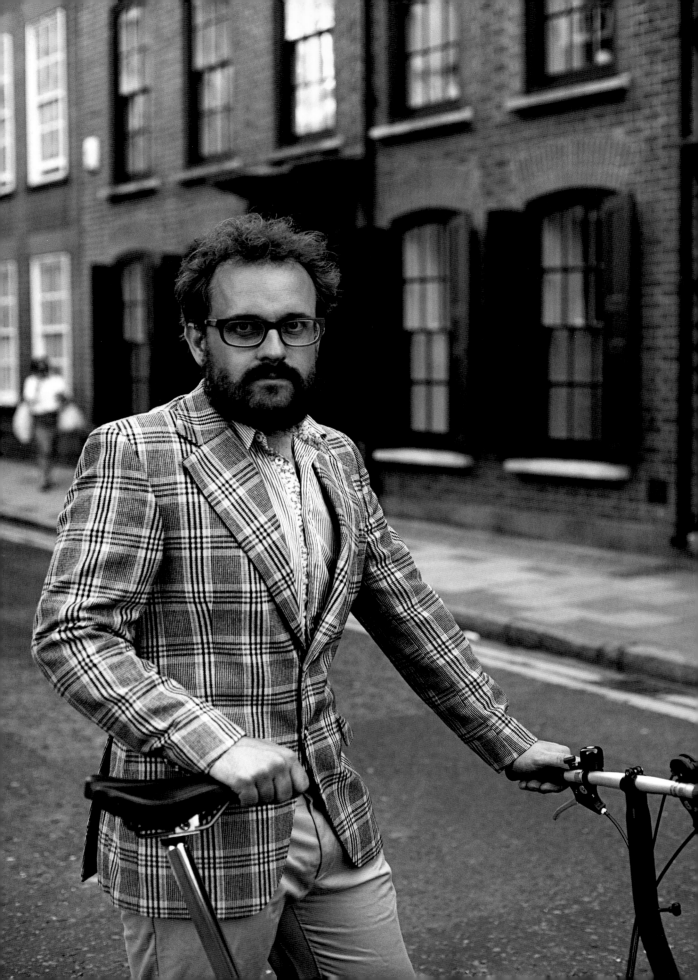

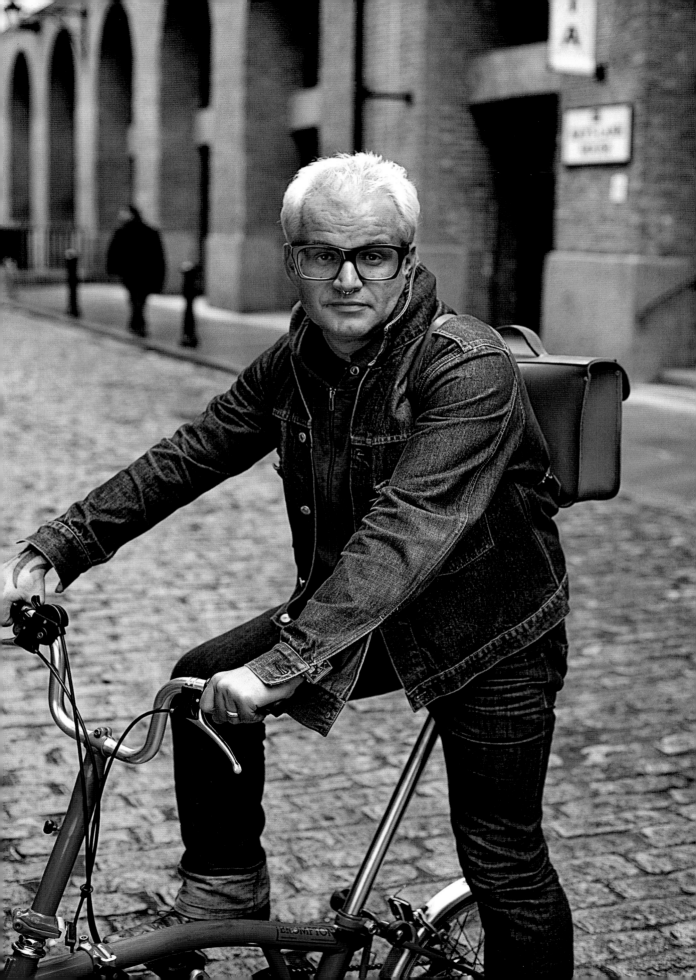

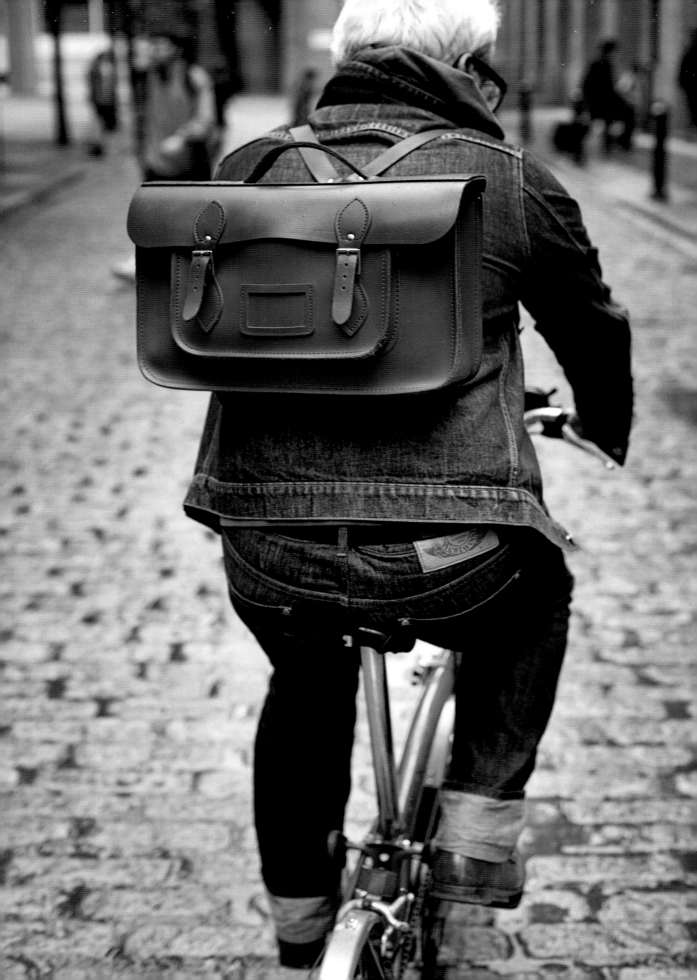

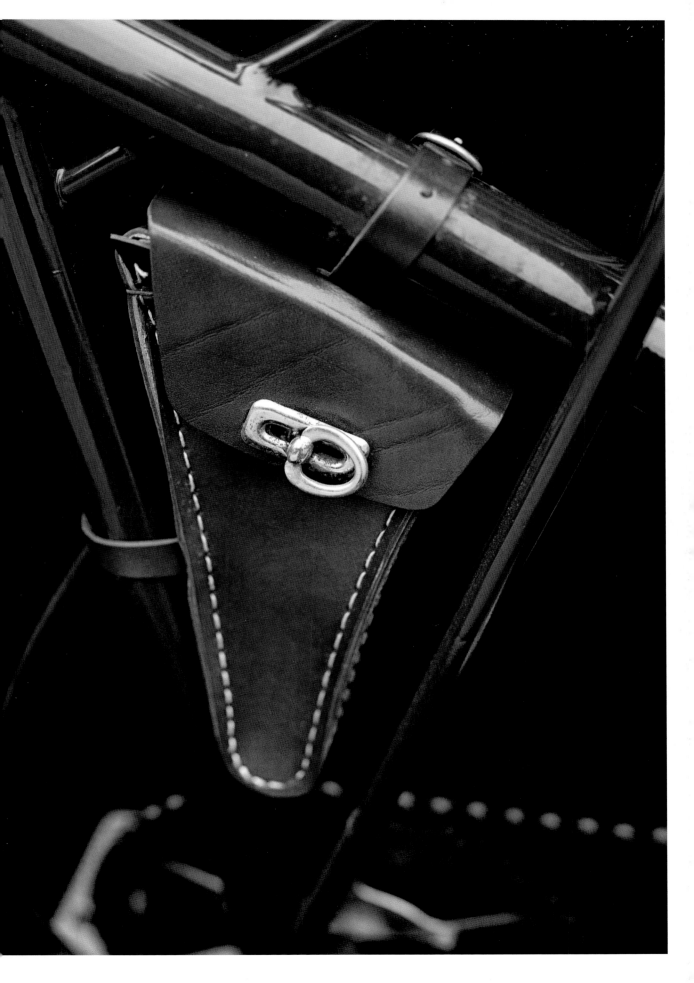

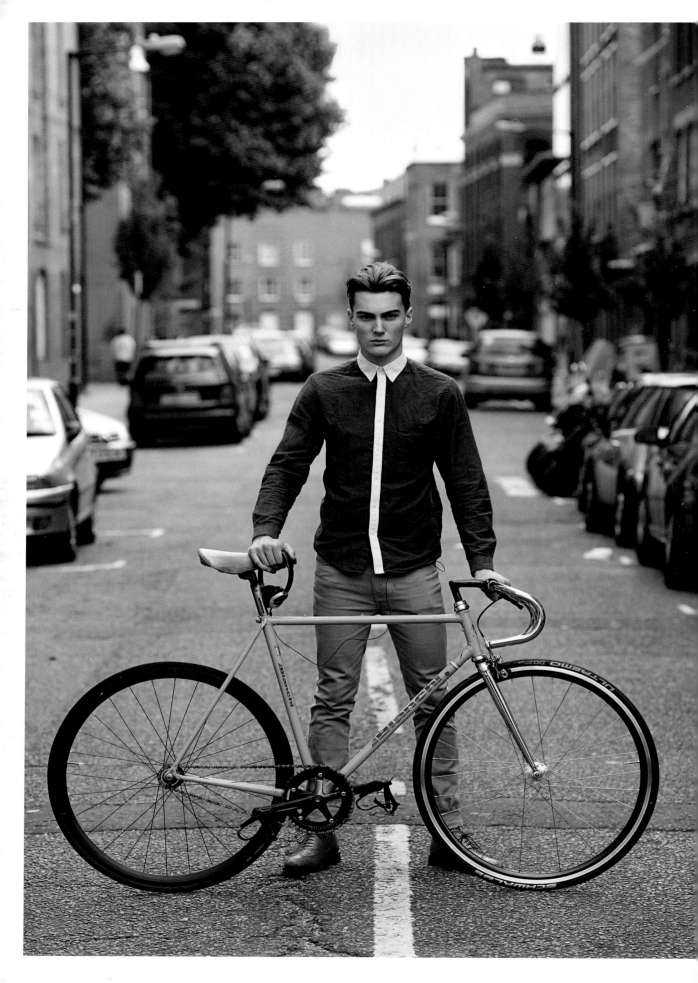

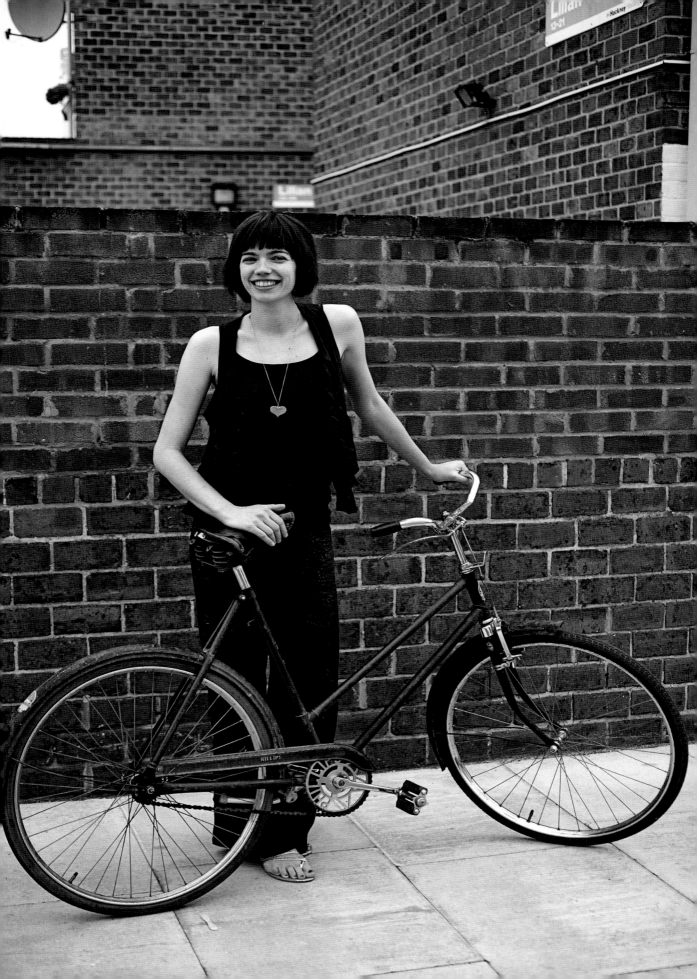

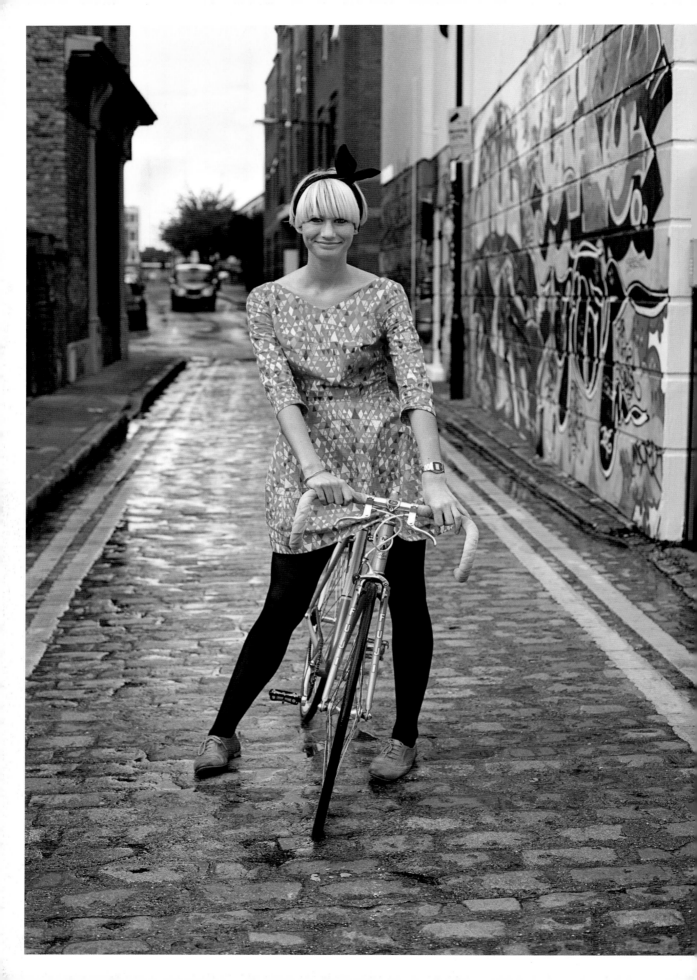

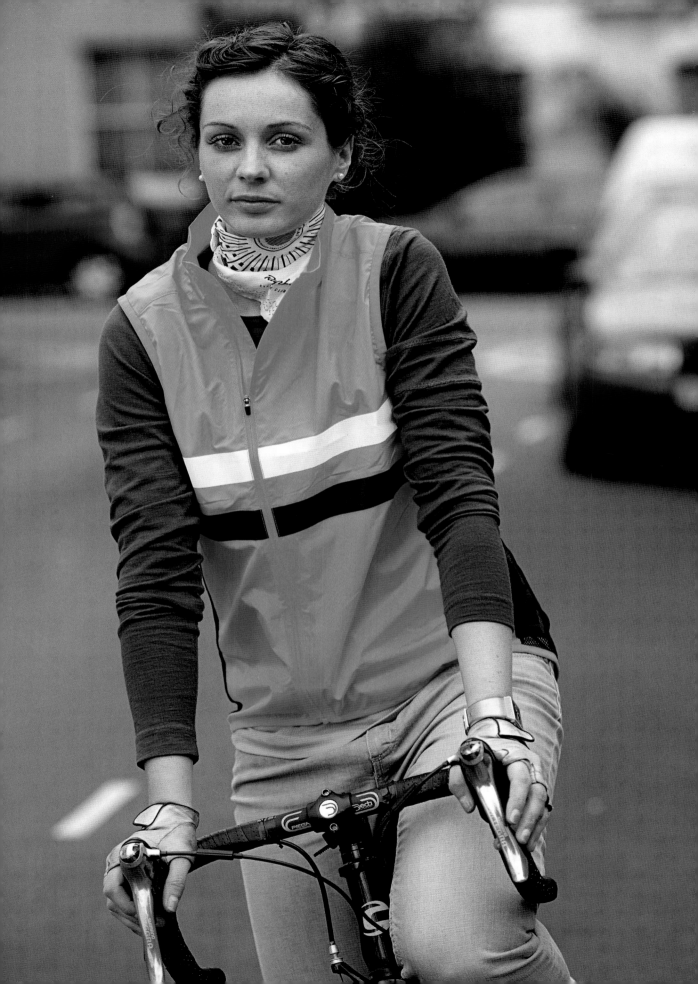

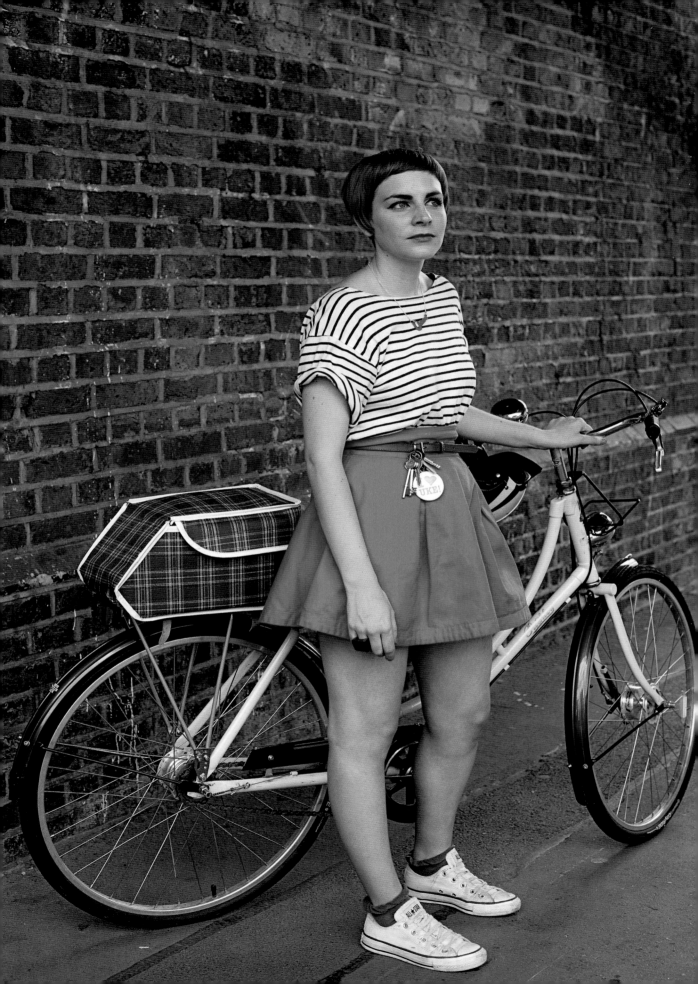

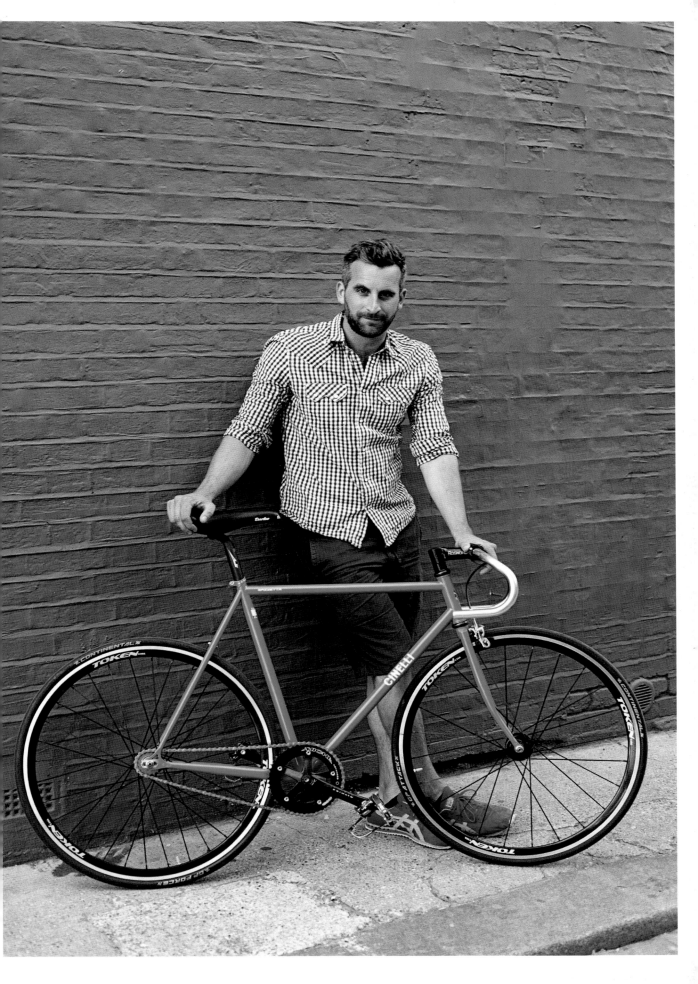

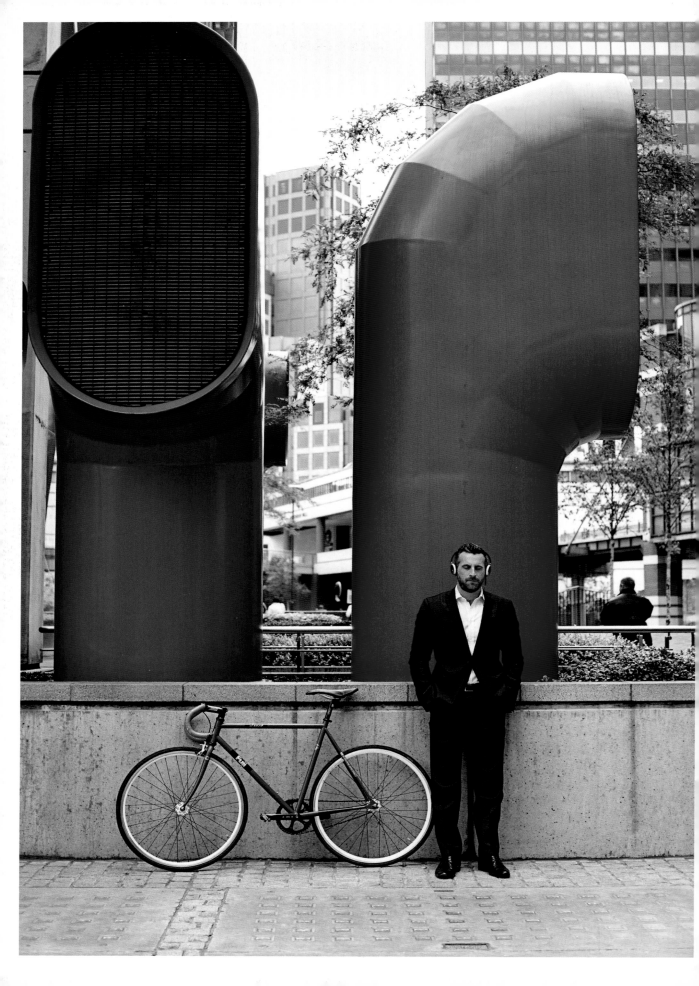

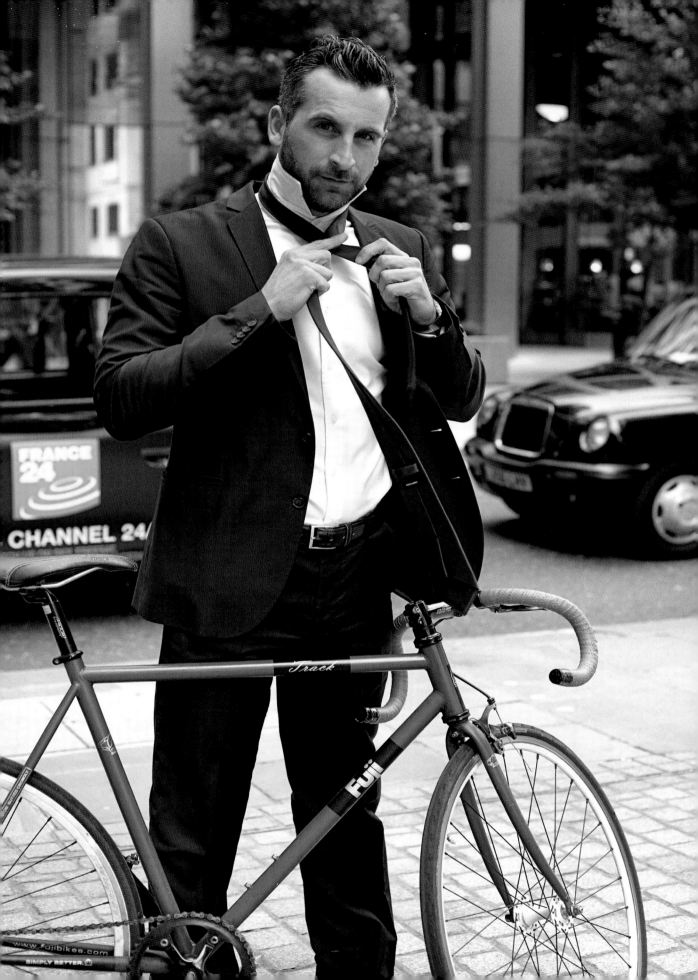

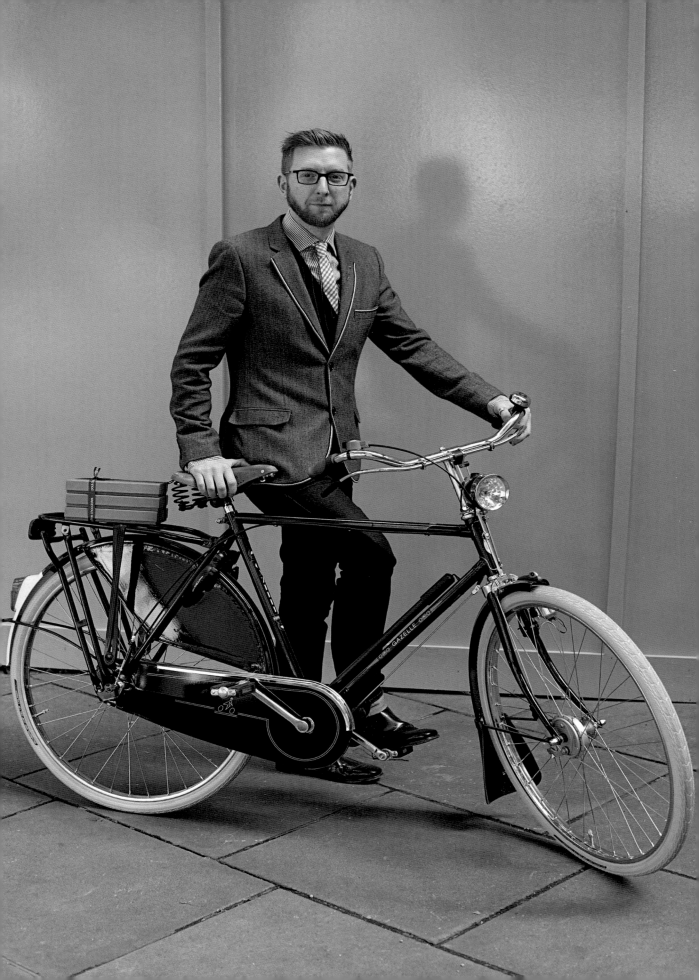

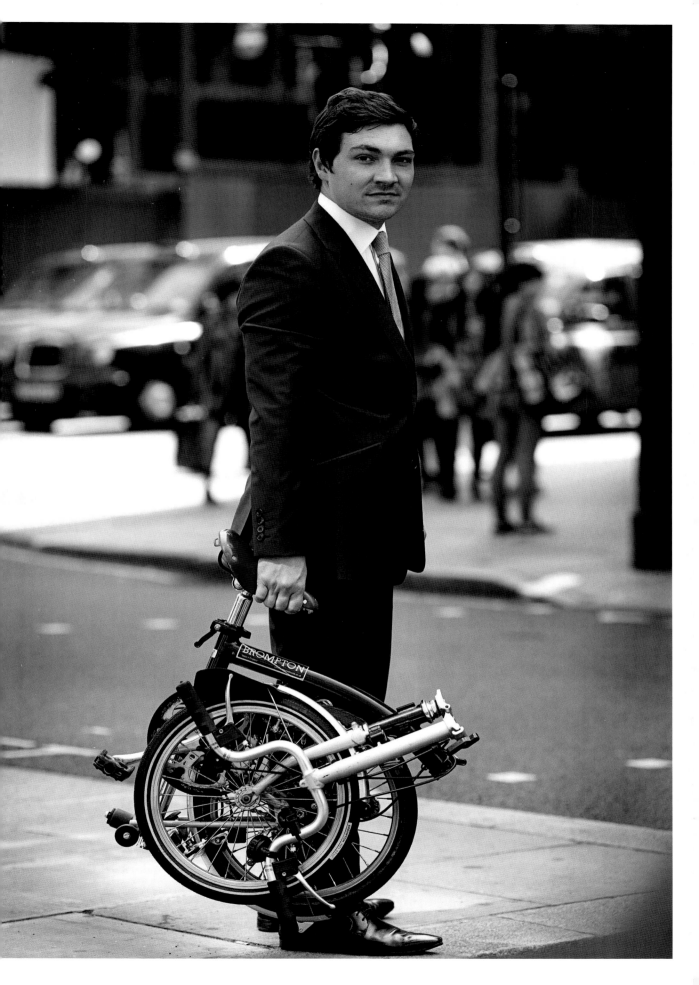

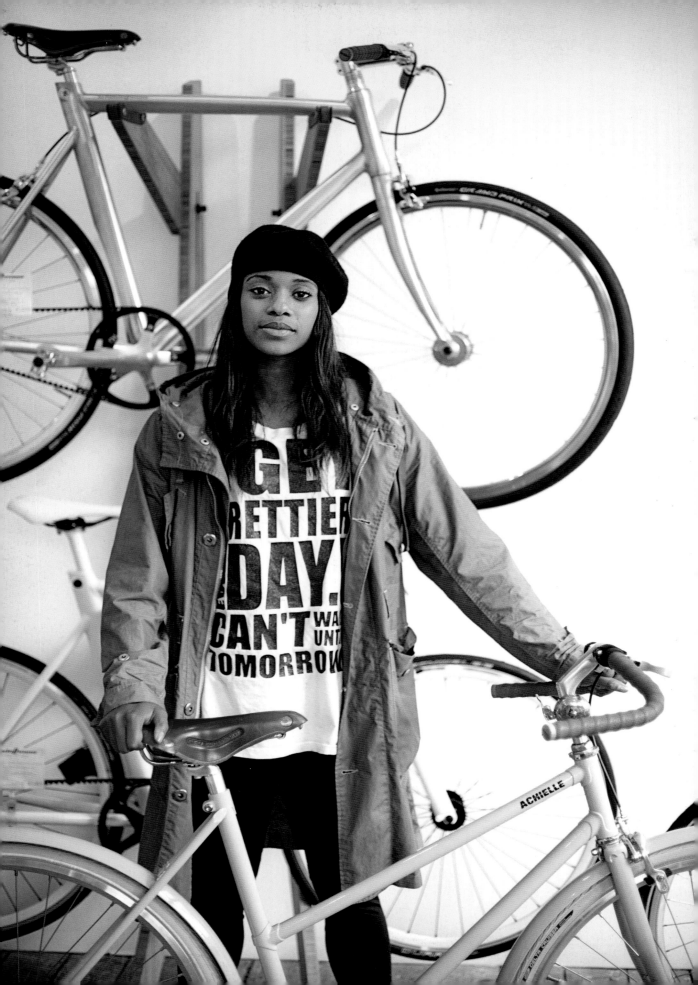

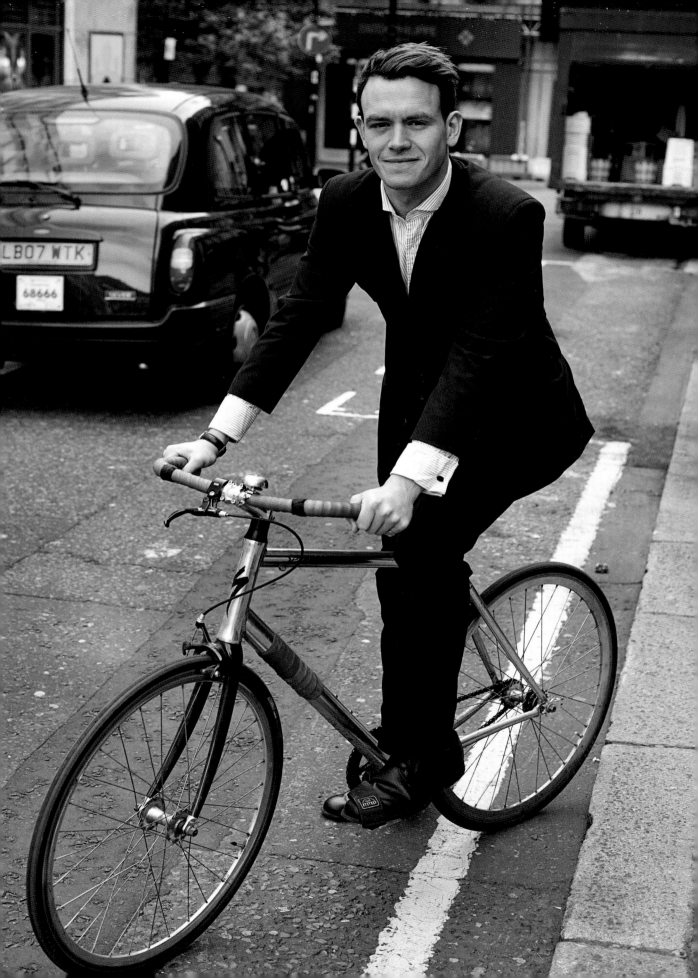

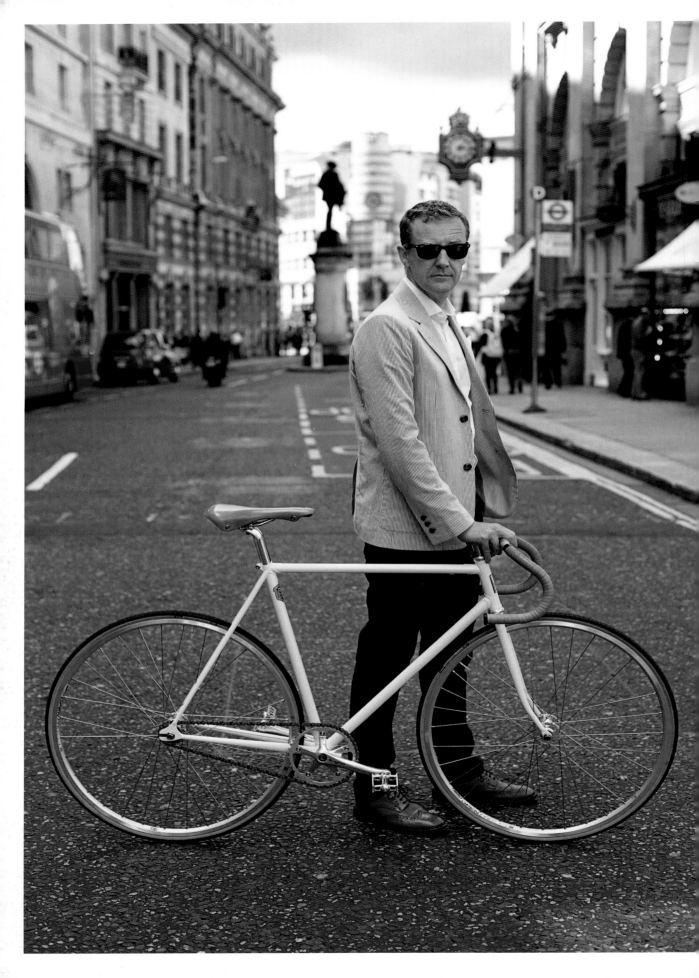

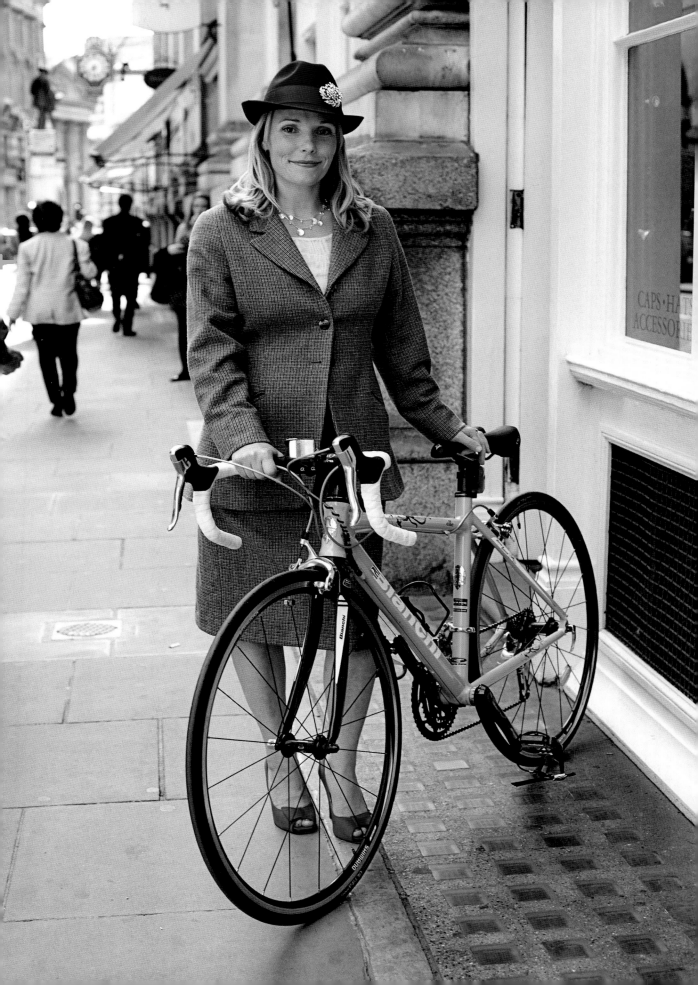

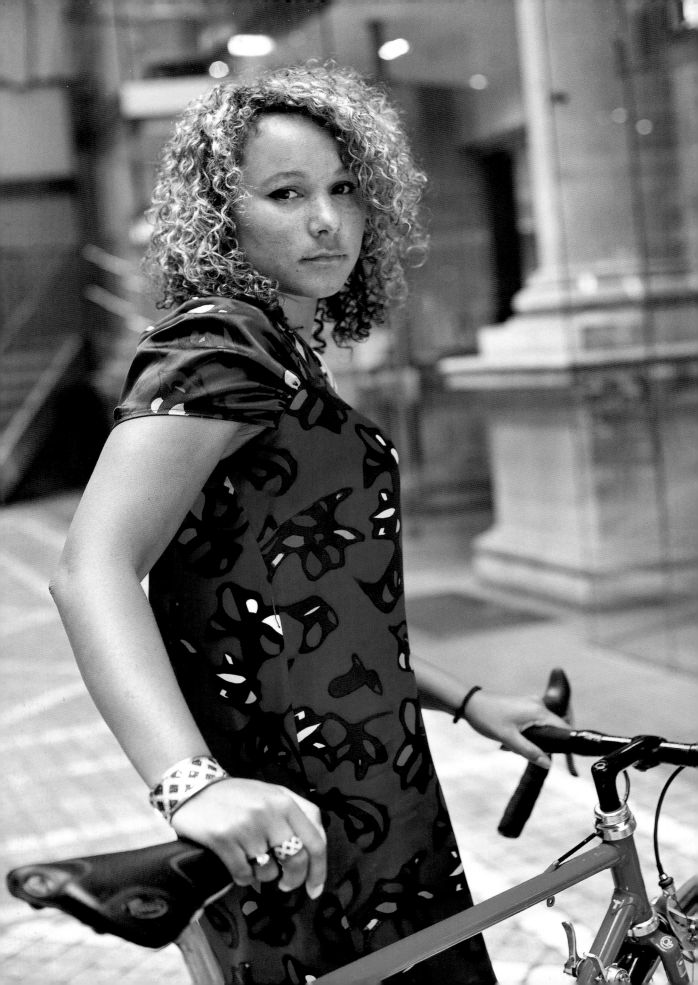

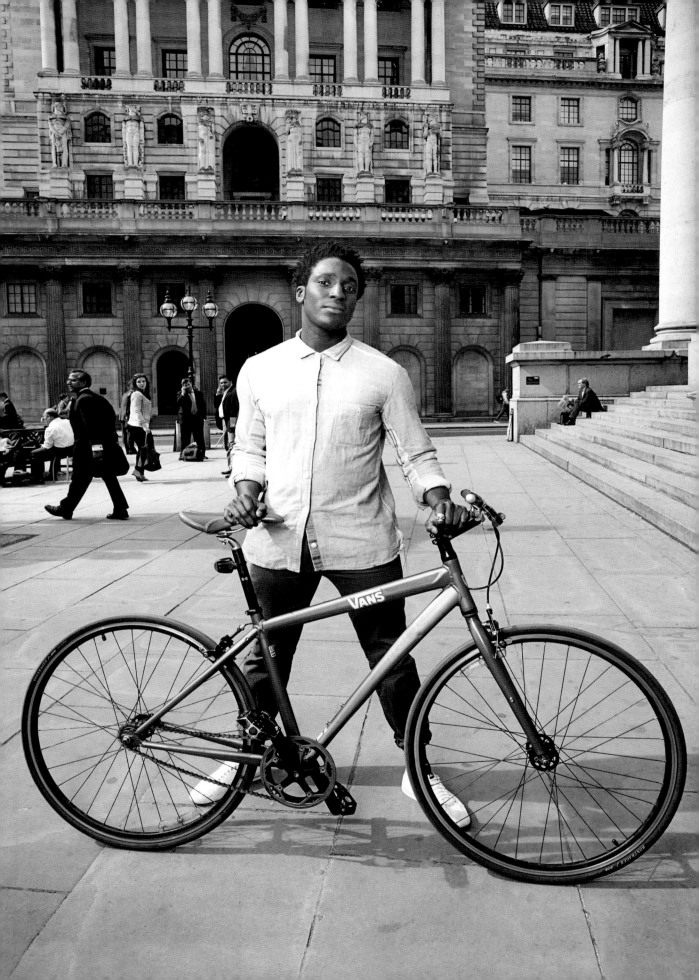

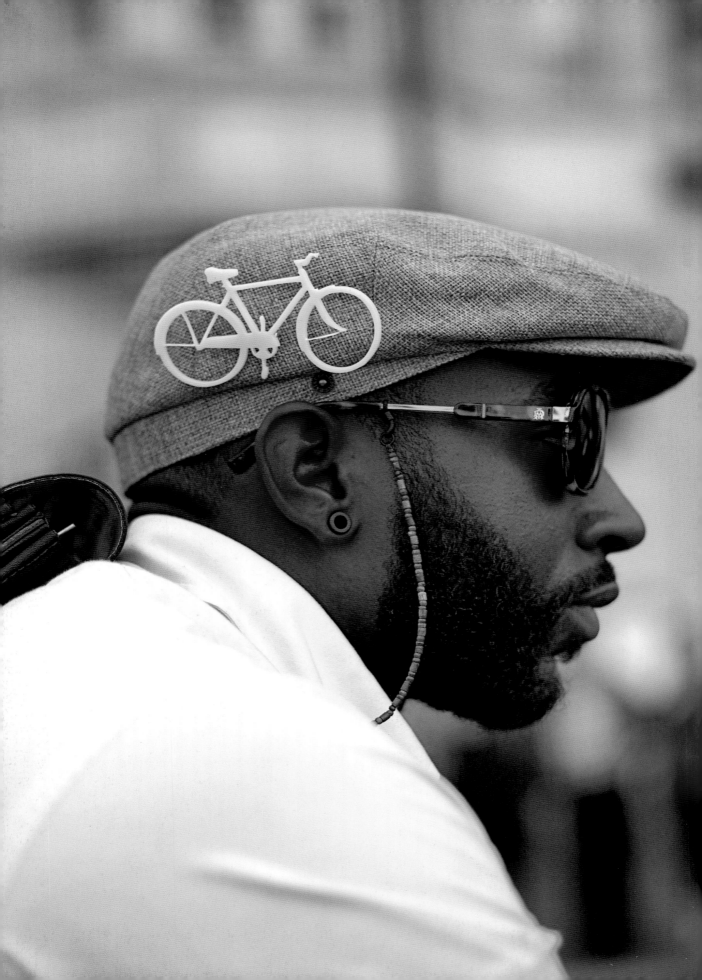

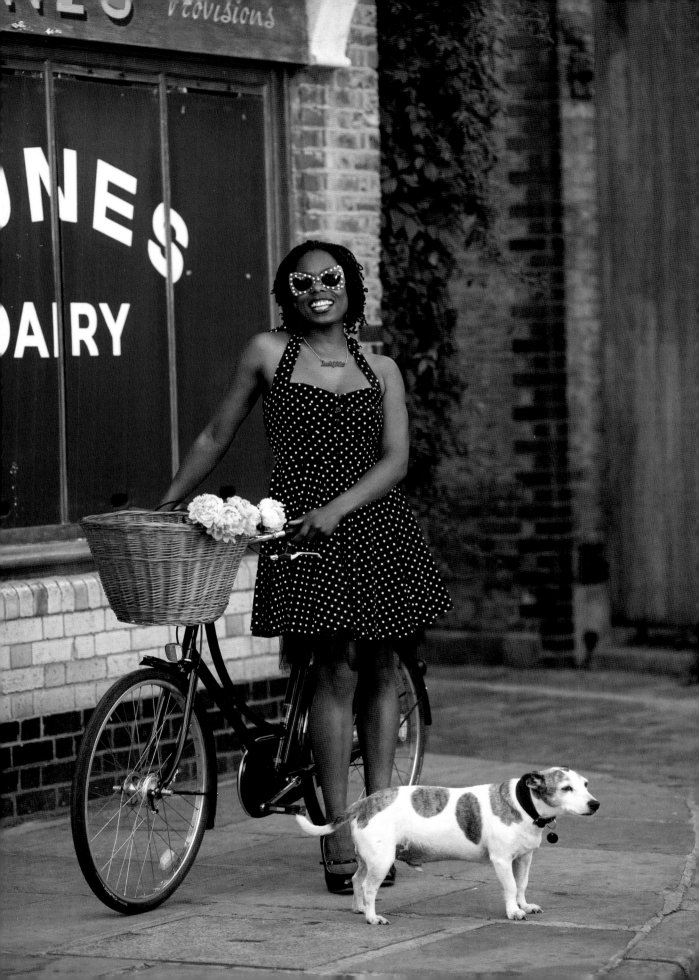

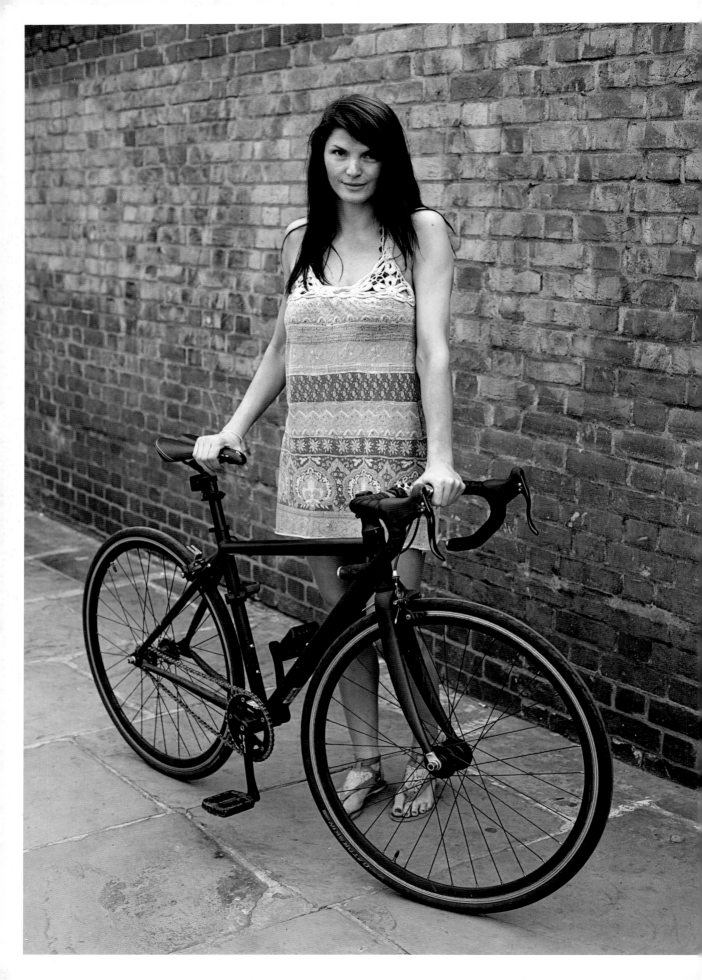

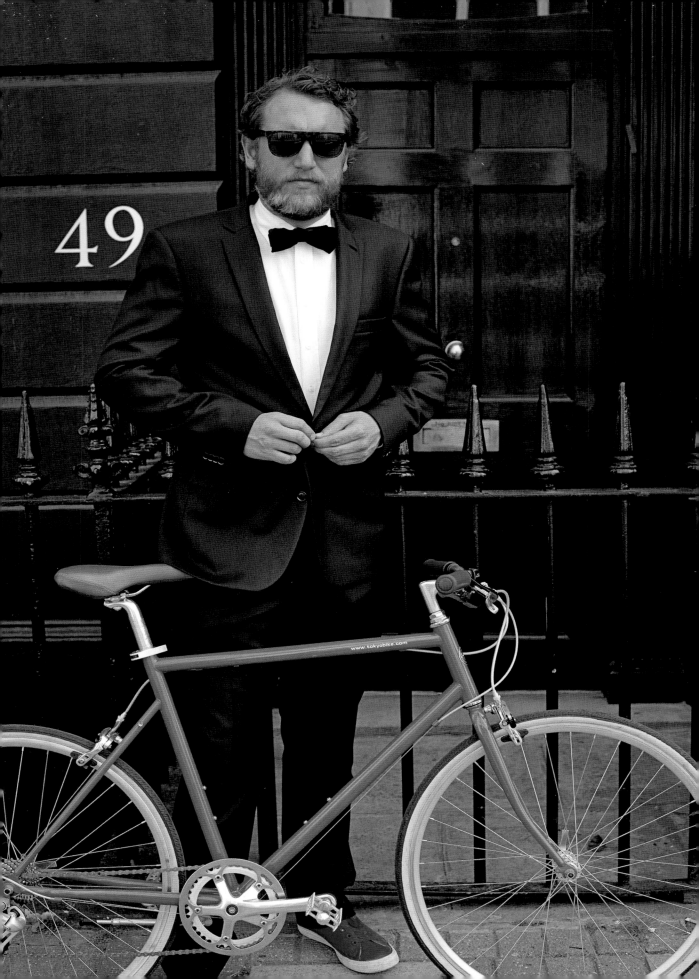

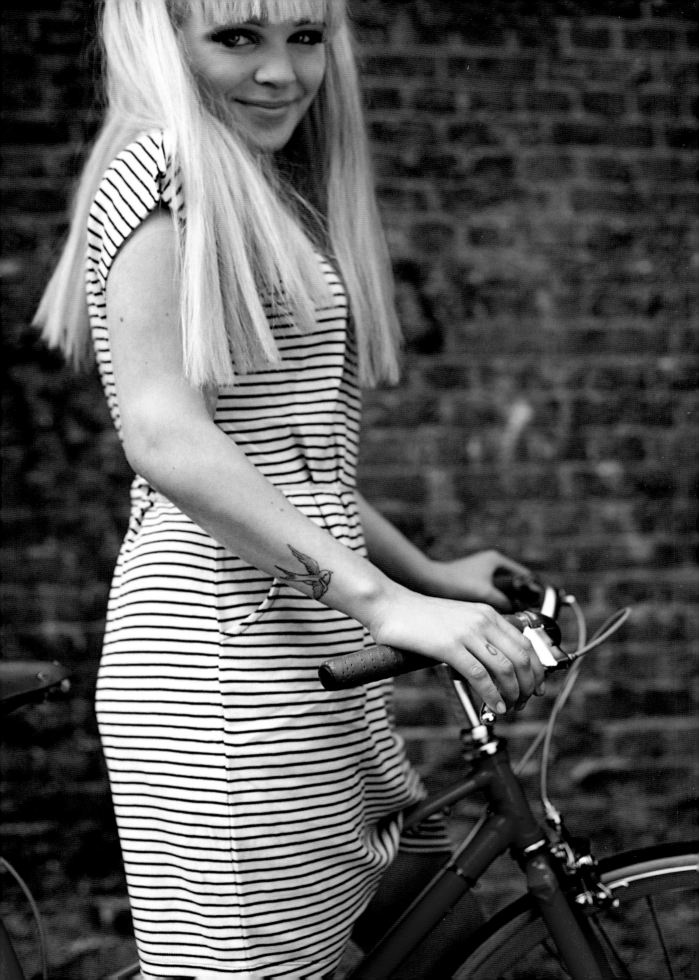

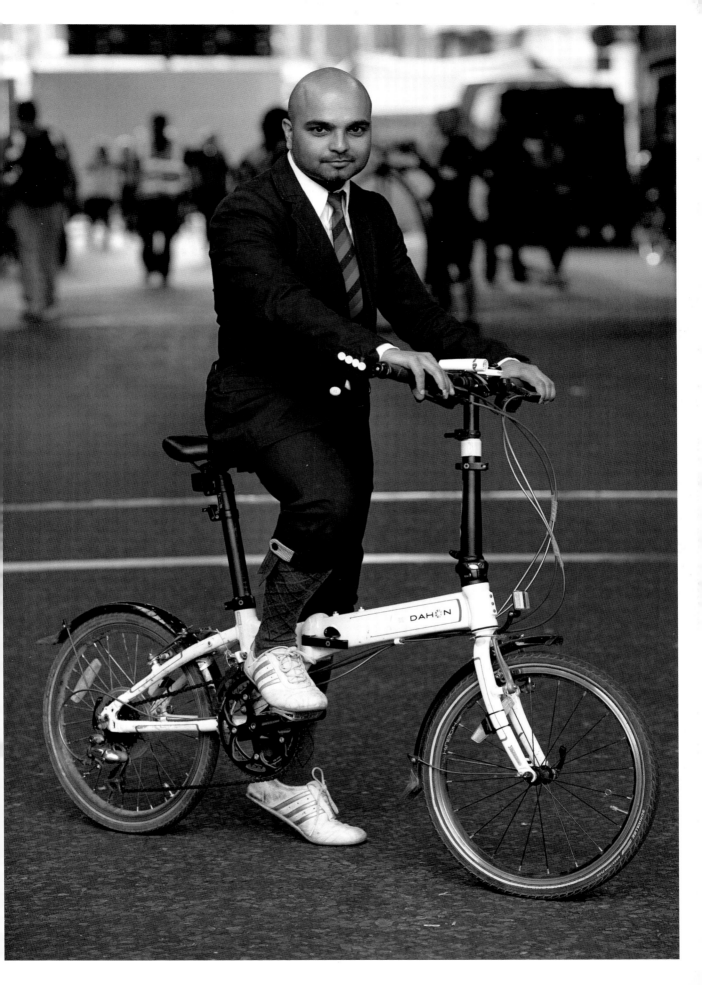

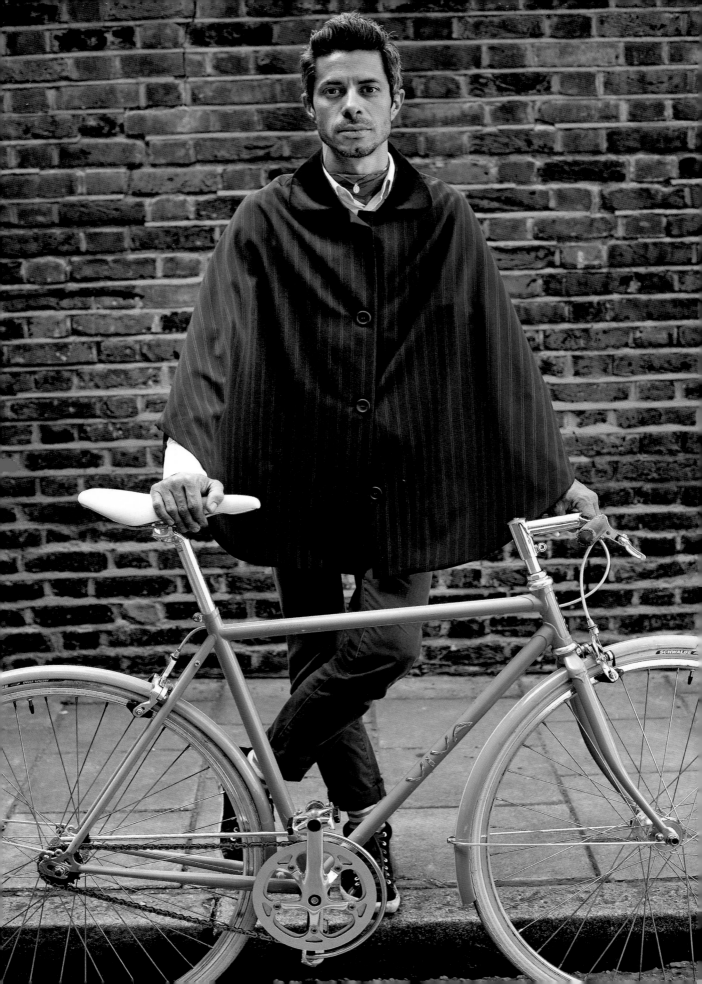

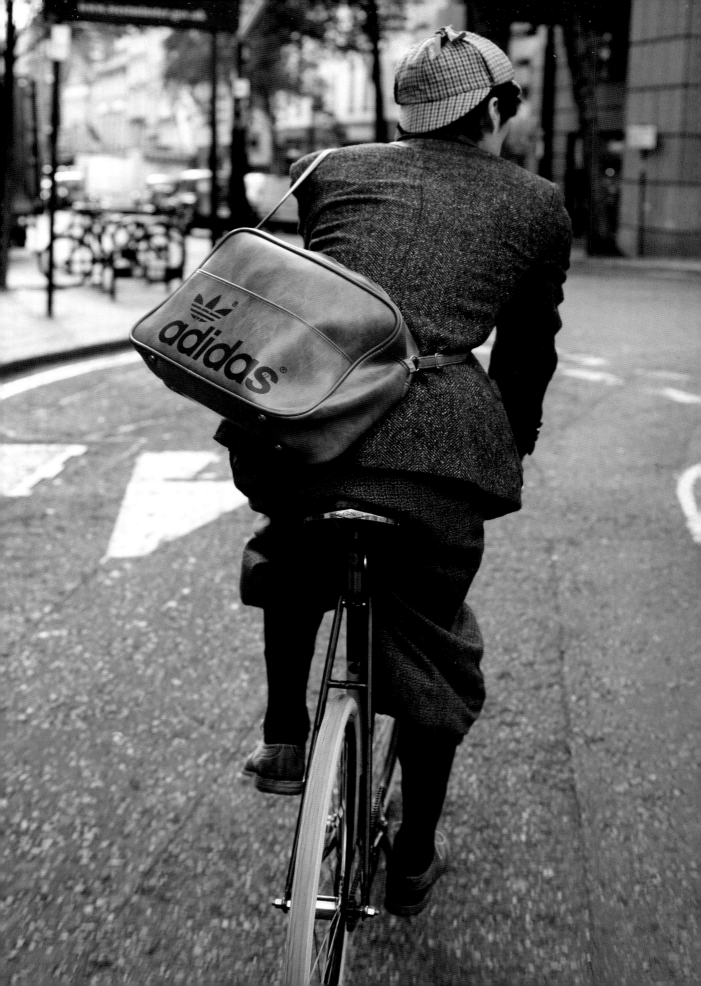

01 02 03 04 05 06

07 08 09 10 11 12 13 14

15 16 17 18 19 20 21 22

23 24 25 26 27 28 29 30

31 32 33 34 35 36 37 38

39 40 41 42 43 44 45 46

47 48 49 50 51 52 53 54

55 56 57 58 59 60 61 62

63 64 65 66 67 68 69 70

71 72 73 74 75 76 77 78

79 80 81 82 83 84 85 86

PICTURE CAPTIONS

01 Adam rides a Tokyobike Classic.
02 Amélie rides a Fixi Inc. BlackJack.
Hannes rides a Rickert classic racing bicycle 1964.
03 Nick rides a 1950s Freddie Grubb (with 1970s Strong-light chain set and Weinman brakes and Sturmy Archer 3 Speed hub).
Rudy from The 5th Floor.
04 Cally with Brough Superior Touring Model 1948 (England) with wood rims and mudguards plus front carrier, under nickel plated finish.
05 Dan with Abici Granturismo .
Elinor rides a Pashley Princess Sovereign.
06 Pandora and Andrew at the London Tweed Run, 2011.
07 Alex rides an Abici Granturismo.
Rob and Grace with Vintage Tandem at Tweed Run, 2011
08 Tony and Victor wearing vintage-inspired riding attire at the London Tweed Run, 2011.
Nick and Malcom with Pashley-Guv'nor at the London Tweed Run, 2011.
09 Kate and Gerald at the London Tweed Run, 2011.
Corinne rides a Pastel Blue Pashley Poppy.
10 London Tweed Run, 2011. Akira rides a Vindec Bicycle.
11 Gentleman with his High Wheel Bicycle at the London Tweed Run, 2011. Cally rides a Pierce 1900 (USA) full suspension front and rear with Kelly bars, wooden rims and an added 1910 Eadie 2-speed gearbox.
12 Cosima rides a Pashley Princess Sovereign.
Quoc rides a Black Jack bike by Fixie Inc.
13 Cally with Lawson Bicyclette re-creation 2005 (UK) 'La Velo-Cerap Tor Mk 2' accurate reproduction of this 1885 machine but with modern components for everyday road and shopping use.
14 Cally with Rene a La Greve Tour De France 1920 fixed wheel (French), curved cranks, inch-pitch chain, speedometer and clock, under copper-plated finish.
15 BSA steel fluted cottered cranks with 46T ring from a Hobbs Race-weight 1951. Peter rides an azure blue Ephgrave No. 1 – 1959.
16 Colette rides a Genesis flyer.
Omara and Tom at London Tweed Run, 2011.
17 David rides a Pashley Roadster Sovereign.
Cara rides an Achielle Saar Deluxe duomatic Bicycle.
18 Luke rides single speed road bike, in unfinished steel tubing made by Rob Sargent of Sargent and Co.
Ruth at the Tweed Run in London, 2011.
19 Fleur rides a Pashley Britannia at the Tweed Run in London, 2011.
An elegant gentleman riding a Faggin during the London Tweed Run, 2011.
20 Amélie rides a Fixie Inc. BlackJack.
David from Huntsman Savile Row rides a Cervelo R3 SL.
21 Mercian track bike with Paul Smith signature.
Sir Paul Smith rides a Mercian track bike.
22 Stephen rides a Raleigh Equipe" i3-speed racing bike.
23 Victor is riding a hand-built bike. A gentleman with a stylish helmet at the London Tweed Run, 2011.
24 Yuki rides a Blush Pink Pashley Poppy Bicycle.
25 Frankie rides a custom build old charge frame with a custom spray job.
26 Pam rides a United Colors of Benetton Bicycle.
Shiro rides a 1980s Maggioni frame customised and hand built by Cloud 9 Cycles.
27 Rudy from The 5th Floor "Ride it like you stole it".
28 Nick rides a Phillip's pre-1950s. Fleur rides a Pashley Britannia.
29 Laura rides a Johnny Loco Husky Women. 1951 Bates Vegrandis owned by Peter Underwood.
30 Jess rides a Kona UTE 2008 Hybrid Bike.
31 Martin rides a Pashley-Guvnor.
Frankie custom built old charge frame with a custom spray job.
32 Para rides a 24k gold plated low profile custom 1980s Rossin TT.
Frankie is on a custom built old charge frame with custom spray job.
33 Peter from The 5th Floor.
Angus at Look Mum no hands, London, 2011.
34 Shiro rides a 1980s Maggioni with Columbus SL tubing.
Hannes wearing an AH310 cycling cap.
35 David Ridding 14 Bike Company bespoke.
Jonathan rides a Tokyobike Classic.
36 Ted from Ted James Design in London, 2011.
Cally holding a sprocket.
37 Ted does frame renovations and repairs, custom builds, prototyping and riding.
38 Frankie rides a custom built old charge frame with a custom spray job.
39 Bike Polo, London Open, 2011.
40 Tattoo at Bike Polo, London Open, 2011.
Jon rides a Damp Butterbean frame with 48 hole 700c wheels, dual v-brakes and around 43 gear inches.

41 Bike Polo, London Open, 2011.
Brendan rides a custom designed 14 Bike Co polo bike.
42 Ben rides a Daily1 with a Globe A1 Premium Aluminium trekking frame with integrated front basket.
Mark rides an On-One Pompino frame with Charge Plug forks.
43 Peter rides a Vivalo Special Pro 1.
Derek rides a Ruegamer Ultralight custom carbon race bike.
44 A 1970 Hetchins Spyder single-speed.
45 Peter holding wood rimmed sprint wheel and wearing a Brooks L'Eroica jersey.
46 Dashing cyclists at London Tweed Run, 2011.
Victor at the Tweed Run in London.
47 Cally in London, 2011. Rachel in London, 2011.
48 Paul from Huntsman Savile Row is working with a Pashley Delivery Bicycle. Kati rides a Pashley Poppy Bicycle.
49 James from Cad & The Dandy rides a Pashley-Guv'nor.
50 Brooks B57 Swallow. Martin rides a Pashley-Guv'nor.
51 Nicola rides a Pastel Blue Pashley Poppy.
A Latvian couple at London Tweed Run, 2011.
52 Scott rides a French Post Delivery Bike.
Alison rides a Bobbin Bonnie and Jake rides a Charge.
53 Jools rides a Pashley Princess Sovereign.
Alison rides a Bobbin Bonnie.
54 Para rides a Dave Yates 853 steel frame with carbon fork Reynolds strike front wheel Shimano rh-500 rear wheel. Powder Coating Armourtex hackney.
Eve riding a Cloud 9 Special, The Queen of Diamonds.
55 Dee riding Condor Potenza 2010 frameset and a front Aero-spoke wheel. Abby rides a 1970s Bickerton Portable Bicycle.
56 Hazel rides a Tokyobike Bisou.
Mariano rides a Cloud 9 Special – Classy B.
57 Tosh rides a 1979 Triumph Traffic Master.
Sian ridding a Bobbin Glory.
58 Monica rides a classic Dutch bike.
Tosh rides a 1979 Triumph Traffic Master.
59 Tom's Bobbin Monsieur.
Paul from Huntsman Savile Row rides a Kronan Bicycle.
60 Amy rides a Graham Weigh, Columbus SLX, Tubing paint job, custom, designed by Amy Fleuriot at Cyclodelic.
Tom rides a Bobbin Monsieur.
61 Yang rides an Evisu X Grand 1888 bike.
62 Nick rides a Phillip's pre-1950s and Paul rides a 1939 Hercules.
63 Martin rides a Brompton.
High Wheel Bicycle at the London Nocturne, 2011.
64 Paul rides a 1939 Hercules.
65 Jonathan rides a Pashley Sovereign from the 1950s.
Akira from Nonusual.
66 Jake rides a Charge.
Donna rides a 2010 Specialized Globe Camel 3.
67 Eleonora rides a Pashley Poppy wearing a Poncho from Otto London. Amy rides a Graham Weigh and is wearing a Cyclodelic Cycling Dress.
68 Rachel rides a Coventry Eagle men's road bike.
Peter rides a Vivalo Special Pro 1.
69 Bernard rides a 2011 Bianchi Pista Dalmine.
Marija rides a Bobbin Bonnie.
70 Jules rides a Globe A1 Premium.
Patricia rides a 1970 Hetchins Spyder single-speed.
71 A smart gentleman on a vintage bike.
Alison rides a Bobbin Bonnie.
72 Mikael rides a Bromton and so does Tim.
73 Tim rides a Bromton. Lawson Bicyclette.
74 Jesse rides a Bianchi. Sonia rides a vintage Philips.
75 Lisa rides a Fuji Feather 2010. Claire rides a Cannondale R1000.
76 Chiara rides a Pashley Sonnet Pure with a Vintage Box Bag.
Yves rides a custom made Cinelli Gazzetta in Bel Verde green.
77 Yves rides a custom made Fuji fixie.
78 Paul A. Young rides a Gazelle Toer Populair.
Ross rides a Brompton 3 speed.
79 Cara at The Bicycle Man with an Achielle.
Matthew rides a Specialized Bicycle.
80 Toby rides a 14 Bike Company, bespoke.
Zofia rides a Dama Bianca Elle" Bianchi bike.
81 Nicola rides a Pinarello 1987 Montello SLX.
Andi rides a Trek Soho Bicycle.
82 A dashing gentleman at the London Tweed Run, 2011.
Jools rides a Pashley Princess Sovereign.
83 Nicky rides a Cannondale Supersix Women's 3.
Rupert rides a Tokyobike classic.
84 Peppi riding a Cloud 9 Special, The Queen of Diamonds.
Shailesh rides a Dahon fold up.
85 Otto rides Viva Bellissimo and wearing a Poncho from Otto London. Akira rides a Vindec Bicycle.
86 Alex and Zofia both riding Bianchi.

HORST A. FRIEDRICHS

Internationally renowned photographer, Horst A. Friedrichs was born in Frankfurt in 1966. He studied photography in Munich and has worked as a freelance photojournalist for a number of magazines including The New York Times, Geo and Stern. In 2008, he received the prestigious Lead Award for Best Reportage Photography of the Year. He has published a number of books including the best-selling I'm One: 21st Century Mods and Or Glory: 21st Century Rockers (Prestel). He lives in London.

ACKNOWLEDGMENTS

A big thank you to everyone who took part in this project: Adam, Akira, Nick Clements, Cally Callomon, Tim Gun, Quoc, Angus, Bernad, Rudy, Peter Pieper, Peter and Patricia, David and Paul from Huntsman, Alex, Dan and Guy from Dashingtweeds, Rob and Grace, Tony and Victor, Nick and Malcom, Corinne, Kate and Gerald, Fleur, Luke and Ruth, Martin, Omara and Tom, Hannes and Amélie, Sir Paul Smith, Boris Johnson, Pandora and Andrew, Stephen, Yuki, Frankie, Pam, Adam and Khris, Anwar The Bicycle Man, Tom and Sian from Bobbin, Chris and Adam from Cloud 9, Para, Shiro, Lisa, Jonathan, David, Rupert, Hayley, Toby, Alex Gala, Jessica, Egelnick and Webb, Felicity and Lucy from Goldengoose PR, Brendan, Jon, Mark, Derek Wiles, Ben and Jules, Cara, Ted, Rachel, Scott, Alison and Jake, Jools and Ian, Mariano and Eve, Yves, Peppi, Marija, Matthew, Alex and Zofia, Sonia, Ross, Marija, Matthew, Dee, Tosh, Monica, Amy, Nick and Paul, Yang, Donna, Jonathan, Jesse, Eleo and Otto, Mikael, Paul A. Young, Kevin, James, David Morgan, Shailesh, Chiara, Lewis Leathers, Jason Rainbird, Roty340, Cosima, Nina, Elinor, Colette, Yos and Jorge, Carola, Uli, Andrea, Dagmar, Andi and Ginz.
A big Thank You to my assistant, Filip Milovac, and everyone else that assisted me (especially Hannes Hengst).
I would also like to express my gratitude to The Rt. Hon. The Lord Mayor of The City of London Alderman Michael Bear and Jenette Coduto, City of London, for involving me in the City Cycle Style project.

Thank you also to Lars Harmsen from MAGMA Brand Design, who developed the concept and design of this book, for his generous work, his huge enthusiasm and unending creativity. His company and friendship are invaluable.

Thank you to my Publisher at Prestel, Christian Rieker, along with Curt Holtz, Andrew Hansen, Olli Barter, Ali Gitlow, Florence Andrew, Claudia Schwind, Pia Werner, Nele Krüger, Renate Ullersperger and Katharina Harderer.

A special thanks to my agent, Regina Anzenberger and her team who have always supported my ideas and projects.

My wife Adriana and my daughter Greta for their love, faith and inspiration.

For my parents.

SOURCES & LINKS

Brands: 14bikeco.com | AH310.com | benetton.com | bobbinbicycles.co.uk | brookssaddles.com cicli-berlinetta.de | cinelli.it | classiclightweights.co.uk | cloud9cycles.com | colnago.com | condorcycles.com cyclodelic.co.uk | dashingtweeds.co.uk | eroica-ciclismo.it | evisu.com | fredperry.com | huntsman.com Jonathankelsey.com | lairdhatters.com | lookmumnohands.com | mensfile.com | oakcycles.com | ottolondon.com pashley.co.uk | paulsmith.co.uk | quocpham.com | rapha.cc | rugby.com | steelmagazine.fr | stilrad.com stormmodels.com | tedjamesdesign.com | the5thfloor.co.uk | thebicycleman.co.uk | thecurator.co.uk theoldbicycleshowroom.co.uk | tokyofixedgear.com | tweedrun.com | velorution.biz | wheelmencompany.com Blogs: copenhagencyclechic.com | thebikeshow.net | themichauxclub.blogspot.com trackosaurusrex.com/pblog | velo-city-girl.blogspot.com Bike Polo: 321polo.net | leagueofbikepolo.com | lhbpa.org | oakcycles.com

DISCLAMER

Always wear a helmet: no matter how old you are, where you ride, or how long you ride. Because cyclists are so exposed on the road, head injuries afflict thousands of people every year. Wearing a helmet is the single most effective way to prevent injuries in an accident.

Safe cycling!

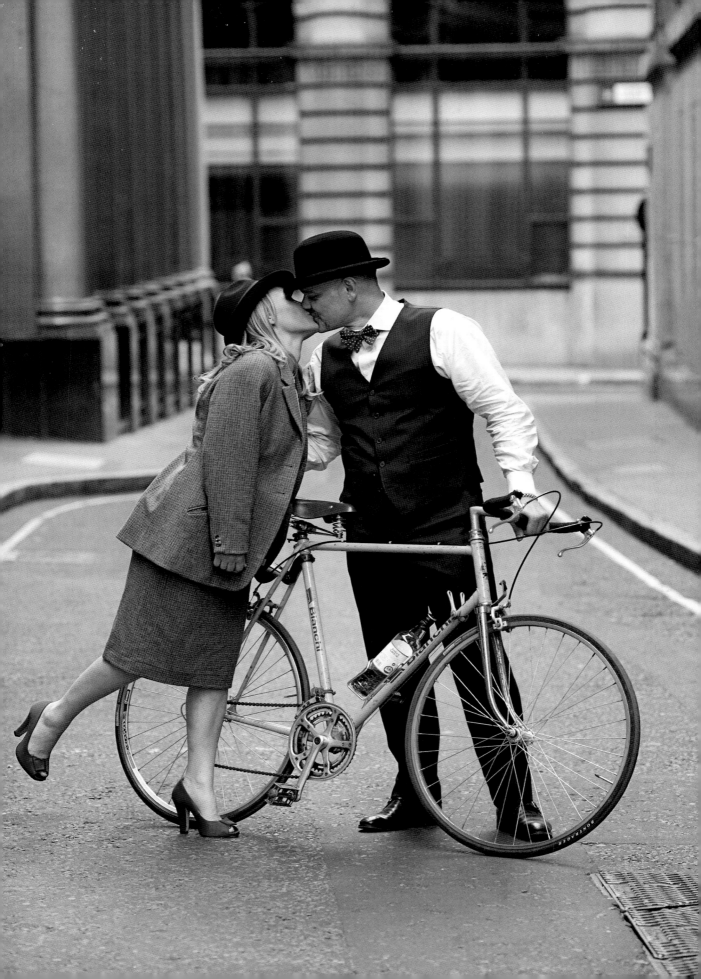

© Prestel Verlag, Munich · London · New York 2012
© for the photographs by Horst Friedrichs, London, 2012
© for the text by Nick Clements, 2012
© for the design by Lars Harmsen, Magma Brand Design, Karlsruhe, 2012
Fourth Printing, 2013

Prestel Verlag, Munich
A member of Verlagsgruppe Random House GmbH

Prestel Verlag
Neumarkter Strasse 28
81673 Munich
Tel. +49 (0)89 4136-0
Fax +49 (0)89 4136-2335

Prestel Publishing Ltd.
14-17 Wells Street
London W1T 3PD
Tel. +44 (0)20 7323-5004
Fax +44 (0)20 7323-0271

Prestel Publishing
900 Broadway, Suite 603
New York, NY 10003
Tel. +1 (212) 995-2720
Fax +1 (212) 995-2733

www.prestel.com

Library of Congress Control Number is available; British Library Cataloguing-in-Publication
Data: a catalogue record for this book is available from the British Library; Deutsche
Nationalbibliothek holds a record of this publication in the Deutsche Nationalbibliografie;
detailed bibliographical data can be found under: http://dnb.d-nb.de

Prestel books are available worldwide. Please contact your nearest bookseller or one of the
above addresses for information concerning your local distributor.

Editorial direction by Curt Holtz
Design and layout by Magma Brand Design, Karlsruhe
Production by Nele Krüger
Origination by Reproline Genceller, Munich
Printing and binding by Neografia, Martin

Verlagsgruppe Random House FSC® N001967
The FSC® -certified paper Profisilk has been supplied
by IGEPA, Germany.
ISBN 978-3-7913-4662-5